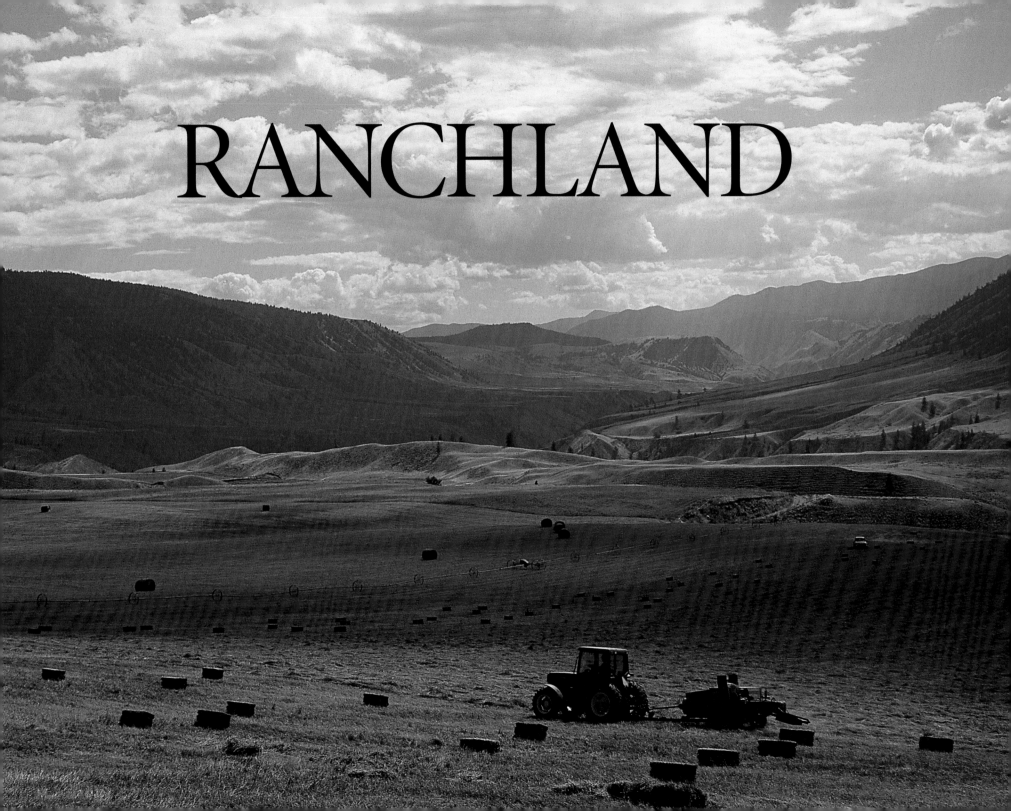

RANCHLAND

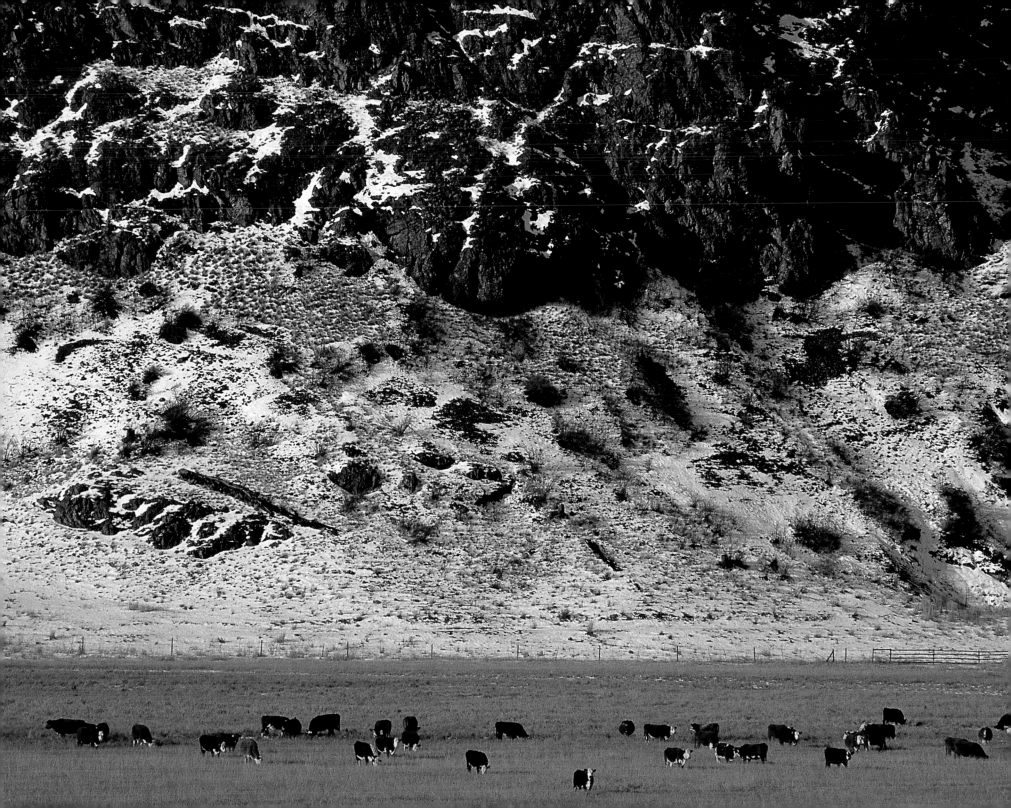

RANCHLAND

British Columbia's Cattle Country

Rick Blacklaws & Diana French

HARBOUR PUBLISHING

Contents

FOREWORD
Stephen Hume

Few of the myths that are indigenous to North American culture have proved as durable as that of the cowboy. From the pulp fiction heroes of Louis L'Amour to the gritty contemporary figures of Gretel Ehrlich's Wyoming stories, from the romanticized Victorian images of Frederick Remington to the faux austerity of Madison Avenue's Marlborough Man, from the 1862 midnight brawls of R. Byron Johnson's peculiar British Columbia classic *Very Far West Indeed* to the epic frontier manhunt for Simon Gunanoot to Susan Allison's still electrifying description of a buckskin-clad horseman on the Hope-Princeton trail in 1860, the motif of the solitary, self-reliant, rugged individual in the saddle permeates popular culture. Fifty years ago, at the height of the Cold War, when capitalism and communism were eyeball-to-eyeball like Soapy Smith and Frank Reid getting ready for their shootout on the Skagway docks, seven of the top ten shows on American television were westerns, an indication of the way in which cultures retreat into the comforting power of their myths in times of uncertainty, fear and risk. This fascinating statistic also serves as a reminder of how one segment of North American culture has appropriated to itself—along with the self-defining term American—the symbols, legends, histories and metaphors of a phenomenon that had its origins with the Mexican vaquero and found some of its most dramatic

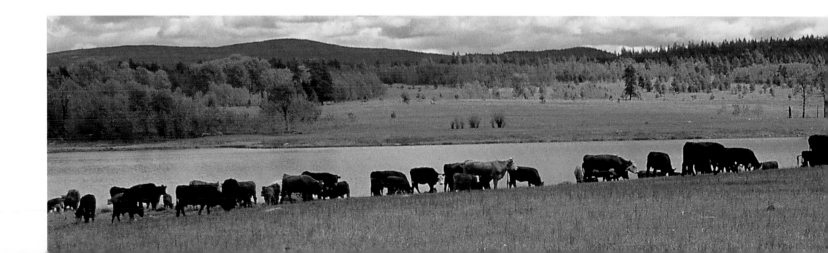

manifestations not on the Santa Fe Trail but along the Cariboo Trail, far to the north of the boundary that Montana ranchers still call the High Line. For, contrary to the notions fostered by Hollywood, the cowboy is as deeply entangled in British Columbia's sinewy, muscular past as loggers, fur traders and sourdoughs.

When the first livestock was raised west of the Canadian Rockies is uncertain, but it may have been at the fortified outpost established on Nootka Sound by the Spanish military commander Don Pedro Alberni in 1790. Or it may have occurred in association with one of the Hudson's Bay Company forts in the Interior of the province, where cattle and horses were kept to provide beef for the trading post and mounts for the Fur Brigades, whose trails can still be seen in the Okanagan Valley. One thing is certain: the cowboy entered British Columbia's history in a major way with the discovery of gold on the Fraser River and its tributaries. Larry McMurtry's Pulitzer prize-winning saga *Lonesome Dove* resurrected the cattle drive as the Odyssey of the Old West, basing it loosely on famous expeditions from Texas to Colorado just after the American Civil War. But cattle drives of an equally dramatic nature were already taking place across British Columbia as drovers brought livestock from as far away as Oregon to supply the goldfields at Barkerville. Some of the cowboys driving these steers north through the bunch grass prairies of the Nicola Valley and the Cariboo, decided it made more sense to raise cattle closer to market and stayed to establish the great ranches where more than one-third of the province's 800,000 beef cattle are raised, in an industry that contributes hundreds of millions of dollars to the British Columbia economy every year.

The cowboy, it turns out, is not only a mythological figure but a vital part of everyday life in the Far West. He is cross-cultural and eclectic, from Okanagan chiefs to Irish gentry, from Welsh drovers to Confederate Army cavalry troopers in exile. Most important, he is us. *Ranchland* takes us beyond legend and history and into the geography of the contemporary cowboy, reclaiming from the dreamscape of myth and the grandiose portfolios of American chauvinism, a vital and illuminating part of British Columbia's rich and diverse heritage.

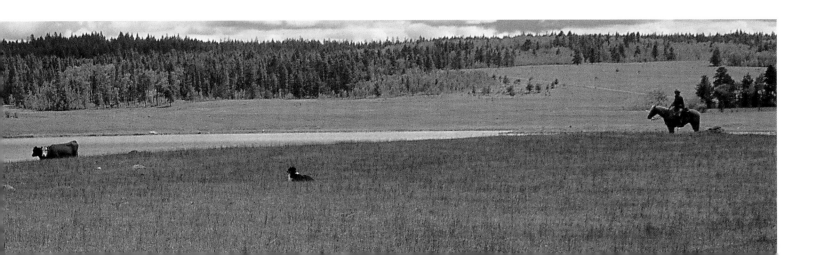

Cattle Country

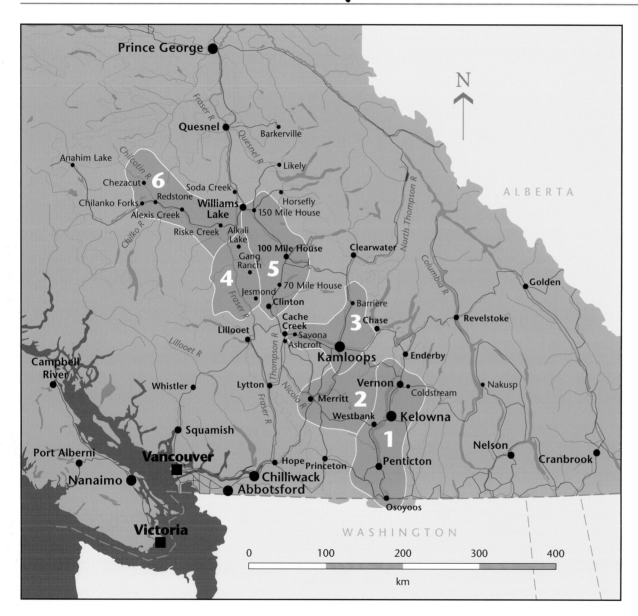

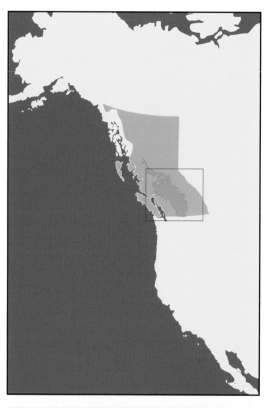

Major cattle grazing areas

1 Regions covered in this book

Region 1: The Okanagan Valley (Chapter 4)

Region 2: The Nicola Valley (Chapter 5)

Region 3: The Thompson Valley (Chapter 6)

Region 4: Cariboo: The River Road (Chapter 7)

Region 5: Along the Cariboo Road (Chapter 8)

Region 6: The Chilcotin (Chapter 9)

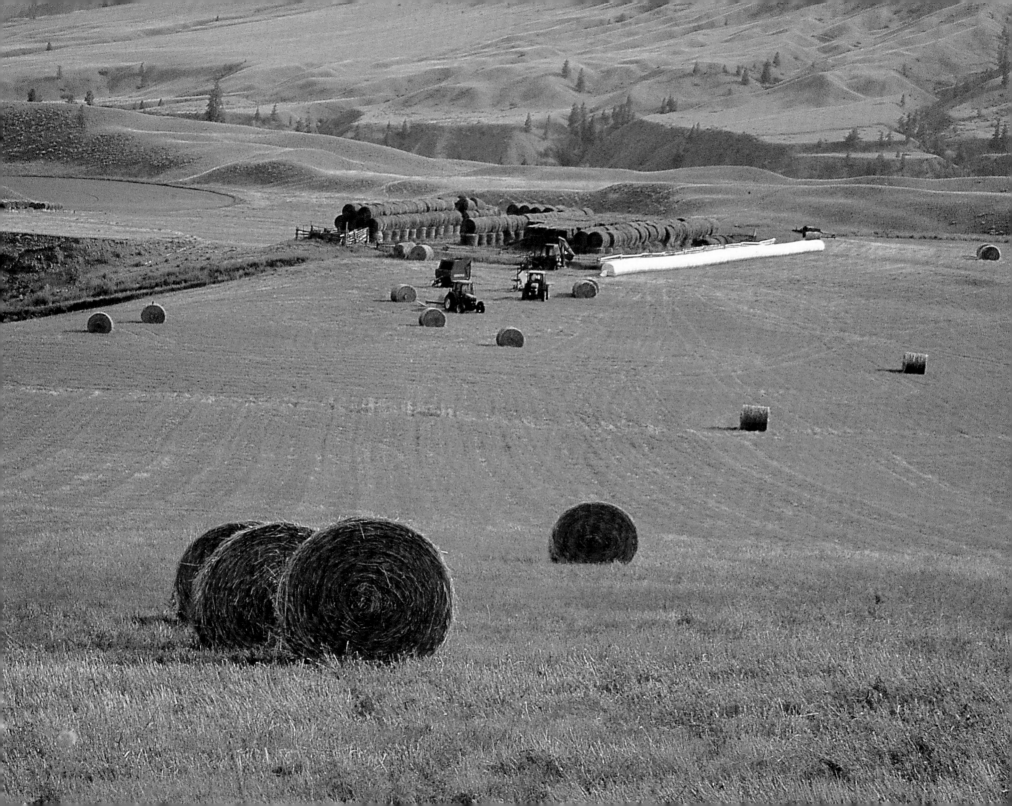

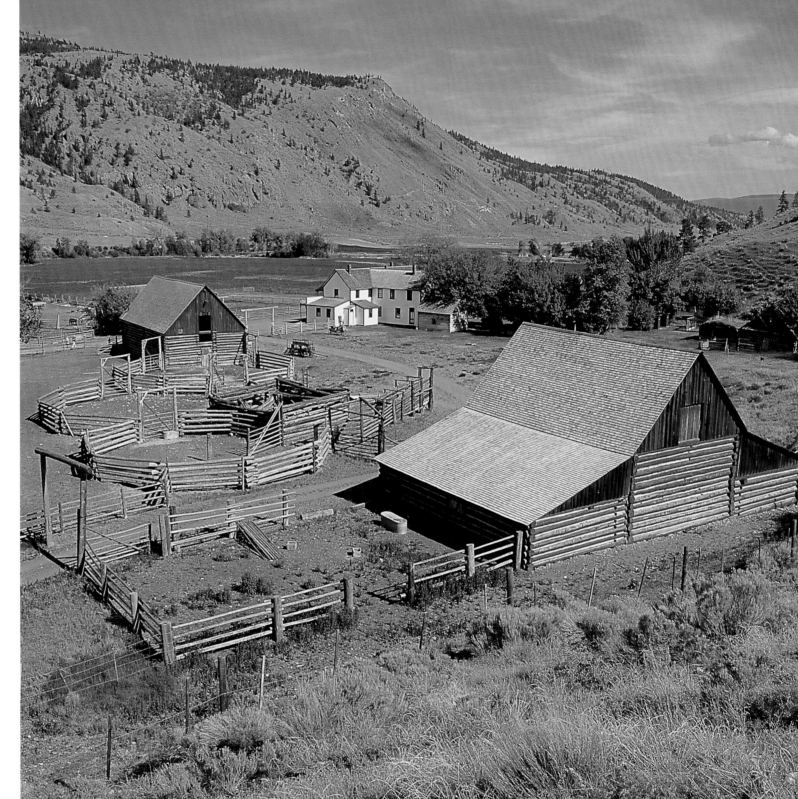

HAT CREEK HISTORIC RANCH, NEAR CACHE CREEK. THE RANCH WAS ESTABLISHED IN THE EARLY 1860S BY DONALD MCLEAN, A LONG-TIME HUDSON'S BAY COMPANY FUR TRADER. IT IS NOW A PROVINCIALLY OPERATED HISTORIC SITE AND TOURIST ATTRACTION.

1 Winning the West

Fur traders were the first outsiders on record to seek their fortunes in what is now British Columbia. These Scots traders and French coureurs de bois wrote some colourful pages in the history books, but they left few footprints. Gold seekers followed them in the 1850s. Their heyday lasted a mere decade, and though they left more tangible signs of their passing, their lasting importance is that they opened the door for the cattle industry. It was the cattlemen who won Canada's West.

The Hudson's Bay Company had a cow or two at their fur trading posts in lower British Columbia as early as 1821, but that was not the beginning of the cattle industry: it was the company's attempt to make the forts self-sufficient by providing the employees with milk, meat and butter. By 1846 there were 5,000 head shared between Forts Victoria, Langley, Kamloops and Alexandria. Cattle raising as an industry began after gold was discovered along the banks of Tranquille Creek, which flows into the Thompson River near Kamloops. The first boatload of prospectors bound for the goldfields arrived in Victoria from California in April 1858. The first beef cattle drive from Oregon crossed the border at Osoyoos, also bound for the goldfields, two months later.

The timing of BC's bonanza was just right for cattlemen in the northwestern United States. The end of the California gold rush left them with surplus cattle and experienced drovers were ready to hit the trail to exploit the new market.

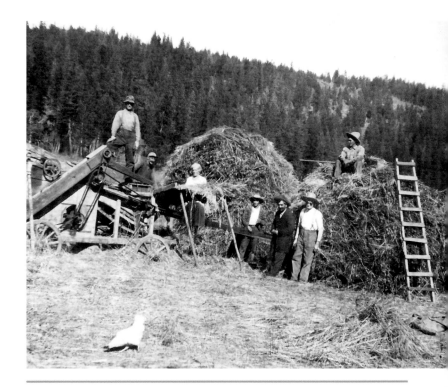

MAKING HAY AT CLARKE RANCH NEAR WILLIAMS LAKE, EARLY 1920S.
PHOTO COURTESY MUSEUM OF THE CARIBOO CHILCOTIN

The first drive, organized by General Joel Palmer, left Oregon in April for the 1,280 km drive eastward beside the waters of the Columbia, then north along the Okanagan River and around Lake Okanagan before turning northwest to Fort Kamloops. His cowboys travelled with ox-drawn wagons carrying supplies, and a mix of cattle, some of them small Spanish black cows, Durhams, and shorthorns.

"We encountered many difficulties due to swollen rivers in June and July, and the Indians were not always friendly," Palmer wrote in what has to be an understatement. Along with swollen rivers and unfriendly Natives, they faced treacherous terrain, bloodthirsty bugs, capricious weather, long days and sleepless nights.

The herd moseyed along at about 19 km a day, fast enough to reach their destination before supplies ran out, slow enough for the animals to maintain their weight. The drives were brutal for the cowboys; no one cared if they maintained *their* weight. They lived out in the open for months with only their wide-brimmed hats, leather chaps and maybe a slicker for cover. The only beef they ate was jerky; otherwise their diet was sow belly, beans and bannock. "Nighthawking"—riding herd on the horses all night—was not popular. Nor was "riding drag" behind the herd in the dust kicked up by hundreds of hooves if the weather was dry, in churned-up muck when it rained.

Palmer sold the oxen and his remaining supplies at Kamloops, then trailed the cattle to the Fraser River camps, where hungry miners snapped them up. The rewards for Palmer and those who followed him were worth all the hardships. They paid $10 a head for the cattle, plus $2 duty

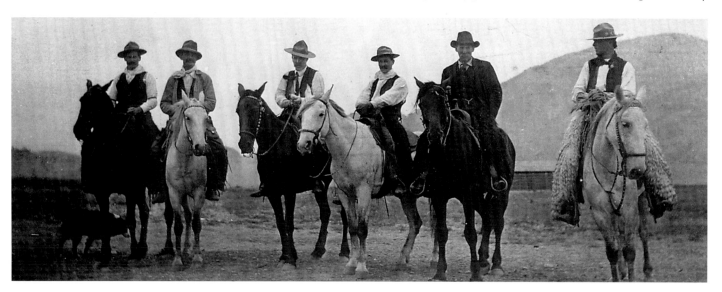

Cowboys in the Osoyoos area. Left to right: Ed Richter, Charlie Richter, Will Haynes, Jack Mackenzie, William Manery, William Richter. *BC Archives* C-00835

for every one that crossed the border. The only other expense was a $30 per month wage-plus-grub for each rider. The cattle ate free and brought $100 to $150 a head at the goldfields. Even when the gold rush reached Barkerville, extending the cattle drives by several hundred miles, the stockmen made more money on one drive than most miners made during the entire gold rush.

Timing of the cattle drives was critical. No sane drover would tackle a Cariboo winter on the trail. In Barkerville's heyday, residents there consumed some 1,400 head of cattle a year, but there was little market for beef in winter because most miners deserted their diggings to hole up in warmer climates. Successful drovers purchased cattle in the US in the fall when prices were low, crossed the border, then wintered them on the grasslands along the way. The Thompson and Nicola areas were popular for wintering. Here miles of delicate bunch grass grew, each tuft standing straight up from the ground like an up-ended whisk broom. A man or two were left to watch the herd, and in spring, when the grass greened up, the owners would return with the rest of their crew and the drive would continue north.

In 1863 Jerome and Thaddeus Harper, drovers and entrepreneurs, formed a partnership with the three von Volkenburgh brothers, who owned butcher shops in strategic centres in the goldfields. A typical Harper drive included 500 steers, 50 cows and as many horses, all to be sold. The cattle were held on the wild pasture lands and trailed to the von Volkenburghs' shops as needed, perhaps twenty animals a day. This partnership virtually controlled the BC cattle market for the next twenty years.

Miners and drovers, like fur traders, were transients, and James Douglas, governor of the colony, wanted settlers for this new land. In a letter to the Colonial Secretary in Britain in 1859, he wrote: "The miner is at best a producer and leaves no traces but those of despoliation behind; the merchant is lured by hope of gain, but the durable posterity and substantial wealth of states is no doubt derived from the cultivation of the soil. Without the farmer's aid British Columbia must forever remain a desert, be drained of wealth, and dependent on other countries for food." A year later Douglas issued a Land Act which allowed a British subject to pre-empt 160 acres (64 ha), for which he could earn a Crown grant by building a home or a fence, or cultivating some land, and by paying $1 per acre. The British Columbia Land Ordinance of 1870 doubled this land allotment for those staking the grasslands of the Interior, and by the mid-1860s pre-emptions were strung like beads along the travelled routes between the US border and the goldfields. Company men and luckless miners settled on meadows that were little more than good garden plots (one enterprising farmer at Soda Creek sold his turnip crop to miners for $3,000). Entrepreneurs established stopping places and roadhouses, and most had a few cattle. Many of these places became the province's cattle ranches. Typical were Herman Bowe, who built a roadside inn and what is believed to be the first ranch in western Canada on the river trail at Alkali Lake; and the Hudson's Bay fur trader Donald

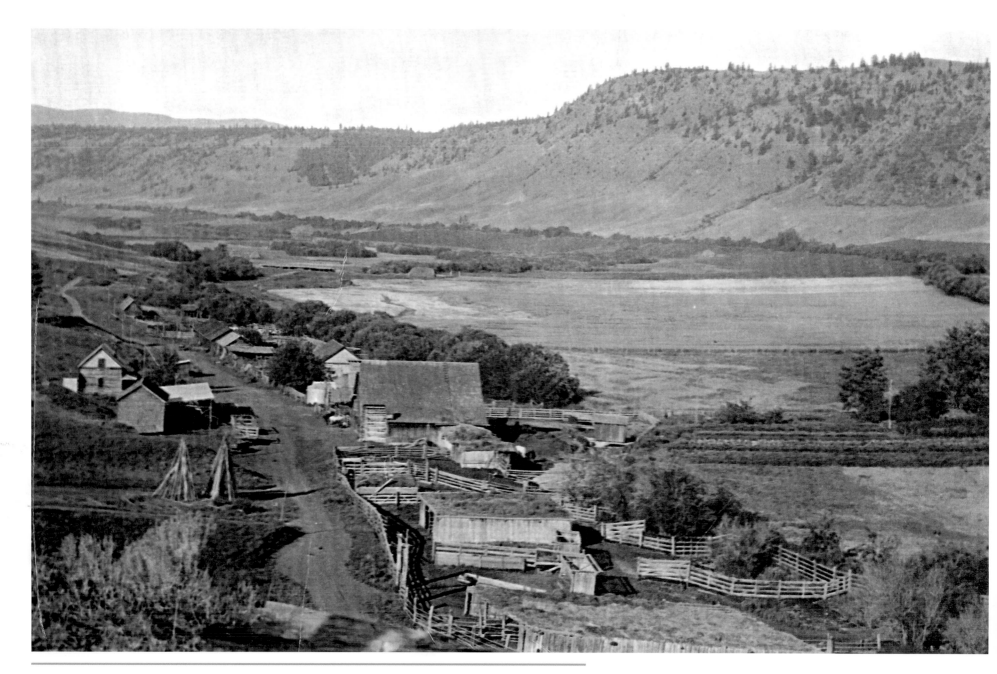

ALKALI LAKE RANCH HOMEPLACE, BC'S FIRST CATTLE RANCH, 1930S. *PHOTO COURTESY MUSEUM OF THE CARIBOO CHILCOTIN*

McLean (later killed in the "Chilcotin War"), who built a stopping place at Hat Creek in 1860 and put the rest of his property to good use raising cattle.

The combination of a ready market, acres of grassland, a plentiful water supply and a generally law-abiding populace attracted men primarily interested in cattle ranching. Lewis Campbell, who settled in Kamloops, and John Wilson, in Savona, built ranching empires with the profits from their cattle drives. Antoine Minnabarriet, an Oregon rancher, came to prospect for gold but stayed to establish the Basque Ranch near Spences Bridge. Some successful miners switched to ranching. A Pennsylvania miner named Peter Curran Dunlevy, the first to make a stake in the Cariboo goldfields, developed a 1,000-acre (400 ha) farm on the bench above Soda Creek. John Carmichael Haynes, an Irishman, came to BC to join the constabulary and by 1861 had become the customs officer and gold commissioner at Osoyoos; on the side he kept busy pre-empting land and buying cattle from the drovers who stopped there to pay duty on them. Francis Xavier Richter, an Austrian, brought cattle from Oregon to pre-empt west of Osoyoos. Three English military men, Charles Houghton and Forbes and Charles Vernon Ranch, established what is now the Coldstream Ranch east of Vernon.

Some settlers pre-empted, improved their land and obtained their Crown grants only to sell them: the Perry Ranch at Cache Creek was made up of seven pre-emptions. Others were paid to pre-empt by foreigners with money and big plans but no intention of swearing allegiance to the queen. This is probably how the American Harper brothers acquired their properties.

The gold rush inevitably waned, wiping out that market for beef, and by 1870 cattle prices had tumbled to $12 a head. While the Lower Mainland's growing population was the obvious alternative market, the railroad—promised when BC joined Confederation in 1871—was slow to materialize. The ranchers' only recourse was to drive their animals to the coast, but it was rugged country through the mountains, and the weary beasts arrived there in poor condition. Lower Mainlanders could import beef in prime condition from the United States and get it more cheaply.

Still, Interior ranchers persevered. Smaller outfits combined herds and hired drovers, and larger ranchers trailed their own herds to the coast. Okanagan and Nicola Valley stockmen used the Dewdney Trail, which crossed the southern Interior through Keremeos, Princeton and Hope; Ashcroft and Kamloops stockmen took the Cariboo Road; Cariboo and Chilcotin herds went via the Seton-Anderson trail and Harrison Lake. All the routes ended at Yale, where the cattle were shipped by boat and scow to New Westminster and Victoria.

Declining markets, difficulty reaching those markets and American competition were only the first of the ranchers' problems. The wonderful grasses that had first attracted the ranchers were in serious trouble. In 1873 the Reverend M. Grant, travelling through the Cache Creek area with the Canadian Pacific Railway magnate Sir

Sandford Fleming, wrote that the once bountiful grasslands were now "little better than a vast sand and gravel pit bounded by broken hills, bald and arid except for a few summits that support a scanty growth of scrub pines. The cattle have eaten off all the bunch grass within three or four miles of the road, and a poor substitute for it, chiefly in the shape of a blueish weed or shrub, has taken its place." The weeds and shrubs were tumbleweed and sagebrush, which may be sentimental subjects for western ballads but aren't much use as fodder.

The bunch grass had been so prolific that most stockmen believed there was no end to it, but it is a delicate grass with poor regenerative powers, and a tuft of it can be levelled in a couple of good chomps by a hungry cow or horse. It might have survived the passing pack trains and cattle drives, but ranchers relied on it for year-round grazing. With little local market after the gold mining waned, surplus animals grazed at will. The grass simply could not stand it. Hundreds of hectares had already been lost by the mid-1870s.

Henry Cornwall, who with his brother Clement established the Ashcroft Ranch on the Cariboo Wagon Road, recognized the bunch grass was too delicate for heavy grazing and tried cultivating alfalfa as early as 1862. The idea didn't catch on. The Cornwalls, who were English gentry, were ridiculed for "babying" their cattle by rounding them up in winter to ensure their safety. By contrast, the American Harpers left their cattle to their own devices and many starved over the winter.

THE CORNWALLS

The history of BC and the Cornwall family go hand in hand. Two brothers, Clement and Henry Cornwall, established the Ashcroft Ranch in the early 1860s. Ashcroft Manor (named for the Cornwall home in England) was the social centre for British gentry, and guests travelled hundreds of miles from the Chilcotin and the Okanagan to attend race meets and other events there. The Cornwalls were renowned for their fox hunts. The brothers imported hounds from England, and they departed from tradition only in that they hunted coyotes, foxes being in short supply in the Cache Creek area.

ABOVE RIGHT: CLEMENT CORNWALL, 1860S. *BC ARCHIVES F-02698*

Then came the killer winter of 1879–80, when deep snow arrived in November and covered the few surviving nubbins of grass until March. Spring revealed a barren land littered with carcasses. Settlers with smaller holdings either walked away or, if they were lucky, sold their land to larger outfits. Abandoned log cabins, the bleached skeletons of log fences, and an occasional lilac bush are all that remain of their dreams.

It took another disastrous winter to convince stockmen that the benefit of putting up winter feed outweighed the costs. The introduction of horse-drawn mowing machines helped change their minds. They began building dams and irrigation ditches and growing forage crops. Another incentive was weight gain. Left to rustle, animals were three years or older before they reached marketable size. When fed over the winter, they could be sold sooner.

CPR construction crews finally began laying track across BC in the early 1880s. The crews provided a sweet but short-lived beef market, and the track supplied a long-term solution to the problem of transportation to coastal markets, but the railway was not all good news. The right-of-way divided some properties and cut off the water supply to others, and for the smaller outfits, the freight rates were too high to make the trip to the coast markets economical. The railway gave Alberta ranchers easy access to BC's Lower Mainland markets, and it wasn't long before their beef was providing stiff competition. BC cattlemen were forced to improve their stock. Larger ranches began importing pure-

WAGON WHEELS AT THE MULVAHILLS' CHAR MEADOW RANCH AT CHEZACUT.

bred animals from eastern Canada and England to replace the motley herds that had ranged from Texas longhorns to anything with cloven hooves that lowed.

The CPR brought an end to the Harper empire. Thaddeus secured the first contract to supply beef for the construction crews, but lost the second when he was out-witted by Joe Greaves, founder of the Douglas Lake Ranch in the Nicola Valley. Greaves rode all over the Interior buying cattle and left them on the ranches. When Thaddeus went to buy, there was nothing for sale; he lost the contract and Greaves won it. Greaves' cattle were the first to reach Port Moody by rail, passing through Yale on St. Valentine's Day 1884—a total of eighty-five head on five flatcars with the sides and ends boarded up.

In 1886 the Douglas Lake Cattle Company became the first ranch to register as a corporation. The Harpers' Gang Ranch was sold in 1888 to the British-owned BC Land & Investment Company, making it the only foreign-owned ranch in the province at the time. A subsidiary, the Western Canada Ranching Company, operated the ranch. The BC Cattle Company Ltd. was incorporated in 1890 by two Okanagan pioneers, Thomas Ellis and Richard Cawston, and a Victoria businessman, John Irving, who had bought the von Volkenburgh holdings, including a large ranch at Canoe Creek. While these ranching companies were acquiring land, the Okanagan Land and Development Company, headed by George Mackay, a Scotsman, was reversing the trend by buying up ranches to subdivide. Vast Okanagan spreads between the US border and the Shuswap, where thousands of cattle had roamed unfenced grasslands, became fruit orchards and dairy farms.

At the end of the century BC ranchers lost out to Albertans when mines opened in the Kootenays, but they did take advantage of the Omenica and Klondike gold rushes. Henry Koster Sr., who later became a partner in the Alkali Lake Ranch, successfully trailed a number of herds to the Klondike for the Burns Packing Company. Norman Lee, a Chilcotin rancher, wasn't so fortunate. In 1898 he headed for the Klondike, 1,920 km distant, with 200 head of cattle, thirty horses, six cowboys and a cook. At Teslin Lake they butchered the beef and loaded the carcasses on rafts to float them to Dawson City. A storm wrecked the rafts, the beef was lost and Lee arrived home with nothing but his dog and a blanket.

The completion of the Canadian National Railway in 1906 and the Kettle Valley branch line in 1916 improved access for Thompson/Nicola Valley ranchers. World War I forced prices up, and population growth in the Lower Mainland raised the demand for beef. BC ranchers were encouraged to enlarge their herds, and the province's beef stock population almost doubled between 1915 and 1917. Prices sank immediately after the war but soon climbed again, and by 1929 there were more than 290,000 beef cattle in the province.

Then came the Great Depression—and drought. Little hay grew in those dry years, and grasshoppers ate what did grow. Ranchers all over the province were forced to sell their stock, and they took whatever price was offered at the

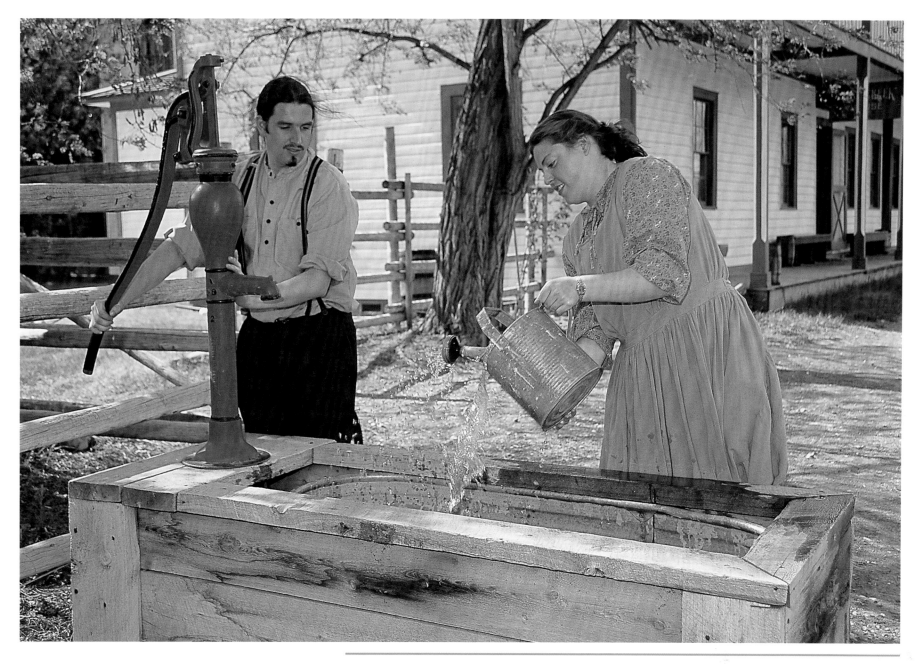

GABRIEL ASSELIN AND ALEXANDRA MARTIN BRING RANCHING HISTORY TO LIFE AT HAT CREEK HISTORIC RANCH.

railhead because there was no point in trailing their animals home again. By 1934 a heavy steer was bringing $34, compared to $102 five years earlier. Those who kept their cattle were no better off. The dry summers were followed by the worst winters on record, and the animals that had found grazing in the summer died in the long, bitterly cold winter. The smaller ranchers couldn't afford to stay on their land, but they couldn't afford to leave it either. Trapping and working on the roads kept many afloat, but so many cattlemen lost stock that by the mid-1930s the province's cattle population was back to pre-war numbers.

It took another war for prices to recover: major changes in the industry began in the 1940s. In 1943, stockmen formed the BC Livestock Producers Cooperative Association to ensure cattlemen a fair price for their cattle. A few years later ranchers began trucking their animals to market, and within fifteen years few cattle were hoofing to the railheads. The third major change came in the 1950s, when a glut of grain in Alberta caused cattlemen there to finish their animals on grain. The fat on grain-fed beef is whiter and the meat looks fresher, so it was easy for marketers to convince consumers that it tasted better than traditional grass-fed BC beef. Because little grain is grown in BC's ranching areas, ranchers here began shipping calves and yearlings to be finished on grain at Alberta feedlots. It was cheaper to ship butchered beef back to BC than to ship live animals, so before long the slaughtering was done in Alberta as well. BC slaughterhouses were soon out of business.

FAIR GAME

With their pockets full of money after selling their cattle at the goldfields, drovers were fair game for thieves. Ben Snipes, who later had a huge ranch in Washington, trailed thousands of cattle into BC. On his first trip, at age twenty-two, he delivered a herd to the gold rush city of Barkerville. He had been warned that robbers were waiting, so he crept out of town after dark, riding a mule and burdened with $50,000 worth of gold dust. He travelled, always at night, over 670 miles (1,120 km) in seven days, and got home safely.

In the 1960s the grasslands that had lured US stockmen to BC a century earlier beckoned again. Squeezed by escalating taxes, high land prices and the demand for residential property, cattlemen from Oregon, California and Texas headed north to take advantage of the lower land prices in BC. They found ranchers happy to sell because production costs were rising faster than cattle prices, and estate taxes were making it difficult to pass the land on to their children. By 1965 more than half the ranches in BC belonged to Americans. Most of the newcomers prospered, and stayed.

As the twenty-first century begins, BC has some huge ranches, some tiny ones and all sizes in between, along with hobby ranches and working guest ranches. Some are owned by Canadians, some are not. In the earlier days, cattle were marketed as two-year-olds. The majority of ranches now are cow/calf operations. Calves born in the spring are usually sold that same fall. Some ranches hold the calves until the next year. Whatever age, the calves go to feedlots for "finishing." There are also purebred operations that raise registered breeding stock for sale to ranchers.

The business of raising beef cattle has seen many changes since its beginnings, but none has dimmed the aura of romance that clings to the industry. Modern methods haven't quieted the din that rises from a ranch when calves are weaned, or the bawling that ensues when the cattle hit the stockyard pens. Cattlemen are still a hardy breed, and like those who pioneered the industry, modern ranchers wear a mantle of freedom and independence that hasn't diminished over the years.

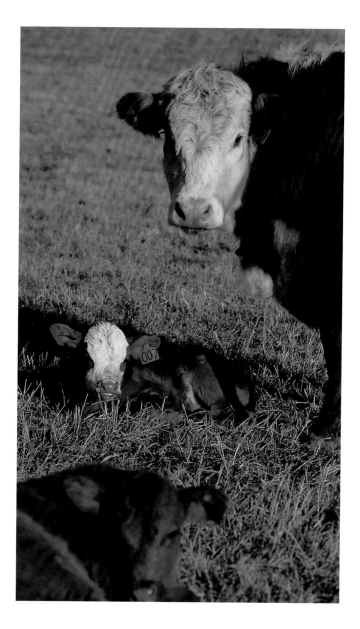

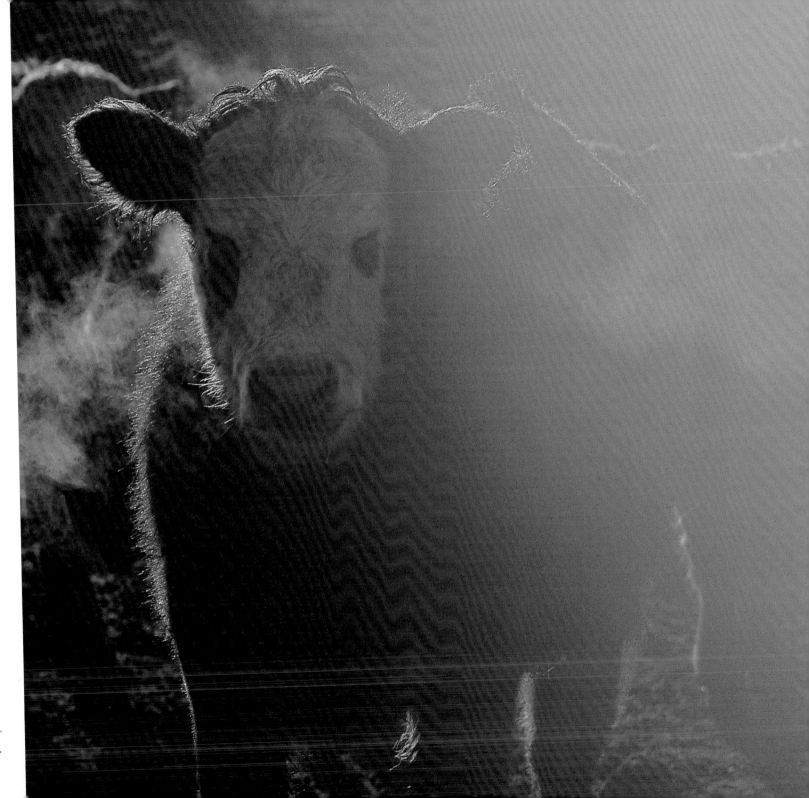

WINTER MIST.

2 A Year on a Ranch

Conjure up the typical image of a cattleman and you see a brave and handsome man riding tall in the saddle, trailing a vast herd of lowing cattle across wind-rippled grassland. Or perhaps a lone cowboy riding into the sunset, his day's work done. A pleasant, bucolic scene.

*A*ll ranches have their own ways of doing things. There are huge differences between what happens on a corporate ranch with 2,000 head of cattle and on a mom-and-pop outfit with 250 head, but what all cattlemen share is the connection to the land, the rhythm of the seasons. What they also have in common is the cow. Oddly enough, cows are seldom factored into the western mystique, yet they are what it is all about. They are smelly, clumsy beasts of no great beauty, but they are nature's recycling machines.

"Sun to·grass to protein, that's what raising beef cattle is all about," the late Laurie Guichon used to say. "Grass isn't much use as human food. Cattle are the tools that convert grass into protein. You can't ranch unless you look after the grass." The fact that many, if not most, BC ranchlands have been supporting cows for well over a century indicates that cattlemen have learned how to do that.

The ranch year begins with calving—a critical time, as calves are the future of every ranch. Because cattle are sold in same age/same size/same sex/same colour groups,

ORPHANED CALVES REQUIRE SPECIAL CARE AND ATTENTION.

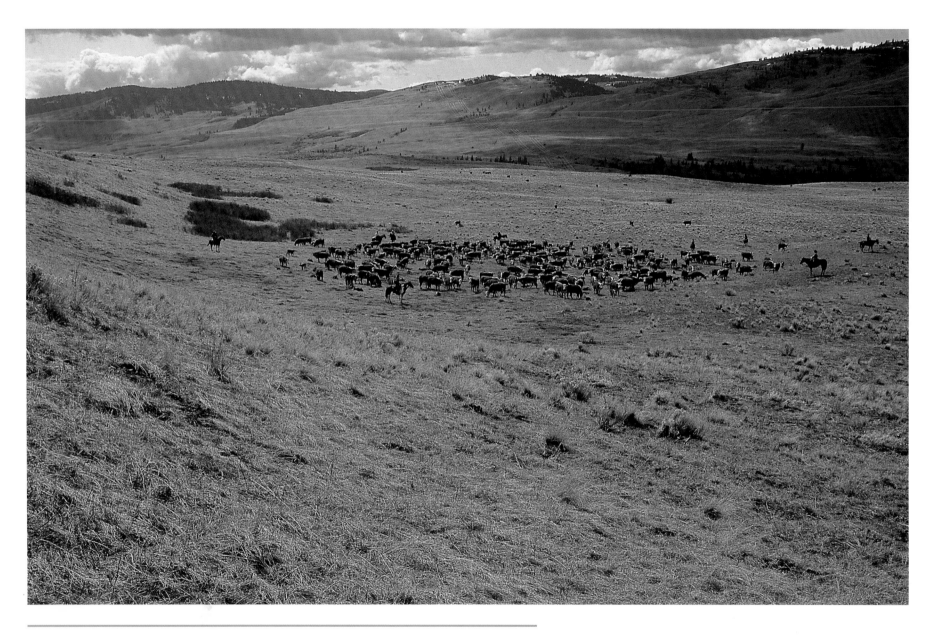

MOTHERING-UP AT THE QUILCHENA CATTLE COMPANY RANCH. AFTER BRANDING, COWBOYS TAKE THE HERD TO THE MEADOW TO REUNITE CALVES WITH THEIR MOTHERS AND LET THE HERD CALM DOWN.

parenthood is planned with great care (by the rancher, not the cow) so that calves are born within weeks of each other. The time of calving varies from ranch to ranch: it can occur any time between January and June, but March and April are the usual birth months. An older cow will generally look after herself, delivering with no fuss under a tree somewhere. Ideally, she will produce a healthy calf every year for eight to twelve years, so except on the very large ranches, owners get to know each cow and her idiosyncrasies. Heifers, the first-time moms, can have trouble giving birth. Large ranches have special maternity barns or pens with a twenty-four-hour watch and a crew equipped to deal with every kind of emergency. Small outfits make do with a maternity pasture as close as possible to the house, and a member of the family checks the heifers every few hours, day and night, until the last calf is born. When a heifer has trouble on a family ranch, all hands might be called on to help. Help might be a Caesarean section, a gentle tug by hand or strong tug with a "puller," or an arm-in turning of a calf coming wrong end to. It is a given, especially on small ranches, that the heifers needing the most help will pick the most miserable night to deliver. They rarely appreciate help and can behave badly, either rejecting the calf and refusing to let it nurse, or going after their helpers. On big ranches, calves arriving on cold nights might spend their first hours warming up in a specially designed "hot box." On a family ranch they are likely to be taken to the house, dunked in warm water in the bathtub, then wrapped in a blanket. Sometimes heifers die giving birth, and unless there is a willing foster mom available, orphaned calves are bottle-fed.

Before the cattle are turned out on the range, the calves are branded, vaccinated and dehorned, and bull calves are castrated. The younger the calves, the less stressful all this is for them. Because brands cannot always be read easily from a distance, some ranchers follow the old custom of making a distinctive slash in the cartilage of one of the calf's ears or in its wattle, the fleshy fold of skin on the neck. But most use ear tags. Dehorning is necessary to keep the animals from inflicting injury on themselves or others when they are penned or trucked. Along with humane considerations is the fact that bruised carcasses are not desirable.

Branding has changed little over the years, but new methods have replaced the old Keystone dehorner, a hand-held guillotine-like horror that caused the horn stump to bleed profusely. If used incorrectly, the animal could bleed to death. Today the Barnes type dehorner is fitted onto the horn bud to nip it off. Some ranchers apply a caustic soda stick on and around the calf's horn bud to destroy the horn-producing cells, but this method has drawbacks. The paste can rub off onto the mother cow's belly when the calf sucks, and since calves tend to nurse from one side only, the end result can be a mother with a bald spot on her belly and

ALEX ROBINSON, COWBOSS AT QUILCHENA CATTLE COMPANY, ATTENDING TO AN ORPHAN CALF.

Branding:
KEEPING TRACK *of* WHO'S WHOSE

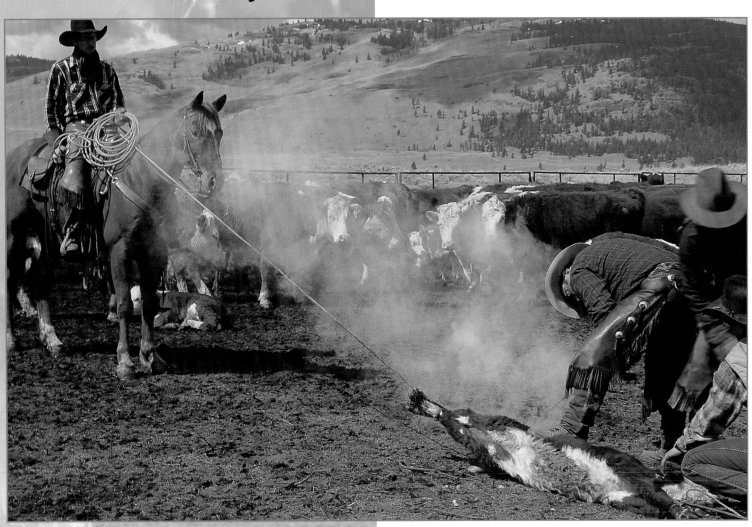

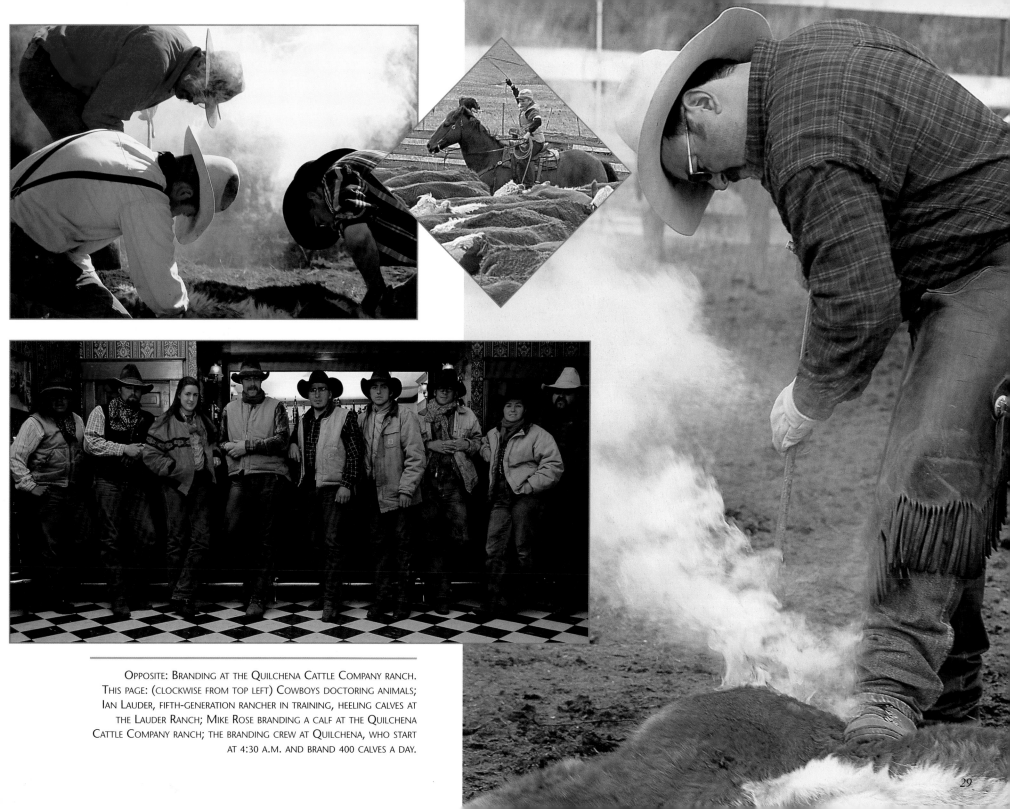

OPPOSITE: BRANDING AT THE QUILCHENA CATTLE COMPANY RANCH. THIS PAGE: (CLOCKWISE FROM TOP LEFT) COWBOYS DOCTORING ANIMALS; IAN LAUDER, FIFTH-GENERATION RANCHER IN TRAINING, HEELING CALVES AT THE LAUDER RANCH; MIKE ROSE BRANDING A CALF AT THE QUILCHENA CATTLE COMPANY RANCH; THE BRANDING CREW AT QUILCHENA, WHO START AT 4:30 A.M. AND BRAND 400 CALVES A DAY.

BRAND NAMES

Brands, the permanent markings used to identify stock, have been registered in BC since 1869, when an ordinance for "the better protection of cattle stealing" was enacted by the legislature. A stock brand is as distinctive as a signature, and it positively identifies ownership of range stock. Traditionally made with a hot iron, it is placed on the left or right hip, shoulder or rib. A brand that is registered as LHH indicates that it will be placed on the left hip of a horse; RRC goes on the right ribs. In the early days many brands were symbols, but because they are so difficult to catalogue and almost impossible to list on a computer, ranchers today are encouraged to use letters or numbers. Older brands often consisted of single characters; a newer one typically has three characters, read from top to bottom and left to right.

Characters that are not numerals or letters also have specific meanings. A straight line is a bar, a longer line a rail, a slanted line a slash. A character in a square is described as boxed; remove a side and it's a half-box or bench. Common brands include circles, diamonds, chevrons, rafters or any combination thereof. Squeeze a circle and you get a goose egg; a half diamond over another character is a rafter; two rafters make a chevron. A circle under a character makes the character "rock." Brands walk, run, fly, swing or tumble. They may be crazy, lazy or otherwise impaired.

A number of early BC brands are still in use. Gang Ranch uses the original Jerome Harper [JH], Douglas Lake Ranch the original lll. The Durrell's Wine Glass Ranch at Riske Creek uses the symbol of a wine glass, and the cattle at Maiden Creek still wear the rocking heart. Both are century ranches (each had been owned by one family for 100 years when the BC Ministry of Agriculture celebrated its centennial in 1994). Colin Bambrick of Big Creek not only uses his grandfather's brand, he uses the same branding iron. When the Mulvahill brothers split their parents' ranch, Randolph kept the original *J* up and down, and Bill joined the characters with a slanting bar, making a fancy *N*. Chezacut's Lazy *V* was chosen just because it was easy to read and required only one iron.

BRANDS LEFT TO RIGHT: RICH HOBSON, VANDERHOOF; PERCY MINIBARRIET, ASHCROFT; E. KENNEDY, OKANAGAN FALLS; HARRY BROWN, ROCK CREEK; THE DIAMOND "S" RANCH, PAVILION; DAVID MAURICE, RISKE CREEK; MOON RANCH, CHILCOTIN; M. HARRISON, BIG BAR.

a calf with one horn. Another method is a hot iron touched to the horn bud. The best way to avoid horns would be to raise "polled" or hornless cattle. Few cattlemen do this.

One process that was not carried out in the old days is inoculation, a seven-in-one shot that includes protection against pneumonia and blackleg, which has been a problem on some BC ranches. Blackleg is a highly infectious bacterial disease characterized by a gaseous swelling of the muscles of the upper legs. It is usually fatal.

Bull calves are usually castrated to improve the taste of their meat, reduce their aggressiveness and keep them from getting amorous ideas. Surgical removal of the testicles, or "cutting," was once the only way to castrate. The bottom of the scrotum was cut off and the testicles extracted (and often fried up as a treat known as prairie oysters or cowboy caviar). According to old-timers, at sale time buyers would feel a steer's scrotum, which they called the cod, and if it was filled with fat, they knew the animal had been well fed. With cutting there is always the danger of excessive blood loss or infection. The most widely used method today is to attach a tight rubber band around the top of the scrotum, which then withers and drops off within a few days.

Animals that never leave the ranch don't have to be branded, and bull calves destined to be sold within sixteen months don't have to be castrated. In earlier days, when cattle weren't sold until they were three or four years old, heifer calves not wanted for breeding stock were spayed.

When this ordeal is over the calves are turned loose and the process of "mothering up" takes place, with each mom

identifying her offspring by smell. The little ones tuck in for lunch, which seems to wipe away the trauma they have experienced.

In most areas cattle can be turned out to summer range in mid-May. Once on their way, the mature cows know where to go, with one matron usually leading the way. Bulls are escorted out later to ensure that calving occurs at the appropriate time. The ratio of bulls to cows depends on the lay of the land: on open rangeland, one bull can service twenty cows. In brushy and hilly country it might be one to fifteen cows.

Most ranches depend on Crown range, which is administered by the Ministry of Forests. Tenure (a permit or licence) specifies the number of stock to be grazed, the period of use and the area authorized. The range may be shared, and the fee is based on the number of animals and the previous year's market price for beef. Ranchers may also lease land from the Lands ministry for grazing or haying, for which they pay a lease fee and land taxes.

Large ranches have riders on the range all summer, keeping an eye out for sick or injured animals and predators (both four-footed and two-footed), keeping the cattle moving so they don't overgraze, and making sure the bulls are where they are supposed to be. Some riders are home every night. Others take their horses, gear and supplies to the range and stay there for weeks at a time. Gang Ranch cowboys go to the isolated range with packhorses and camp out all summer under what could be called primitive circumstances. It's no job for greenhorns. Cattle need to be

ALEX ROBINSON BOTTLE-FEEDING AN ORPHAN CALF AT THE QUILCHENA CATTLE COMPANY.

All in a Day's Work

A few things a ranch wife might do on an ordinary day (not at calving, branding or haying time) along with the usual household chores:

Milk the cows

Feed the chickens

Bottle-feed three calves, twice a day

Doctor a sick heifer

Drive to town to get a knapweed spray kit from the regional district

Go to the bank

Pick up parts for the tractor

Spray the knapweed by the back fence near the road

Find the wrench that her husband swears he left on the bench in the shop

Help fix the fence where the calves got out

Cook dinner for four unexpected guests who just dropped by

supplied with salt, and ranchers with smaller herds check the cattle when they replenish the salt blocks.

With the cattle out on the range, attention on the ranch goes to preparing winter feed. A 500 kg mature cow will eat an average of 2,500 kg of forage over a feeding season of 180 days. Depending on climate, altitude and other factors, a hayfield might produce one crop over the summer, or two or three. In "one-crop" country, ranchers need more hay land. Many ranchers plant forage crops; others rely on natural grass. Some small ranches don't put up enough hay to warrant the expense of sprinkling systems. They rely on rain, which usually suffices. Family ranches might have sprinkler-equipped pipes, which must be uncoupled and moved by hand. Large ranches planning on two or three crops go in for self-propelled (and costly) pivot sprinklers, which employ a stationary main tower and wheel-equipped lateral towers, each with a gearbox. The sprinkler heads are attached between the towers, and when a computer turns on the system, the sprinkler lines "walk" in the pattern laid out for them.

Weather is always a factor in haymaking. Ranchers can irrigate when the weather is dry but they can't do much about rain, which can ruin a haying season.

As with sprinkling systems, there is an economy of scale that dictates methods of haying. Loose haystacks are a thing of the past, but many smaller outfits still make square bales because less expensive machinery is required. Square bales are also popular for sale, especially to "pleasure" horse owners. Many ranchers have invested in equipment to produce

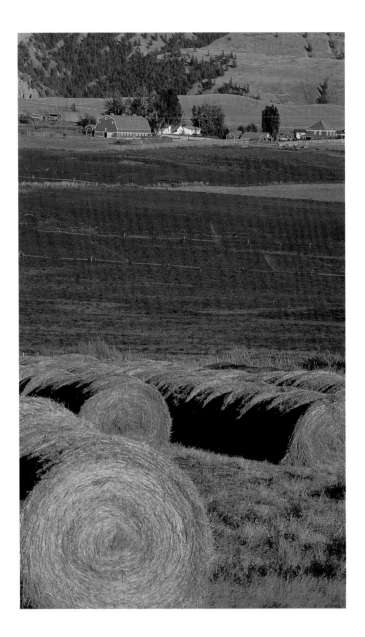

ROUND BALES AND IRRIGATED MEADOWS AT GANG RANCH. WITH GOOD WEATHER AND IRRIGATION, RANCHERS CAN GET TWO OR THREE CROPS A YEAR FROM THIS MEADOW.

and feed out huge round bales. Feeding these bales is a one-person job: a tractor with a forklift is backed up to a bale and it is secured, taken to the feeding grounds and unrolled.

Alternatives to baled hay are silage, or haylage. The silage process involves controlled fermentation of green fodder in a silo, a round metal storage building. Haylage involves stuffing round bales into plastic bags when their moisture content is in the 50 to 60 percent range. When filled, the long, white bags look like low Quonset huts. Excess air is expelled from the bags before they are sealed, but the plastic allows carbon dioxide to vent as fermentation takes place. This process is relatively inexpensive and it shortens harvest time because the cut crop requires only a few hours' drying time between cutting and stuffing. The hay is less likely to be "caught down" by a sudden rainstorm. As Doug Mervyn, owner of the Alkali Lake Ranch, explains: "We can have the sprinklers back on a field the day after we cut the first crop." Because of the time and expense involved in preparing winter feed, more ranchers are buying it.

When the leaves start to turn and the weather gets nippy, the old cows head home from the range, knowing feed will be waiting for them. They need help with gates, and ranchers have to count noses and check for stragglers. Bulls usually need to be retrieved, as they can be reluctant to leave the scene of their amorous encounters. Cattle that are ranged far from home are trucked to and fro, as when Leonard Bawtree, an Enderby rancher, ranged his cattle at the 100 Mile.

VICTOR MINNABARRIET CUTTING HAY NEAR ASHCROFT.

Irrigation:
Making hay

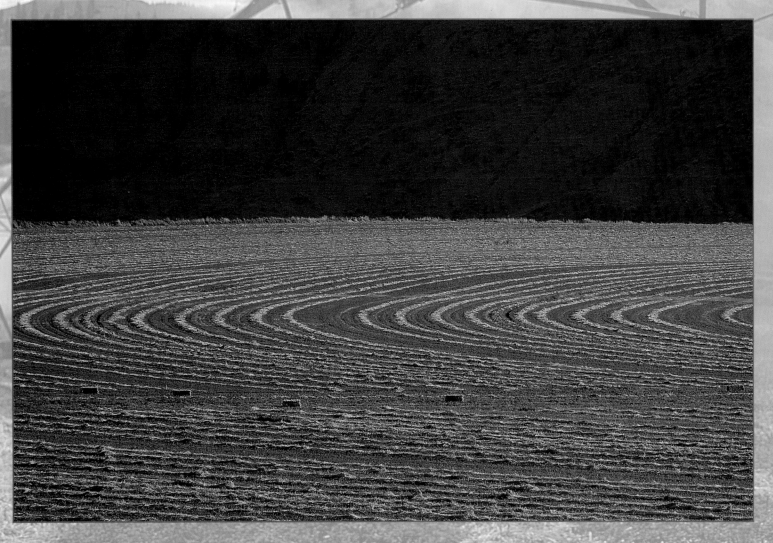

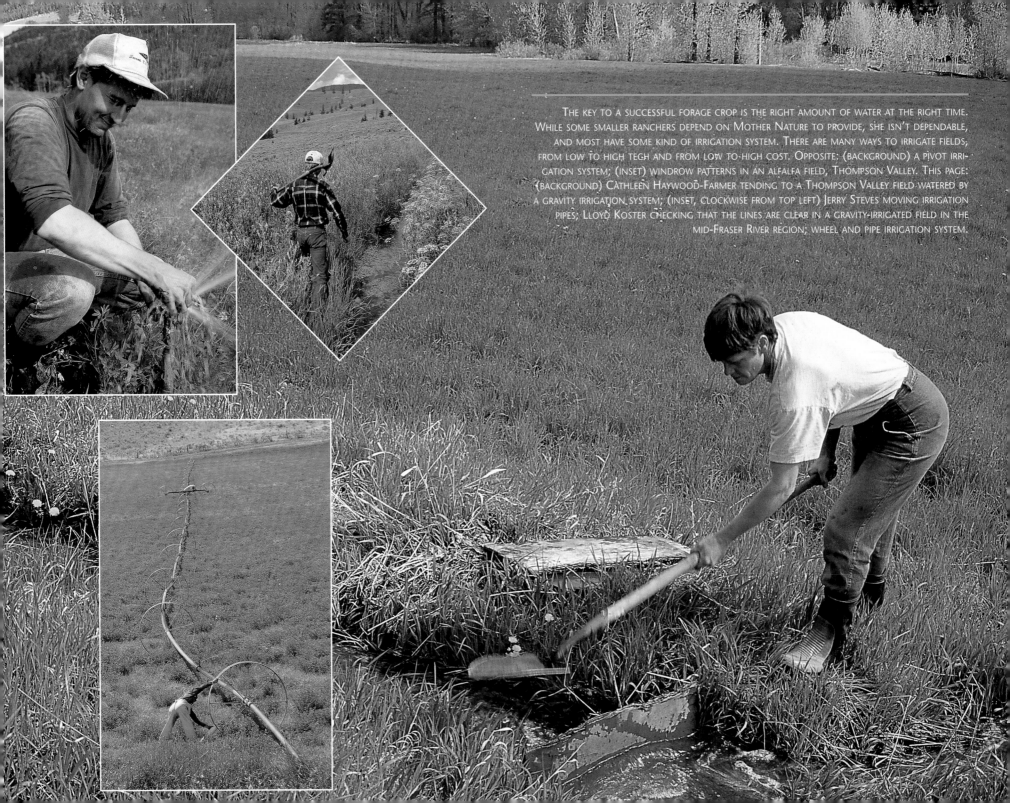

The key to a successful forage crop is the right amount of water at the right time. While some smaller ranchers depend on Mother Nature to provide, she isn't dependable, and most have some kind of irrigation system. There are many ways to irrigate fields, from low to high tech and from low to-high cost. Opposite: (background) a pivot irrigation system; (inset) windrow patterns in an alfalfa field, Thompson Valley. This page: (background) Cathleen Haywood-Farmer tending to a Thompson Valley field watered by a gravity irrigation system; (inset, clockwise from top left) Jerry Steves moving irrigation pipes; Lloyd Koster checking that the lines are clear in a gravity-irrigated field in the mid-Fraser River region; wheel and pipe irrigation system.

WHAT'S IN A COW?

...ction contributes 15 percent of British Columbia's annual agricultural income ..., but overall adds $300 million to the province's economy. Ninety-nine percent ...mal's bones, horns, hide, hooves and tallow, is utilized. Besides such food prod-...shmallows, ice cream, candies and chewing gum, beef by-products are found ...a, deodorants, detergents, fabric softeners, floor wax, glue, paints, photograph-...nt, lipstick, soaps, shaving cream and violin strings. Many of the "camel's hair" ...d by painters are made of hair from a cow's ear. The medical world depends on ...hundred life-saving drugs, including insulin and Heparin. Cows' pituitary ...duce hormones used in the treatment of anemia, respiratory diseases and ...Cattle by-products are found in automobile tires, asphalt, car polishes and ...hydraulic brake fluid. Fatty acids from inedible beef fats find their way into ...lubricants, glossy coating for magazine paper, printing ink and paper whiten-...w is everywhere.

In the early days before fences, cattle wandered where they pleased and were often found 50 or 60 miles from home. Crews of cowboys spent weeks rounding them up. Each ranch had a cow camp on the range, usually a small log cabin near a creek with a corral nearby. The cabin had a stove and maybe bunks that the cowboys could share with the packrats. If there was no cabin, there would be a chuck wagon (there was always a cook) and a tent for sleeping quarters. In the Cariboo, someone would shoot a moose and hang the butchered halves from the eaves of the cabin or from a tree out of the dogs' reach. (There were always cattle dogs on a roundup.) As the days went by, the outer layers of the meat would get black and would be cut off to feed the dogs. Cowboys breakfasted on fried moose meat, eggs and pancakes. Their lunch was moose meat sand- wiched between huge slabs of freshly baked bread (the cooks could do wonders on a camp stove) and a whiskey bottle full of tea. Dinner was more fried meat. Cowboys liked their meat well cooked. Very well cooked. Fred Long, who cowboyed in the Chilcotin country, says that faced with a medium-rare steak, one cowboy sent it back, com- plaining he'd "seen cows get well that was worse hurt than that."

Hygiene wasn't a big concern. Fred remembers asking his cowboss about laundry. "He looked himself over and then said he thought he'd be good for another month."

Few BC cowboys carried guns. Fred carried a pistol that looked like a six-shooter but five chambers were blocked. He used it for mercy killings. "You are not going to

leave a sick or injured animal on the range to starve to death or be mauled by predators."

Once back at the ranch, calves are weaned in the fall. Not surprisingly, this is a noisy time. The little ones object loudly to leaving their moms, moms bawl equally loudly in response. Even a small herd can make a din. Then the cattle are sorted into those to be sold and those to be kept. (Some heifer calves are kept for breeding stock.) On some ranches the cows are pregnancy tested and the "open" or

MR. MACHO CONTEST

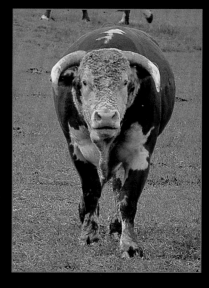

There is a world of difference between a bull's first sale and his last. The first is a Mr. Macho Contest. When the bull walks to centre stage, he has been curried, combed and polished until even his hoofs shine. He is sleek, dignified and well aware of his worth. Ranchers take great care selecting bulls; some wits say they take less time choosing wives. At the sales, a buyer checks the bull's scrotum circumference and semen quality and inspects the soundness of his feet and legs. (Underpinnings are important because the bull not only has to walk around all summer, he needs stout hind legs for the breeding process.) Temperament is also a consideration: no rancher wants a bull with attitude.

In terms of dollars, even a bull with moderate macho will pay for his purchase price many times over. He may be "in production" (indulging his natural urge) for only a few years, but he will service fifteen to twenty cows every summer. Off-season, he has no responsibilities except to eat and laze around. These years are pretty good ones from both the rancher's and the bull's points of view.

At six years old or less, a bull is past his prime and he is sent off to auction. The big old Hereford bulls are the saddest sight at the end of their glory days. At the first sale, their faces are so white they hurt your eyes. At the last sale they are covered in manure from rubbing their faces in the stockyard dirt as they bellow and paw and challenge their neighbours. They don't know it's the end of the trail. Bulls are awarded grand championships at the beginning of their careers, for promise. Performance gets them nothing. In the end it's weight that counts. They go from kings of the range to hamburger.

LEFT: LARRY MCMILLAN, COW BOSS AT THE GUICHON RANCH, CHECKING EAR TAGS. ABOVE: HEREFORD BULL.

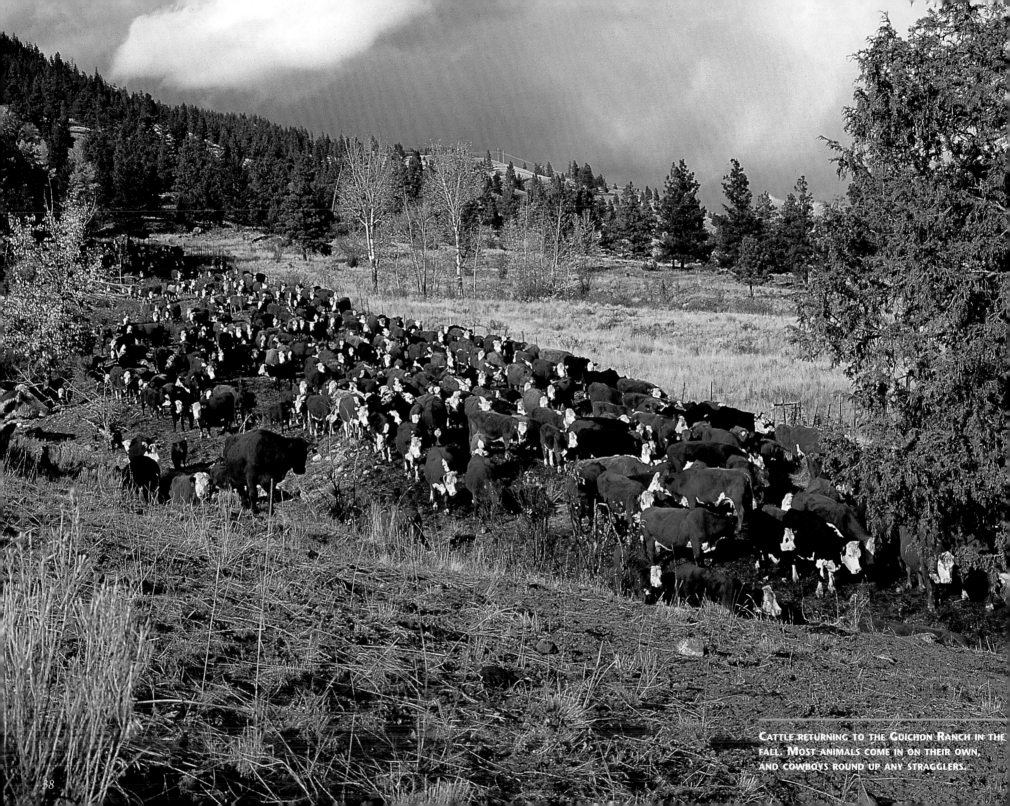

CATTLE RETURNING TO THE GUICHON RANCH IN THE
FALL. MOST ANIMALS COME IN ON THEIR OWN,
AND COWBOYS ROUND UP ANY STRAGGLERS.

barren animals go to market. Ranchers don't care to keep boarders. Since January 2001, animals slated for market are ear-tagged before they leave their herd of origin. This tag has a visible number, a bar code and the logo of the Canadian Cattle Identification Agency (CCIA), a non-profit watchdog organization. The tag remains on the animal up to and including the time of its final carcass inspection at the packing plant, so if there is a problem, it can be traced back.

GOOD BREEDING

There are 279 recognized breeds of beef cattle in the world, some of which are very old. The Saler is said to go back 7,000 years to the Egyptians, and 20,000-year-old cave carvings discovered in France depict cows closely resembling Limousins. The white-faced Hereford, a popular breed in British Columbia, is relatively new, dating back to 1742. Hereford fans claim the breed converts grass to beef more efficiently and cheaply than others and that Herefords thrive on either grass or grain, are extremely hardy and can rustle for themselves well into the winter. While there may have been Herefords among the cattle entering BC during the gold rush years, the first registered Herefords were imported here in 1884 by Joseph Guichon, a Nicola Valley rancher.

Some ranches run purebred stock but most have crossbreeding programs, and smaller ranches may have unregistered or "commercial" herds. Every rancher has a favourite breed. Some swear by the British breeds: the Hereford, Angus, Devon, Galloway or Highland. Others opt for French breeds such as Charolais, Blonde d'Aquitaine, Limousin and Saler; the Swiss Simmental; or the German Gelbvieh. Texas Longhorns are making a comeback, as is the Corriente, a small black cow descended from animals brought to Mexico from Spain in 1493.

LEFT: GEORGE KEENER AT THE WILLIAMS LAKE STOCKYARDS. HE STARTED WORKING THERE AT THE AGE OF SIX.
ABOVE, LEFT TO RIGHT: SIMMENTAL CROSS HEREFORD/ANGUS; BLACK ANGUS COW; LIMOUSIN CALF.

Ode to the Bull

Our poets have told us
again and again
The blessings that beasts
have conferred upon men.
How sheep give us wool,
and goats give us milk,
How hens give us eggs,
and worms give us silk.
But no one has ever
acknowledged in full
Our debt to the "Natural
Urge" of the Bull.

—Anonymous

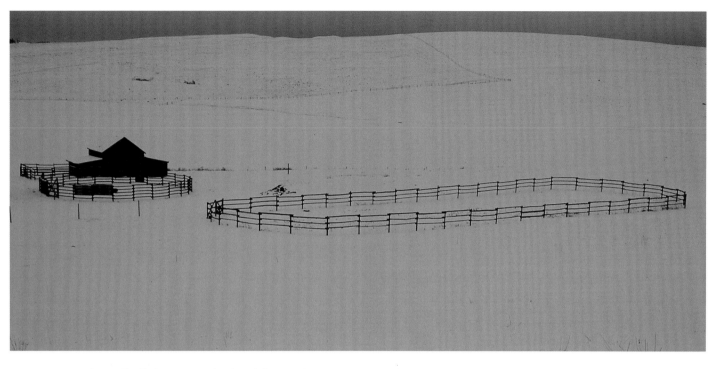

Most ranches sell all their animals slated for market in the fall. However, auction sales are held most months of the year in both Kamloops and Williams Lake stockyards, and cattle can also be sold electronically. Animals are trucked from the ranch to stockyards and/or feedlots in cattle "liners," big trucks that carry up to ninety animals each. Most animals end up in Alberta feedlots, where they are fattened up on grain before being slaughtered. Those that come back to BC come as carcasses.

Winter is "feeding and fixing" time. Feeding might begin in November or January and end in April or June, depending on the weather, the availability of fall grazing and other circumstances. Mom-and-pop ranchers are anchored for the duration because someone has to feed the cattle every single day. Cattle eat more in cold weather, and the rancher's nightmare, which sometimes comes true, is to run out of hay.

The other winter chore is "fixing" or maintaining equipment, although some ranchers leave that task until spring. Staff is let go on the big ranches and cowboys spend the winter on unemployment insurance, "letting the cobwebs grow on their riding boots," while some owners take holidays. Ranches are still feeding when calving begins in the spring, starting the cycle all over again.

ABOVE RIGHT: WINTER IN THE KNUTSFORD AREA NEAR KAMLOOPS.

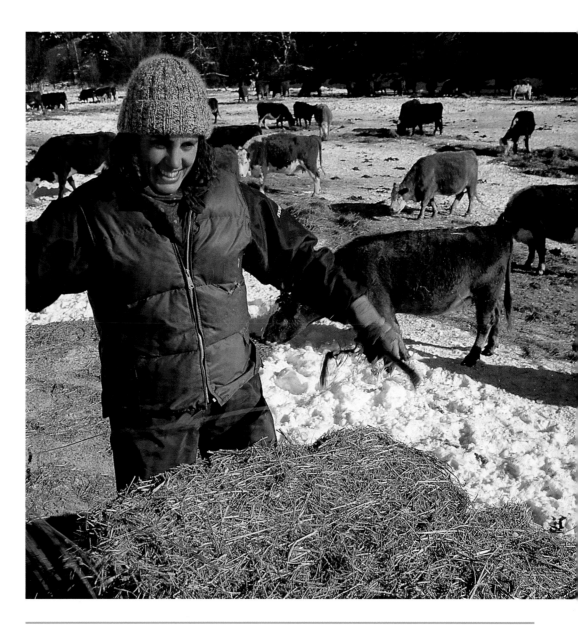

WINTER FEEDING. THE HEALTH OF THE BASIC HERD AND THE WEIGHT GAIN OF ANIMALS TO BE SOLD ARE THE MAIN CONSIDERATIONS FOR RANCHERS. LEFT: CATTLE AT THE COLDSTREAM RANCH FEASTING ON SILAGE FROM A FEEDING BUNK. ABOVE: JOYCE HOLMES AT EMPIRE VALLEY RANCH, THROWS SQUARE BALES OF HAY FROM THE BACK OF A FLATBED TRUCK. CATTLE ARE FED EVERY DAY, USUALLY IN THE MORNING, OVER WINTER.

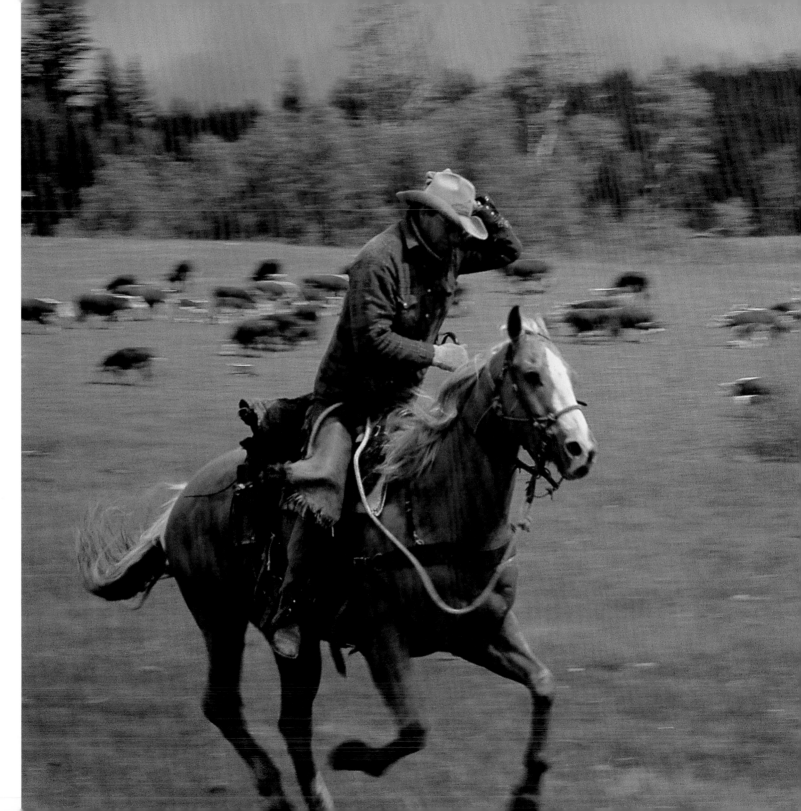

CHASING A STRAY CALF DURING
SPRING ROUNDUP IN THE CHILCOTIN.

3

Cowboys *and* Cattlemen

Men on horseback have been handling stock since history was first recorded. No one yet has found a substitute for an alert, knowledgeable cowboy who knows the range and knows cattle.

Spanish and Mexican vaqueros who trailed long-horns along the Rio Grande River were the first North Americans to handle cattle. After the United States took over the territory north of the river to create the state of Texas, vaqueros became "bucka-roos"—the anglicized version of "vaquero." The name "cowboy" came along in the second half of the nineteenth century.

The British Columbia cowboy is said to combine the Mexican vaquero's skills, equipment and clothes; the US frontiersman's grit and resourcefulness; the First Nations' respect for nature; the British gentry's sense of law and order and manners; topped off with his own unique brand of humour.

BEV AND LARRY RAMSTAD, MANAGERS OF THE GANG RANCH.

The difference between a cowboy and a cowman or cattleman is that the cowman owns the ranch. He manages the operation and decides when to buy and sell. If an owner isn't a cowboy, it behooves him to hire a manager who is.

The job description for cowboys has always been the same. Cowboys trail cattle, gather them, hold them and separate them; they brand, dehorn, inoculate and castrate them. They make sure the cattle in their care have water, food and protection from predators; they notice when they are off their feed, and they act as nurse and midwife when required. On smaller ranches cowboys are jacks of all trades doing whatever needs to be done, be it fencing or haying. A cowboy's working hours can sometimes be dawn to dusk, seven days a week, holidays included, in every kind of weather.

Given that job description, it isn't any wonder experienced cowboys are getting hard to come by.

The traditional cowboy is a horseman. He knows how to ride horses, train them, shoe them and doctor them. Even with the proliferation of the "Japanese quarter horse" (the all-terrain vehicle), most ranches need a saddle horse or two. It used to be that a cowboy was judged by his horses, and David Maurice still sees it that way. He prefers to ride his own, not the ranch's horses. "I need a big strong horse that can go all day and pick its feet up," he says, but he adds that his dog does most of the work. "She goes where the horse can't, and she takes the danger out of it. Dogs are good company. They don't complain, they don't tell lies, and they don't make trouble." David had one dog

EVAN HOWARTH, RISKE CREEK COWBOY WHO RIDES FOR THE COTTON RANCH.

for seventeen years but most are shorter-lived. They get kicked, hurt, even run over. Survivors, like faithful horses, are pensioned off.

It must be noted that some cowboys and cattlemen are women. Few cowgirls worry about the gender label. As one wag put it, "Ranching always was equal opportunity. Men never minded sharing the work." The truth is that women have always played a strong role in ranching, sometimes because they had to, more often because they wanted to.

You cannot tell a cowboy by his plumage. A hundred-dollar hat doesn't make a cowboy; neither do pearl snaps on a shirt. Anyone can dress western. Some real cowboys don't. When one veteran cowman was asked why he was wearing runners and ball cap instead of cowboy boots and a Stetson, he said he didn't want to be mistaken for a lawyer. If there is a cowboy uniform, it is blue jeans and a silver trophy belt buckle (won, not bought).

You can tell real cowboys by their walk. People who spend time in the saddle have a slightly rolling walk, a straight back and a flat backside. No matter what their age, cowboys have tanned, weathered faces. They can also be identified by their talk. They inevitably greet each other with "Finished calving?" "Feeding yet?" "How's the hay?" "If they go ahead with those damn weight restrictions, my truck will be overweight if I take my wife and a loaf of bread." Cattle prices, weather and government officials are likely to come up in the conversation: "You'd have called it a blizzard if it wasn't spring," or (referring to a politician): "He wouldn't know a saddle blanket from a pancake."

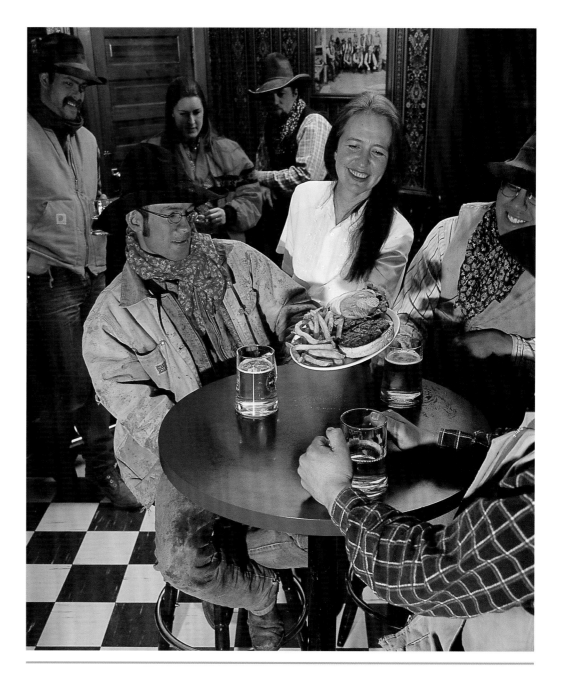

THE SALOON AT THE QUILCHENA HOTEL, WHERE OLD MEETS NEW.

COWBOY CULTURE

Poetry, music, art and crafts have developed with ranch life, and BC has its share of artists in each field. The late Vivien Cowan of the historic Onward Ranch instituted the Cariboo Art Society more than fifty years ago, with her friend A.Y. Jackson as honorary president. The society is still going strong and is believed to be the oldest continuing art society in the province.

Cowboy poetry and music are growing in popularity, and Mike Puhallo, a Kamloops rancher, is spending more of his time organizing and perfoming at cowboy festivals than he is on the ranch. Mike started writing as a youngster, but hid it in his sock drawer. "I used to think God played a dirty trick on me," he says, shaking his head. "I figured he gave me the soul of an artist but no talent to go with it." When a broken wrist put him out of action in 1990, he taught himself to paint, and when he took his artwork to a western show, he attended the poetry acts and realized his work wasn't so bad after all. Mike's poetry reflects cowboy history and real-life experiences. "The rodeo cowboy is romanticized," Mike says, "but few people know anything about the working cowboy."

When Kamloops city officials heard his poetry reading at a bull sale, they asked him to organize a cowboy festival. He recruited the western singer/songwriter Bud Falk, his wife Connie, and Spirit of the West radio host Hugh McLennan, and together they formed the BC Cowboy Heritage Society to handle the business side of it. Now the Kamloops Cowboy Festival is an annual event, held in March so that the performers—many of them working ranchers—are free to attend. They also created the BC Cowboy Hall of Fame, located in the Museum of the Cariboo/Chilcotin in Williams Lake, and inducted their first "famers" in 1998.

But the one sure test of a "real" cowboy is what happens when you put him on a horse.

Legend has it that cowboys drift from ranch to ranch, never putting down roots, and that is true, but Jim Michel has been at the Guichon Ranch in Nicola Valley for twenty-five years. The late Joe Rosette spent fifty of his sixty-two years working in a fifty-mile radius on the Gang, Empire Valley and Alkali Lake ranches.

Cowboying runs in families. Marvin Alexander is the fourth generation in his family to work at the fourth-generation Lauder Ranch in the Nicola Valley. The late Bill Twan spent forty years at Alkali; his son Bronc, the ranch manager, has been there all his life, as have Bronc's sons Willee and Jesse.

The first Twan in the Cariboo was a voyageur, a "middle man" in the canoes carrying furs down the Fraser River. His son John bought Fort Alexandria when the Hudson's Bay Company left, and he raised his family there. Sons Bill, Clarence, Dave and Charles were cowboys of considerable renown. In earlier days rodeo cowboys were working cowboys, and Bill was a top competitor. He specialized in the Roman race—riding the track with two horses, a foot on the back of each. It is no longer a rodeo event.

From the time he was little, Bronc rode with his dad, and when he finished school he went to work for him. Bronc and his sons are rodeo competitors too, and they are on the rodeo road most weekends in the season. Bronc team-ropes, and the boys compete in several events. Willee was BC high school rodeo champ in 1999.

ABOVE: MIKE PUHALLO; OPPOSITE: BRONC AND LIZ TWÁN

David Maurice (his mother is Bill's sister) also grew up in the Alkali Ranch, where his dad Hermie, another Cariboo legend, worked before going to manage the cattle operation at St. Joseph's Mission at 150 Mile House. David has tried other jobs, even logging, but he says, "I don't need the money that bad. This way I get paid to ride around all day doing what I enjoy." From May to October David is in the saddle. He and Pat Jasper, one of the third generation of cowboying/rodeoing Jaspers of Riske Creek, keep an eye on the hundreds of cattle that scatter over this part-prairie, part-timber range. It is no job for the faint-hearted.

David rodeoed for twenty years. His specialty was roping but he spent six years as a pickup man. Then he and his dog Tina began entering "Top Dog" competitions, which

Call Me a Fool

Call me a fool if you want to,
I'll not deny the claim,
For I spent my life chasing after
Many a foolish game.
I haven't lived my life safely,
I've always played on the edge.
A fool who thinks dreams are a challenge
And a bet's not a bet if you hedge.
A cowboy, a poet, a dreamer,
A rancher and a rodeo hand
I have been and no great wealth I've acquired,
For money slips from my fingers like sand.
But I've gathered a treasure of memories,
And the love of a woman that's true,
And these are the things that matter to me
As much as your gold does to you.
And when your journey is over,
And the final tally is done,
I may only leave with my memories,
But can you do better, ol' son?
You can call me a fool if you want to,
But, boys, I am proud to report,
I've chased every dream that called me,
'Cause life ain't a spectator sport.

— Mike Puhallo

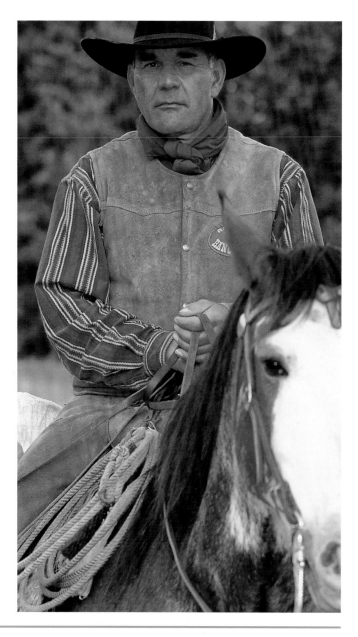

are growing in popularity in cattle country. Top Dog is a timed event in which the dog has to pen five cows by responding to commands from its handler.

David and Tina sit out the three winter months at Riske Creek. "Me and my dog don't go to town unless we have to," he says. "Tina hates town, and we have everything we need here."

The Sieberts, Rosalie and John, "ranch sit" near Merritt during the winter months, then from May to October they ride for the neighbouring Pike Mountain Ranch, looking after anywhere from 700 to 1,000 head of cattle on summer range. The Sieberts have their own horses, two each plus one retired mare that is somewhat of a family member. Rosalie's dad, the pioneer Chilcotin rancher Dick Church, always insisted on "a bit of thoroughbred" in his horses, and she agrees. "When you spend a lot of time in the saddle, you need a horse that suits you all round." They each have a dog, a must for the rough country they ride in. On hot days, the Sieberts start out around 4:00 a.m. and ride until noon. There is no point riding in the heat of the day because the cattle don't move. After lunch they have a snooze; they head out again in the late afternoon.

They ride separately and keep in touch with walkie-talkies. Other than that, their equipment is simple. "A good pair of pliers on one side of the saddle, a thermos on the other," Rosalie says, "that's all I need." The pliers are for fixing fences.

The Sieberts never whoop, holler or gallop. "A good cattleman never takes his horse off a walk," John explains.

DAVID MAURICE. SOME SUMMERS HIS FEET SPEND MORE TIME IN THE STIRRUPS THAN ON THE GROUND. A GOOD DOG, HE SAYS, IS BETTER THAN TWO COWBOYS. THEY EAT LESS, FOLLOW ORDERS, DON'T ASK QUESTIONS AND PROVIDE GOOD COMPANY.

"Cows don't like fast moves and they don't like yelling." Slow and steady is the key in handling cattle, and the animals respond to actions or signals. If a cow comes to a crossing, she'll stop and smell. If she picks up the scent of another cow, she'll cross, but if anyone yells at her, she'll turn around and go back. "Once they start, you might as well let them go," John says.

John's particular skill is spotting ailing animals: their ears are a dead giveaway. The sooner spotted, the sooner cured, he says.

How long will the Sieberts keep riding? Well, John was seventy-four in 2001 and he has no plans to retire. "Riding is what we do," Rosalie points out. "Things always look better from the back of a horse."

R.M. "Red" Allison raises and trains quarter horses at his Lazy A Ranch in Clinton, and he can't remember when he didn't have a horse. Red runs cattle in the summer, but his special niche in the ranching community is his work as a bonded livestock dealer. Ranchers call him when they need a few cows or a special horse or dog, and over the past thirty years he has developed a solid reputation for delivering what his customers want at a price they can afford. The work keeps him on the road a lot and he rarely misses an auction at Kamloops or Williams Lake.

Born and raised in Kamloops, Red is every inch a cowboy, from his hat and the twinkle in his eye to the gloves in the back pocket of his jeans. He worked at the Harper Ranch, and after a stint in the army he went back to cowboying and rodeoing. He's dude-wrangled at

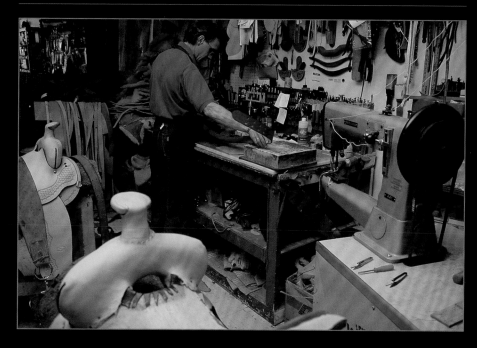

IN THE SADDLE

A saddle is the most important and most personal part of a rider's gear, and getting one to fit right—on both rider and horse—usually means getting it custom-made. That's when ranchers and cowboys call on Mark Denny in Williams Lake. Born and raised there, he started working in leather as a youngster, then learned his trade at Banzel Saddlery in Calgary. His father Tom opened Cariboo Saddlery in 1977; three years later Mark joined him. While he makes all kinds of leather goods from purses to bridles, he is known throughout western Canada for the quality of his custom saddles. Each one takes more than thirty hours to make, but the customer has to allow four months from ordering to delivery because Mark can't start leather work until the "tree" (the base of the saddle) is made.

Cherry Creek, ridden for Alkali Lake, been cowboss at the Circle S in Dog Creek and the Gang, run his own business at Riske Creek and managed the OK Ranch at Big Bar. Along the way he helped found the Interior Rodeo Association and introduced 4-H to the Chilcotin, among other things. He and his wife Dionne bought the Lazy A in 1981.

Red's rodeo career began with steer riding and he rode broncs in the money (he won money in the competition), but when he married in 1954, he gave up the rough stock (broncs, both saddle and bareback). He did ride at the 1957 Calgary Stampede, but only because "it was cheaper to enter than it was to buy tickets." There isn't any job involved with rodeo that he hasn't done at one time or another. Today he judges and helps organize amateur events and competes in cattle penning (he made it to the Canadian finals in that event in 1997 and 1999), and he's teaching his grandchildren the art of roping. Red carries six decades of ranch history in his head and he is a story-teller of some renown.

The Allison sons, Bob, Gerry, Ted and Ken, have all worked as cowboys, and all but Ken have rodeoed. Grandson Craig works at Alkali Lake Ranch and competes with the ranch team at stampede events.

Percy Minnabarriet received his Gold Card Life Membership from Pro Rodeo Canada in 1979, honouring his twenty-five years as a professional rodeo cowboy. He began rodeoing when he was sixteen, winning $1.80 in his first steer-riding competition. It was the start of a career

Cariboo cowboy Red Allison, a lifetime in the industry.

that saw Percy as a top All Around cowboy and, in 1971, BC's champion calf roper.

Percy was raised by his grandmother at Mile 89, near Spences Bridge. His first job was cowboying at the Ashcroft Ranch for the princely wage of $3 a day. It wasn't easy juggling a job and getting to rodeos, especially after he married and had a family. His wife Marie and his six sons and three daughters always travelled with him. They had a 1948 Ford, and whoever was the baby at the time travelled in a banana box.

"Sometimes we really had to scrape and scrimp to save money for entry fees," Marie recalls, but Percy came out of every stampede "in the money." One year his Williams Lake stampede earnings took them to the Calgary Stampede. Another time he won $800 in a single afternoon, and at one Clinton rodeo he came away with five firsts.

In the off-season Percy worked at ranches (ten years at Hat Creek) and for the BC Forest Service. He didn't stop rodeoing from choice: he lost his horse, Ben. A roper and his horse are a team. Ben, his pride and joy, had steel dust (quarter horse) and top deck (thoroughbred) lines, and Percy kept him in a field near the highway near Spences Bridge. One day someone left the gate open and Ben got out, and he was hit and killed by a passing motorist. Percy didn't have the heart to start over again with another horse, so he hung up his ropes for good.

When Percy died in May 2001, a huge number of people attended his funeral to pay their respects. He was buried in the family cemetery at the 89 Mile.

PERCY MINNABARRIET

Antoine Minnabarriet was a successful Oregon cattle rancher when he came north to prospect on the Thompson River. He didn't find gold, but he recognized cattle country when he saw it. He returned to Oregon, collected his cattle and returned to establish the Basque Ranch and roadside inn between Cache Creek and Spences Bridge.

As was the custom, Minnabarriet took a country wife, Mary, a member of the Cook's Ferry Band, and they had one son, Louis. When Antoine found himself a white wife, Mary left the ranch and later married a Frenchman named Peter Audap, who owned the 89 Mile. Louis went to school in New Westminster, trained as a blacksmith and came back to work on his father's ranch. When Antoine discovered some $70,000 worth of gold along the riverbank in the early 1880s, he sold the ranch, then one of the finest in the province, and left the country with his new family. Louis went to live with his mother, then married and had a family of his own. Percy Minnabarriet was his grandson.

Not inheriting the ranch was one thing, but Louis and his descendants, including Percy, were "non-status." They looked like Natives but had no legal status under the Indian Act, so they were outsiders in both white and Native communities. The one place where all of that was unimportant was at a rodeo. "When I rode into an arena and looked at the other guys," Percy said, " I knew I could beat every damn one of them."

Minnabariett did end up ranching, though. Percy and his son Victor established a cattle operation near Ashcroft.

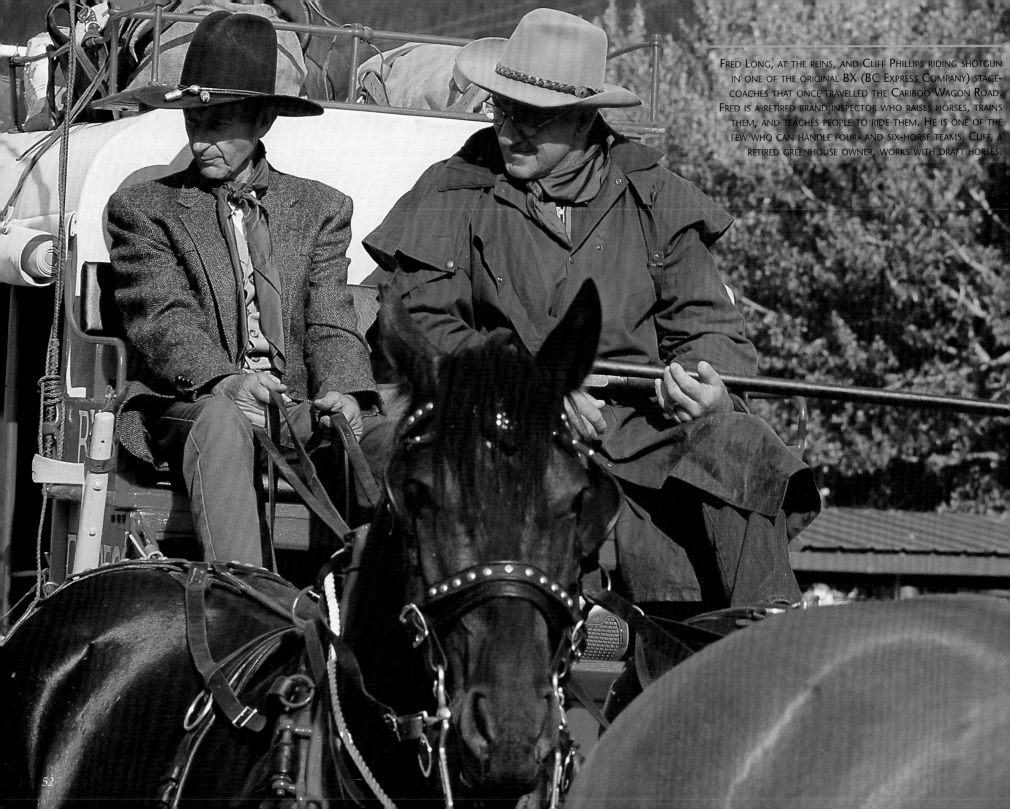

FRED LONG, AT THE REINS, AND CLIFF PHILLIPS RIDING SHOTGUN IN ONE OF THE ORIGINAL BX (BC EXPRESS COMPANY) STAGE-COACHES THAT ONCE TRAVELLED THE CARIBOO WAGON ROAD. FRED IS A RETIRED BRAND INSPECTOR WHO RAISES HORSES, TRAINS THEM, AND TEACHES PEOPLE TO RIDE THEM. HE IS ONE OF THE FEW WHO CAN HANDLE FOUR- AND SIX-HORSE TEAMS. CLIFF, A RETIRED GREENHOUSE OWNER, WORKS WITH DRAFT HORSES.

HORSES & CATTLE DOGS

Amanda Self, who was raised at Tatlayoko in the west Chilcotin, is best known in ranch country for training horses and cattle dogs. She has been riding since she was three and training horses for other people since she was fifteen. She also teaches people to ride and to train their horses. She got her first border collie when she was just eleven ("My parents said I could have one when I was old enough to look after it"), and in the twenty years since then she hasn't been without one at her side, although most of the animals she trains are destined to become working ranch dogs. For the last ten years she has also been involved in the Top Dog competitions held during the Williams Lake Stampede. When she isn't working as a trainer, she is at ranches and cattle sales as one of the four Cariboo brand inspectors.

Fred Long followed an old Cariboo tradition: the immigrant cowhand. He came to Canada from Ireland when he was nineteen. He'd worked with horses at home and he made his way across the country working on ranches. He worked at Alkali Lake and Chilko, but when the Vietnam war broke out he went to England to serve in the King's Royal Horse Artillery. Back in BC, he went to Douglas Lake Ranch to train Chunky Woodward's famous horses.

In 1977 Fred took the job as provincial brand inspector in Kamloops, and later he moved to Williams Lake. Until the Brand Department was privatized in 1997, the job included working with police to prevent cattle rustling and apprehend rustlers.

Fred's ability to train horses, and to train people to ride and handle them, led to another career: working in six western movies as a consultant, trainer and occasional actor.

In 1999 Fred Long retired from brand inspecting after twenty-two years on the job. He and his wife Colleen, a veterinarian, ranch at 134 Mile, south of Williams Lake.

Rodeo:

PUTTING IT ALL ON THE LINE

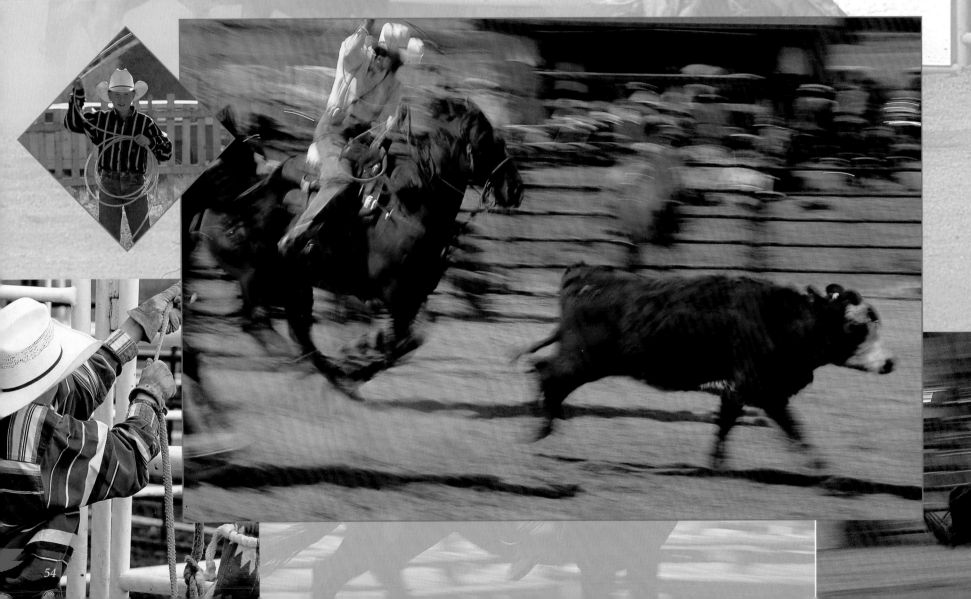

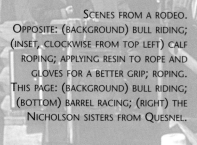

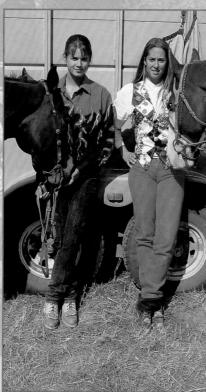

SCENES FROM A RODEO.
OPPOSITE: (BACKGROUND) BULL RIDING;
(INSET, CLOCKWISE FROM TOP LEFT) CALF
ROPING; APPLYING RESIN TO ROPE AND
GLOVES FOR A BETTER GRIP; ROPING.
THIS PAGE: (BACKGROUND) BULL RIDING;
(BOTTOM) BARREL RACING; (RIGHT) THE
NICHOLSON SISTERS FROM QUESNEL.

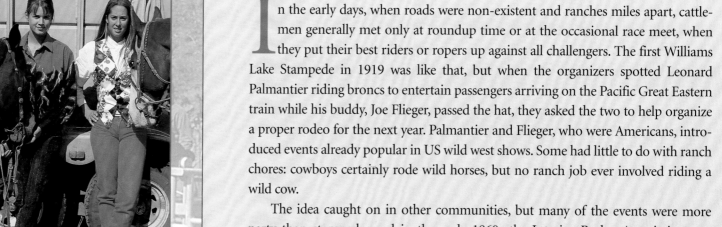

In the early days, when roads were non-existent and ranches miles apart, cattle-men generally met only at roundup time or at the occasional race meet, when they put their best riders or ropers up against all challengers. The first Williams Lake Stampede in 1919 was like that, but when the organizers spotted Leonard Palmantier riding broncs to entertain passengers arriving on the Pacific Great Eastern train while his buddy, Joe Flieger, passed the hat, they asked the two to help organize a proper rodeo for the next year. Palmantier and Flieger, who were Americans, intro-duced events already popular in US wild west shows. Some had little to do with ranch chores: cowboys certainly rode wild horses, but no ranch job ever involved riding a wild cow.

The idea caught on in other communities, but many of the events were more party than stampede, and in the early 1960s the Interior Rodeo Association was formed in Williams Lake to bring some order to rodeos. Similar groups formed in other areas, and they later merged to form the BC Rodeo Association (BCRA). Competitors start with Little Britches, move up to High School Rodeo, then graduate to BC Rodeo Association-sanctioned events. A few go on to the Canadian Professional Rodeo. To qualify for pro status, a contestant must have earned $1,000 in one year or $2,000 over two years in recognized events, such as saddle or bareback bronc riding, bull riding (rough stock), calf roping, steer wrestling, barrel racing, wild cow milking, and wild horse racing. Rodeo schools teach specific skills from riding to judging, and young people receive plenty of help and encouragement from older participants.

Rodeos are a multimillion-dollar industry in Canada, and between May and September a rodeo takes place somewhere in BC every weekend. The largest, the Chilliwack Rodeo in June and the historic Williams Lake Stampede in July, are two events sanctioned by the CPRA in which contestants vie for national championships. The Anahim Lake Stampede, an annual amateur event held in the west Chilcotin since the 1930s, provides a wild weekend for hardy folk. While Bulleramas (bull riders only) are becoming popular, events echoing "real" ranch jobs such as cattle penning are popping up all over the province.

Some say rodeo is in the genes. Others say it's osmosis. It isn't unusual to see a couple of generations of a family entered in the same rodeo, with tots decked out in jeans and cowboy hats, practising their roping and riding skills. They're the next gen-eration of champions.

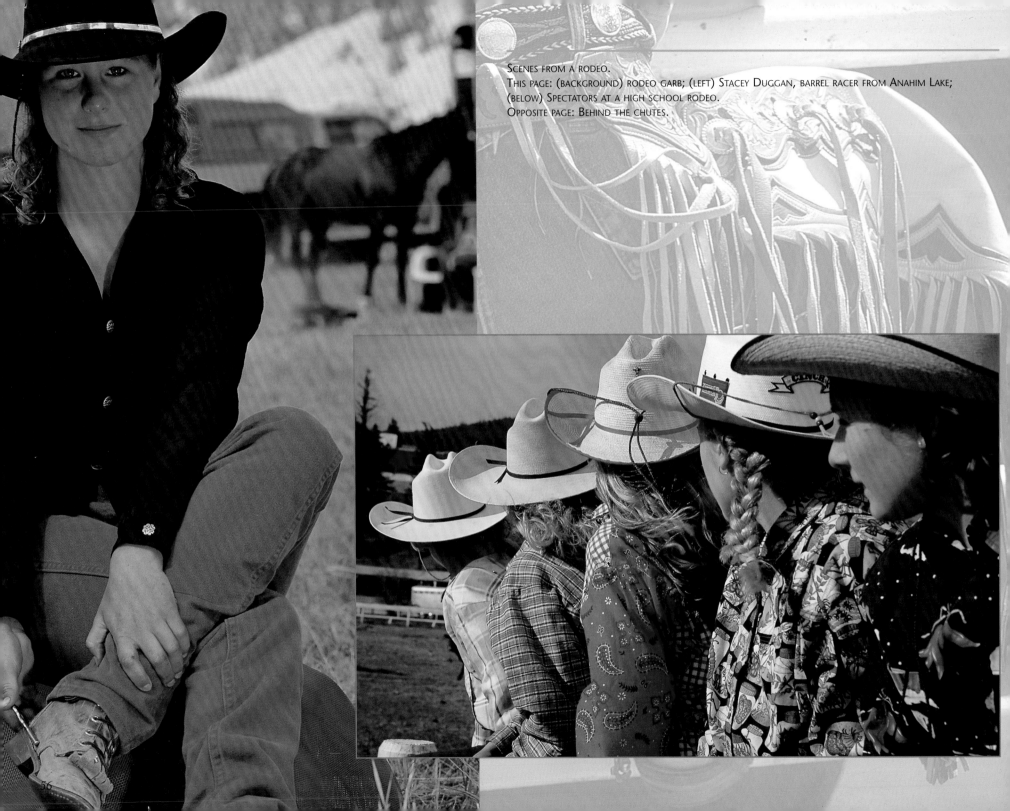

SCENES FROM A RODEO.
THIS PAGE: (BACKGROUND) RODEO GARB; (LEFT) STACEY DUGGAN, BARREL RACER FROM ANAHIM LAKE;
(BELOW) SPECTATORS AT A HIGH SCHOOL RODEO.
OPPOSITE PAGE: BEHIND THE CHUTES.

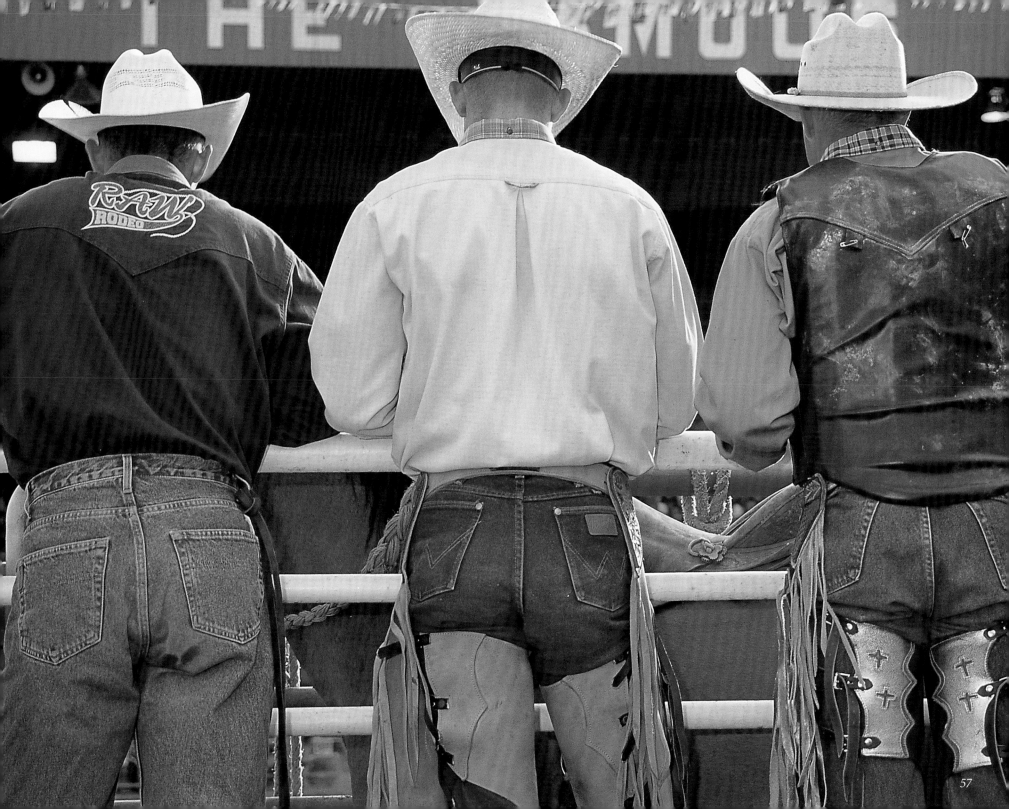

COWBOY GARB AND GEAR

Hat: A cowboy hat is guaranteed to make the face underneath it at least 75 percent handsomer. The high crown keeps the wearer's head cool in summer and the wide brim acts as a sunshade and umbrella and protects the eyes from branches or twigs when riding through the brush. A felt hat can be used as a bucket or a basket, or as a fan to encourage a reluctant campfire. The hat is always taken off at the table (often stowed under the chair) and some say it's bad luck to put a hat on a bed. It is old Cariboo custom for a cowboy's hat to be buried with him.

Boots: The sole is flexible and boots are high-cut to protect the wearer's ankles from the stirrups. The pointy toe makes it easier to slip the foot into the stirrup, the high heel helps keep the foot from slipping out. Boots are not meant for walking.

Gloves: Made of leather or buckskin, they protect cowboy's hands from rope burn.

Neckerchief or bandana: It is worn around the neck so that it is handy when the cowboy needs to cover his nose or mouth for protection from dust. In fact it is used for almost anything that requires a soft cloth—except blowing the nose.

Pocket knife: No cowboy would be without one. It is used for snipping binder twine, cutting a plug of tobacco or castrating a steer, among many other things.

Bedroll: This portable waterproof shelter is made of heavy canvas, 6–8 feet long, 72–84 inches wide with a thin mattress and blankets, rolled together and held with leather straps. The bedroll can weigh up to 150 pounds (65 kg) once the cowboy throws in his personal belongings, photos, cards, a harmonica, a change of clothes and shaving kit.

COWBOY WORDS

aboard—in the saddle

bronc—(from the Spanish for "wild" or "rough") unbroken horse

broomtails—horses

Bull Durham—popular loose tobacco that came in a cotton sack with a drawstring

chaps—leather leggings worn over jeans to protect the rider's legs

shotgun chaps—closed-leg chaps-like pants

batwing chaps—open and hooked chaps

chink chaps—short chaps, usually fringed

cayuse—horse

chew—a round tin of chewing tobacco (snoose) carried in a shirt pocket

code of the West—respect the other person's rights

cowboy candy—Copenhagen snuff

cowboy pension—a roof over his head and a place to hang his saddle

fat factory—feedlot

green—new, inexperienced

greenhorn—inexperienced ranch hand

hectare—the size of a rancher's front yard

Hereford—the cow in cowboy

hospitality—the rule that everyone who comes to visit is hungry

levis—canvas pants first made by Levi Strauss of California. He had a supply of canvas he hoped to sell as wagon covers, but there were no buyers. So he made pants for miners, and they were an instant success. When he ran out of canvas, he started using blue denim and copper-rivetting the pockets. When people's levis wore out, they used them for mopping the floor and tying calves.

makings—a pouch of tobacco, cigarette papers and wooden matches

meadow muffins—cow pies

off feed—feeling poorly

off side—the right side. Horses are mounted on the left side.

on the prod—angry

rank—very bad-tempered

Resistol—a brand-name cowboy hat

rigging—saddles and gear

road apples—horse turds

rope—cowboy arm extender

rough stock—bucking horses and/or bulls used in rodeos

shitter—horse of no particular breed

sold his saddle—really broke

Stetson—broad-brimmed hat originally made by John B. Stetson Company of Philadelphia

tale—long-winded lie

take the last ride—die

team roping rodeo event—a time event involving a header, who ropes the animal by the head, and a heeler, who ropes the heels

ten-gallon hat—(from the Spanish *galon*—"strand of wire"), the silver-braised wirework around the hat crown. Ten gallons meant muy macho. Later it came to refer to the size of the hat.

war bag—saddle bag

weather—always too hot, too cold, too dry, too wet, too long

weather—between damn cold and freezing

wrangler—cowboy who looks after horses

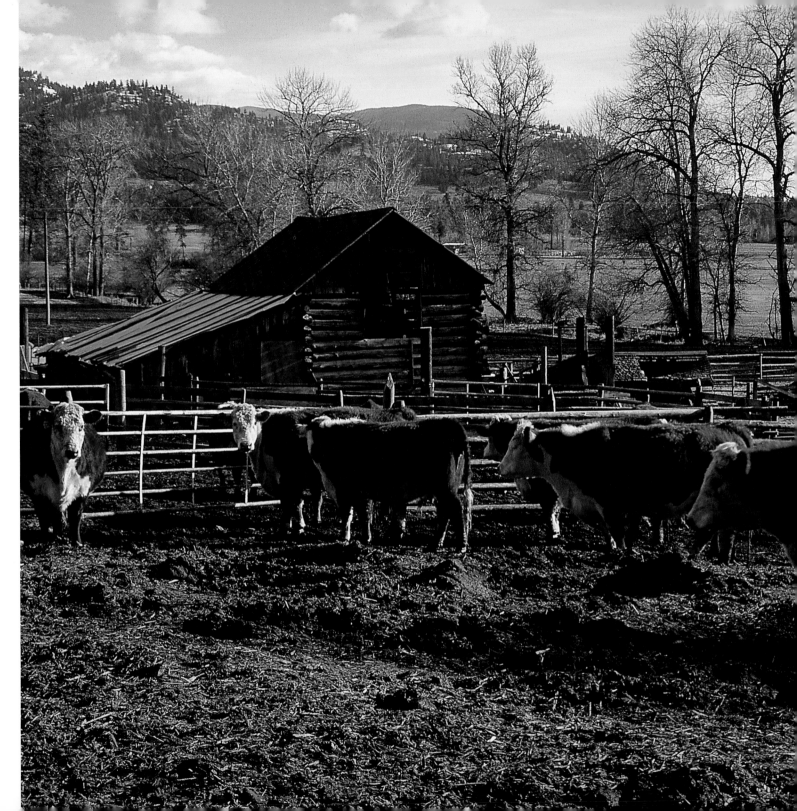

CALVING CORRAL AT THE
THOMAS RANCH.

The
Okanagan Valley

The Okanagan Valley is known for its orchards and vineyards, but cattlemen were the first to settle there: a ranch house here and there, a few corrals and horse barns, and thousands of cattle grazing quietly on the vast sea of grass.

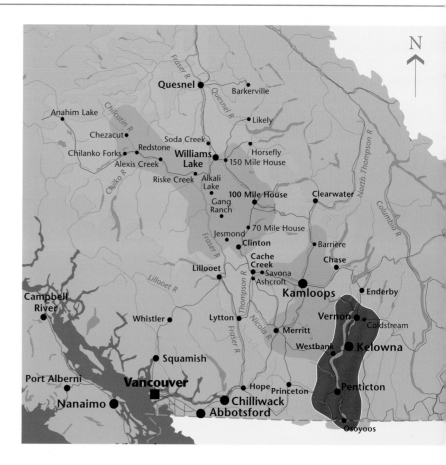

Thomas Ellis, one of the first Okanagan cattle barons, was also one of its agents of change. Ellis pre-empted 320 acres (128 ha) lying between Okanagan and Skaha Lakes, and began ranching in 1866 with seven heifers. He planted his first orchard in 1874. By 1904 his cattle numbered in the thousands, and he had enlarged his orchards and expanded his landholdings to more than 31,000 acres (12,400 ha) stretching from Penticton to the US border. In 1905 he sold his empire to a development company, which subdivided the land for orchards.

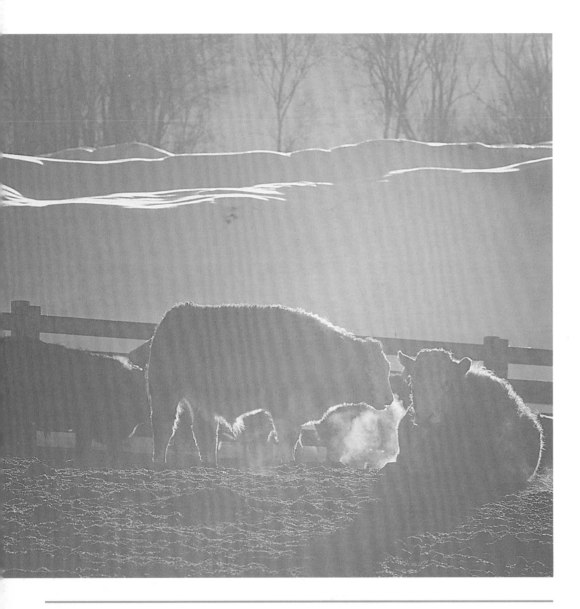

ABOVE: A WINTER MORNING AT THE COLDSTREAM RANCH FEEDLOT NEAR VERNON.
OPPOSITE: THE COLDSTREAM FEEDLOT. MOST BC COWS ARE SHIPPED TO ALBERTA TO BE "FINISHED" (FATTENED UP ON GRAIN), BUT SOME ARE FINISHED IN BC. A YEARLING GAINS SOME 5 LBS (2.2 KG) A DAY EATING SILAGE, A SLIGHTLY FERMENTED NUTRIENT-RICH MIXTURE OF GRAINS, GRASSES AND CORN.

The Coldstream Ranch

The venerable Coldstream Ranch, east of the city of Vernon, began as a Crimean War grant of 1,450 acres (580 ha) awarded to Charles Houghton, a former British army officer. Two former fellow officers, Charles and Forbes Vernon, joined Houghton in the venture. Forbes Vernon became sole owner in 1883. He expanded and improved the operation, then sold it in 1891, giving G.G. Mackay, a partner in the Okanagan Land and Development Company, the task of selling it. It was said that when Mackay died, he'd try to subdivide heaven.

The buyer was Sir John Campbell Gordon, 7th Earl of Aberdeen (and later 1st Marquis of Aberdeen and Temair) and his lady. They acquired 13,000 acres (5,200 ha) and 2,000 head of cattle for $241,000, although this price was later renegotiated. Lord and Lady Aberdeen bought into Mackay's plan to convert Okanagan ranchland into a valley of small orchards, and they set about subdividing parcels of the ranch to sell to hopeful fruit growers. They planted 1,544 apple and other fruit trees on the main ranch property; by 1908 there were 200 acres (80 ha) of bearing trees.

The earl was appointed governor general of Canada in 1892, and Lady Aberdeen's brother, Sir Coutts Marjoribank, mismanaged the operation until 1895, when William Crawley Ricardo took over. Ricardo began aggressively subdividing the ranch and marketing the subdivisions.

The next owner was James Buchanan (later Lord Woolavington), who amalgamated the property with

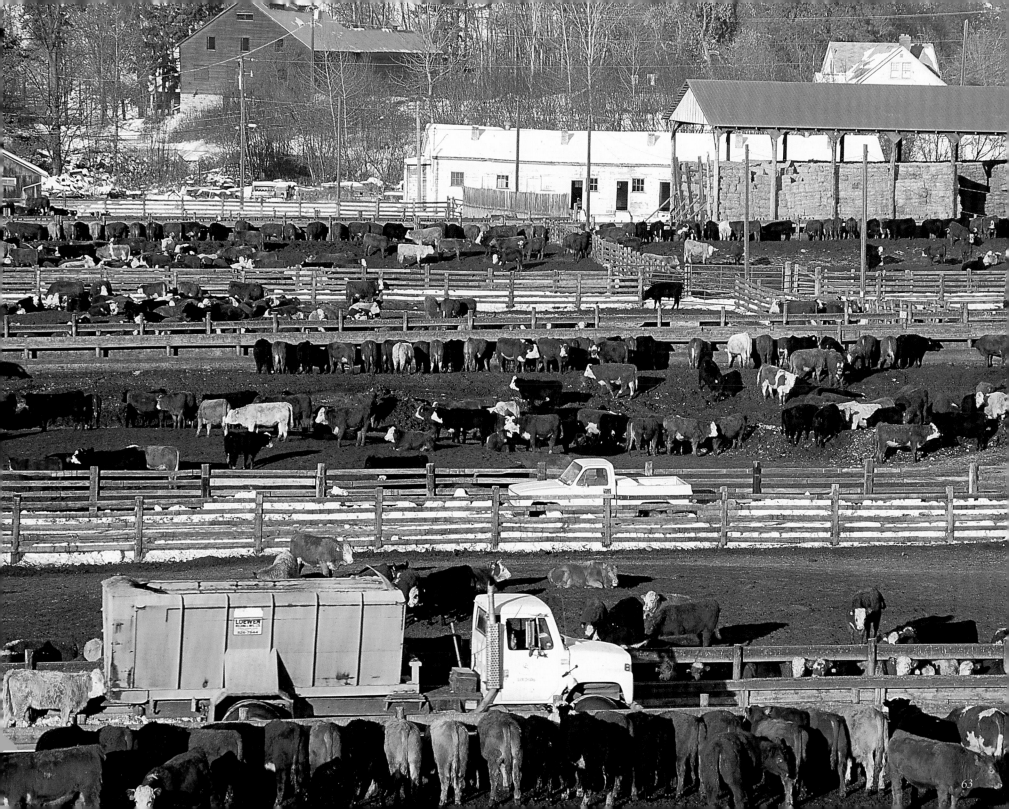

another ranch he owned. In 1920 he transferred ownership to his daughter, the Honorable Catherine McDonald-Buchanan, who remained firmly seated in England. The operation was hit hard during the Depression and land was sold to pay debts and taxes; during World War II a significant portion of the ranch was leased to the army as a battle school. In 1953 C.D. "Bill" Osborn, who had a degree in agriculture, became the ranch's general manager and began turning the operation around. He held the post until he retired in 1974 and was followed by his son Ted, who has degrees in agriculture and business administration.

The British owners weren't interested in subdividing, so the ranch was more or less intact when they sold it in the mid-1990s and Coldstream welcomed its first Canadian owner, Keith Balcaen. He was born and raised in McBride, BC, and moved to Lavington in the 1980s. His family, major contractors in the forest industry, brought with them the long-term plan of developing the ranch's agricultural and forestry resources in the best interest of the local economy.

While its 8,000 acres (3,200 ha) of deeded land represents somewhat less than the original 13,000 acres, it remains one of the larger ranches in the province. It is unique in a number of ways. Located in one of the most developed areas of the Interior, it is a thoroughly modern, diversified operation that makes use of all its resources, yet

the old buildings have been preserved and are still in use. A step into the venerable office is stepping back in time—except for the computer, which sits between an antique heat register and an equally antique wooden filing cabinet.

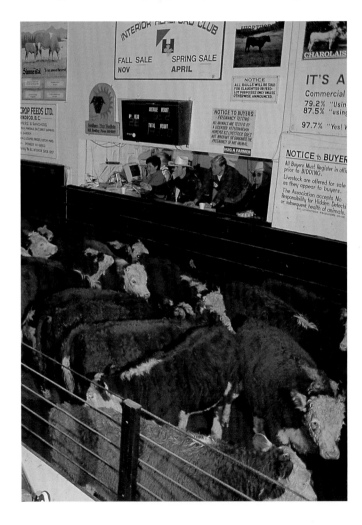

Auction at the Okanagan Falls stockyard. Cattle are sent here from the ranch and auctioned individually or in lots. The OK Falls yard is the smallest of the three stockyards operated by the BC Livestock Producers' Co-op. Sales are held there once a month, except in fall when there are three sales a month. At a fall sale, 1,500 head of cattle might move through the ring—3,000 at Williams Lake and Kamloops.

The ranch itself is a cow/calf feeder operation. The cross-bred herd is two-thirds British breeds and one-third Continental. Some 2,000 acres (800 ha) are under irrigation growing alfalfa, corn and grass, most of which goes into silage. To take full advantage of the abundance of forage, ranch-raised calves as well as purchased calves are fed over the winter and sold directly from the ranch in April as heavy feeders, to established markets in southern Alberta and Washington state.

Fruit growing has continued as well. About 40 acres (16 ha) of high-density apple orchards produce mainly Macintosh, Spartan and Empire varieties, with the help of a full-time crew of twelve people—a number that expands to twenty-six during the growing season and to forty-six when it is time for thinning and harvesting. The ranch's forest lands are under intensive management, and a gravel reserve provides additional income.

Keith Balcaen continues the Coldstream tradition of providing strong support to community life, and the ranch is the site of Scout meetings and campouts, an annual community day, a fund-raising Father's Day Run and other activities.

The Thomas Ranch TO

Thomas Ranches Ltd., near Okanagan Falls, was founded by John Marie Thomas, a Welshman. He arrived in the valley in 1895 and took a job at Naramata, looking after horses belonging to Thomas Ellis. When Ellis sent him to

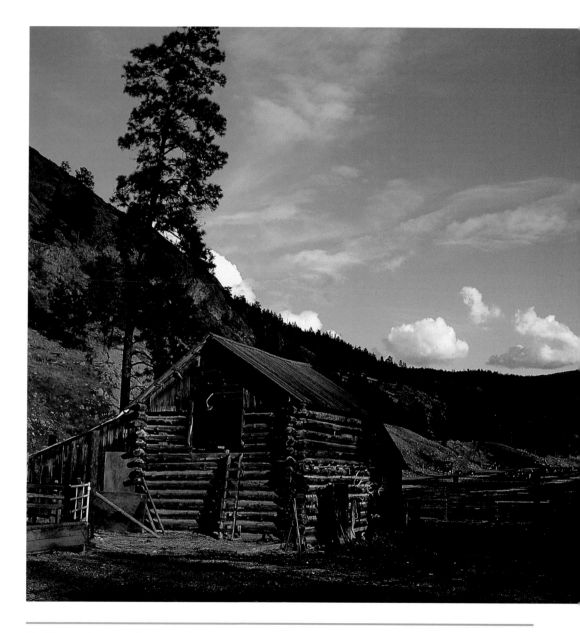

THE THOMAS RANCH AT OKANAGAN FALLS, ONE OF THE NEWER CENTURY RANCHES, ESTABLISHED IN 1898. THIS IS ONE OF THE OLDEST BARNS IN BC.

stallion, a small, powerful draft horse, which sired a line of farm horses used in the local orchards, and when bred to local wild mares, sired some excellent saddle horses as well. He also introduced pheasants to the Okanagan Valley, and within three years there were so many that the government declared a three-day open season on them in October.

When John Thomas's sons took over in 1957, they bought back the Beauchache property, and they still use the original log barn built there by the old fur trader in the 1870s. Five years later they bought their uncle's ranch to make a total of 2,200 deeded acres (880 ha), with 250 acres under gravity-fed irrigation growing alfalfa and barley silage. In 1983 they bought the first haylage machine in the BC Interior, and they still use it. Morrie Thomas says that the system "has been the one change in our operation that has paid the greatest dividends."

The Thomas herd numbers 400 Hereford cows, which summer on a high-elevation 150,000-acre (60,000 ha) lease that lies within a Weyerhaeueser tree farm licence. Further expansion of the herd is limited by the lack of spring and fall grazing land at lower elevations. In November the cattle are sold at the Okanagan Falls stockyards, the traditional shipping point for cattle from the southern Interior. John Thomas was largely responsible for the facility: in 1926 he installed a cattle scale in his yard where the animals could be weighed before being moved to the stockyards. Soon ranchers from all over the Okanagan were herding their cattle to Okanagan Falls via the Thomas Ranch in order to use his scales.

Okanagan Falls to look after his cattle there, Thomas decided it was time to go out on his own and he bought a ranch that had been pre-empted by a French Canadian fur trader named Beauchache. Thomas married in 1912, sold the Beauchache property and bought a portion of the Dog Lake Ranch.

The foundation for his cattle herd was 15 shorthorns, but during World War I, when there was a good market for wool to make uniforms, he had more than 3,000 sheep grazing with his cattle on the open hillsides above Vaseaux Lake. He took great pride in his imported Suffolk Punch

BARN WALLS ARE OFTEN HANDY PLACES TO HANG THINGS. THE BARN WALL AT THE THOMAS RANCH HOLDS FAMILY TREASURES AND MEMORABILIA.

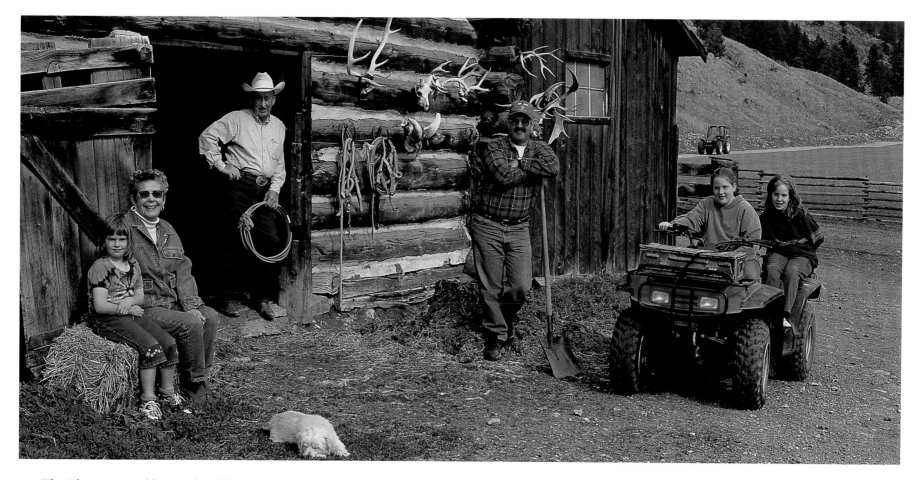

The Thomas Ranch's rangeland lies in an area rich in wildlife, in particular a herd of 300 California bighorn sheep that graze on the rocky uplands. Another herd of approximately 80 bighorns—generally referred to as the Thomas herd—maintain themselves year-round on the hayfields close to the ranch itself, causing a considerable loss of forage for the Thomases' cattle herd. But the family recognized that the unique south Okanagan grassland habitat of these sheep was in serious jeopardy, and in 1993 they sold 222 acres (90 ha) of their deeded land close to Vaseaux Lake to the Nature Trust of British Columbia. They then sold the rest of their land to the Nature Trust in 2001. Thomas Ranches Ltd. continues, however, as the family has leased both properties for grazing under guidelines set out by the Trust.

THREE GENERATIONS OF RANCHERS AT THE THOMAS RANCH. LEFT TO RIGHT: KATIE, DENISE, MORRIE, BRIAN, BONNIE, HEATHER. BRIAN IS MORRIE'S FATHER; MORRIE AND DENISE ARE KATIE, BONNIE AND HEATHER'S PARENTS.

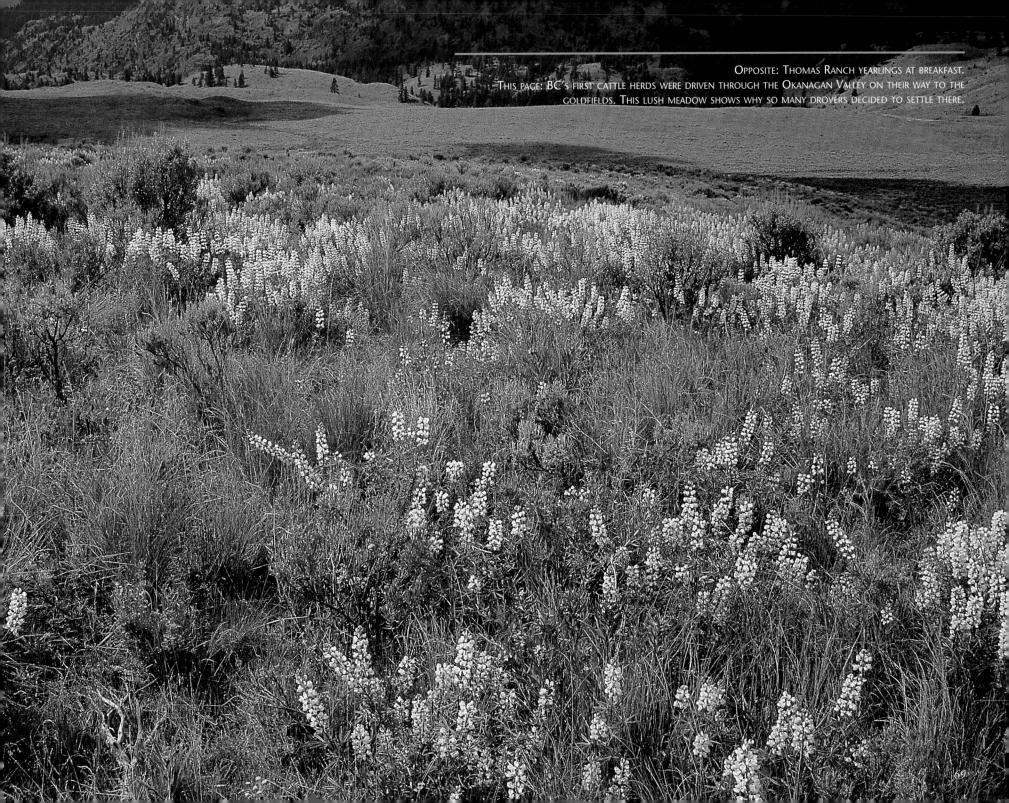

OPPOSITE: THOMAS RANCH YEARLINGS AT BREAKFAST.
THIS PAGE: BC'S FIRST CATTLE HERDS WERE DRIVEN THROUGH THE OKANAGAN VALLEY ON THEIR WAY TO THE
GOLDFIELDS. THIS LUSH MEADOW SHOWS WHY SO MANY DROVERS DECIDED TO SETTLE THERE.

The HISTORIC O'KEEFE RANCH

The grasslands at the head of Okanagan Lake caught the eye of Cornelius O'Keefe as he passed through the valley in 1866, headed for the goldfields with a herd of cattle. Two years later, as the Cariboo gold mines petered out, he returned and pre-empted the 320 acres (128 ha), which became the nucleus of the O'Keefe Ranch, 12 miles (19 km) north of Vernon. O'Keefe prospered in the early years by selling beef to railway construction gangs, and by 1888 he was one of the major landholders in the area, with the grandest house and the most modern farm equipment. He continued adding to his herd, and he diversified by growing grain and apples and raising pigs and sheep. The Depression years took a heavy toll, forcing him to sell land to orchardists to cover his debts. After his death, his son Tierney took over a much scaled-down operation, but it remained a working ranch until June 1967. Then, with great fanfare, it was designated a historic site. For the next ten years the O'Keefe family operated it as a tourist attraction; it was then purchased by the Devonian Foundation of Calgary, which in turn presented it to the city of Vernon. A non-profit society now operates the site.

ABOVE: CHURCH AT THE O'KEEFE RANCH.
OPPOSITE: THE GENERAL STORE AT THE O'KEEFE RANCH, ONE OF THE EARLIEST RANCHES TO BE ESTABLISHED IN THE OKANAGAN. THE HISTORIC SITE INCLUDES PERIOD BUILDINGS AND AN INTERPRETIVE CENTRE.

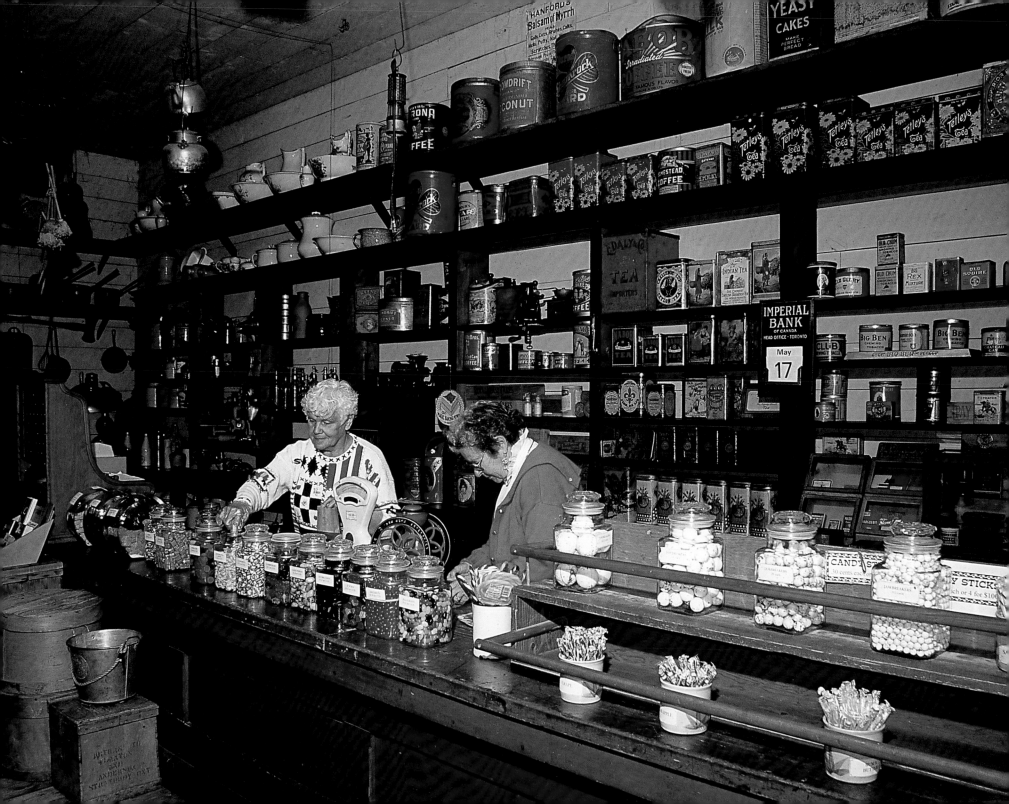

THE GUICHON RANCH, AUTUMN, IN
A VIEW TO THE SOUTHEAST.

The Nicola Valley

The Nicola River—named by fur traders for Okanagan Chief Walking Grizzly Bear, known as Nkala or Nicola—rises on the Douglas Plateau and flows westward to join the Thompson River at Spences Bridge. The valley has everything a rancher needs: splendid grasslands and treed highlands to provide spring, summer, and autumn grazing, and a valley bottom that grows luxuriant forage crops for winter feed. As a bonus, the area is stunningly beautiful—sweeping hills whiskered with bunch grass, aspens marching along the crests of hills and bordering the streams, with everything turning multicoloured in the fall.

The Guichon Ranch JG ✳

The Guichon ranching dynasty began with Joseph, who left his home in France in 1864, at age sixteen, to join his brothers in the Cariboo goldfields. He worked for the renowned packer Cataline (Jean Caux) and on various ranches, and bought cattle with his earnings. In 1867 he and his brothers took up land in the upper Nicola Valley. The brothers left for other ventures; Joseph stayed to build a cattle kingdom.

"Leave the landscape in better shape than it was in when you got it," Guichon said, and his philosophy was passed from father to son down four generations, each taking it a step further. Joseph's great-grandson Laurie was killed in a motorcycle accident in 1999 before he finished his dream, but his widow Judy and their four children are carrying on the tradition.

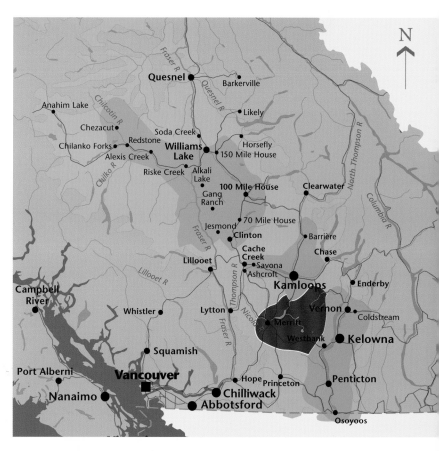

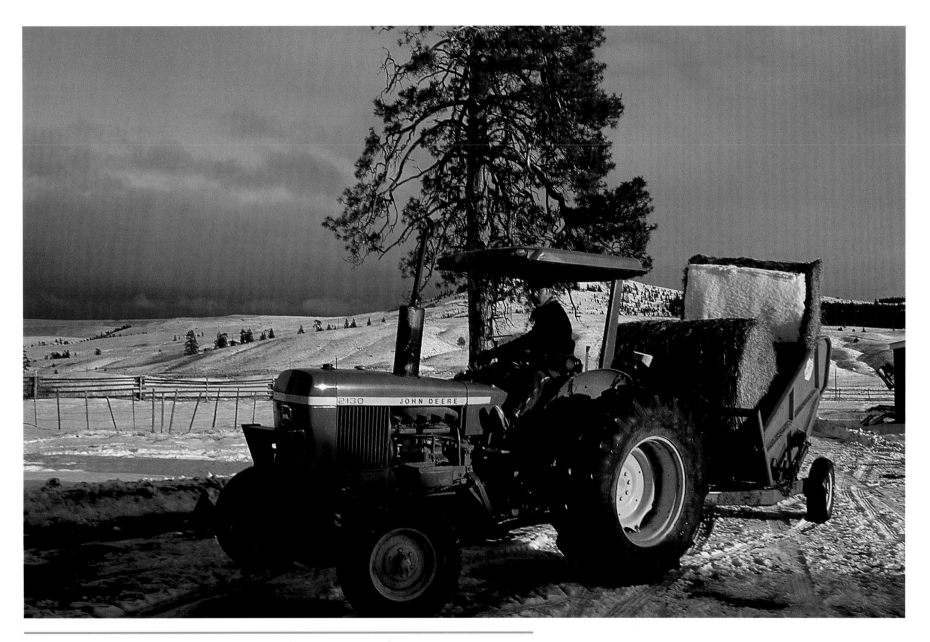

LARRY MCMILLAN HAULING ROUND BALES OF HAY. FEEDING IS ONE OF THE MOST EXPENSIVE OPERATIONS ON A
RANCH, PARTICULARLY BECAUSE COMPETITORS IN WARMER CLIMATES CAN LET THEIR ANIMALS GRAZE ALL WINTER,
INCURRING NO EXTRA EXPENSE.

The GUICHONS

Joseph Guichon, who founded the Guichon Ranch in the 1860s, believed in proper range management and stock breeding. He taught these values to his seven children, who took over the ranch in 1918. They acquired more land and made improvements, and when they incorporated the Guichon Ranch Ltd. in 1933, it was running 4,000 head of cattle and 500 horses on 30,000 acres (12,000 ha) of deeded land. It comprised several individual ranches, large grazing leases, the Quilchena Hotel, a farm machinery dealership, a store, and a service station.

Joseph's oldest son Lawrence managed the farming operations, John was the cowboss and Joseph Jr. was the business manager. Known as the Three Wise Men, the Guichons were gentlemen of the old school, public-spirited, hard-working free enterprisers to the core. When the margin of profit was too narrow, they believed it was up to them to streamline the operation, not to look for government handouts. Lawrence, dubbed the Dean of BC ranchers, was best known for his work in restoring Nicola's native grasslands, which had fallen victim to overgrazing and grasshopper invasions.

Lawrence's son Gerard managed the company, reorganized as Guichon Cattle Company Ltd., then bought the north section, now the Gerard Guichon Ranch Ltd. Gerard took a leading role in cattlemen's associations and grass management groups at the local, provincial and national levels, for which he was inducted into the Order of Canada and the Cattlemen's Hall of Fame in Billings, Montana.

In 1974, when cattle prices plummeted from 70 cents to 40 cents a pound, which was less than the cost of production, the provincial government introduced an income assurance program. Gerard opposed it, calling it welfare and warning that it could rob ranchers of their independence.

Gerard and his wife Ruth managed the ranch until 1979, when their oldest son Laurie and his wife Judy took over.

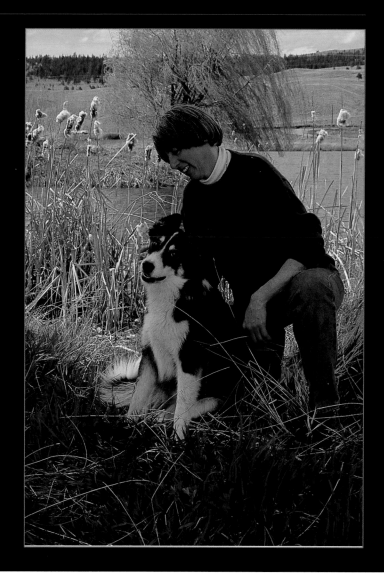

JUDY GUICHON AND ZIP.

The Woman's Touch

Ranch improvements always take precedence over household needs. When Guy and Hilde Rose first took over the Quilchena Ranch, it seemed to Hilde that whenever she needed something for the house, like a new stove, Guy needed something for the ranch. Gerard Guichon's wife Ruth sympathized with Hilde. "I thought I was marrying Gerard," she told her. "It took me a while to realize I had married the ranch."

By the very nature of their work, ranchers are close to the land, but the Guichons have taken extra steps. Laurie spoke of going on walks with his grandfather Lawrence, Joseph's son, and if he poked at a rock or a log his grandfather explained how he was disturbing the home of some living creature. Laurie never forgot those lessons. His father Gerard had the same respect for living things. He and Laurie were among the first in Canada to install a labour-saving automatic self-propelling pivot irrigation system—which was not, at first, all that labour-saving. Ospreys were nesting in a Ponderosa pine tree within the path of the pivot, and rather than allowing the sprinkler to disturb the birds, Gerard and Laurie reversed the irrigation arm by hand every other day, a task that took both muscle and time.

When Gerard read Alan Savory's book *Holistic Resource Management*, he was so impressed he sent Laurie and Judy to a seminar to learn more about it. The young Guichons listened to Savory explain how grazing cattle can actually improve grassland if they are managed properly, and they were hooked. "We wondered what we were getting into at first," Judy says. "It sounded like some kind of cult, but once you realize the implications of what you are doing, you have to do it right. You feel guilty if you don't."

Doing it right involves an intense grazing plan that feeds the cattle but allows the soil and grass time to rest and recuperate. Doing it right means respecting all the living things that share the ranchland: vegetation, bugs, wild and domestic animals, and humans. Doing it right means

maintaining everything from the roots up and considering the cow to be the last link in the chain.

Modern ranching has become more and more dependent on technology and financial programs, but Laurie believed that if ranchers keep putting their earnings back into the mechanics of the operation, they would end up like BC fishermen, who invested in bigger boats and better technology and ended up with no fish. Laurie believed that if you look after the land, it will look after you: that the goal is not maximum production, it is quality of life and the sustainability of the natural "capital"—the land, particularly the health of the soil and the watershed.

The Guichon ranch hasn't put up hay since 1990, so it needs little machinery. The cattle do the harvesting through controlled grazing, and what hay is needed is bought from the Vanderhoof area. From late April to July, Guichon cattle and contract cattle belonging to other ranchers graze on the former hay meadows. The animals do the fertilizing. The grass recovers, and grows, over the summer and is ready for the cattle again when they come off the range in October. The cattle are fed hay beginning in February.

Moving the cattle is the key, because damage is caused not by the number of animals on grass at any time, but by the length of time they are there. According to Savory, one cow on a field for thirty days can do more damage than thirty cows in one day. The cattle are moved every twenty days on forested land, every ten days on another range and every two days on the lower slopes. Sometimes it is necessary to haul water to them. Grazing is controlled by fence—

the ranch has 700 miles (1,100 km) of it, some of it electric—and the cattle are moved by saddle horse or ATV. They are trained to respond to a whistle: when they hear it, hundreds of them walk calmly through a gate, having learned that they are going to greener grass.

The holistic approach takes major time and effort, to plan, control, monitor and replan. Is it worth it? "Once you get your head out of the sand you can't ever put it back in," Judy says.

The Quilchena Cattle Company R

Quilchena, "the place where willows grow," is the other part of the Guichon story. The ranch was divided in 1957 and Guy Rose, son of Virginia Guichon, bought the Quilchena property with its headquarters 14 miles (23 km) east of Merritt, overlooking Nicola Lake. It included a store and the historic Quilchena Hotel.

Guy was raised in Vancouver, but as a teenager he spent his summers at the family ranch. He remembers piling off the bus, having lunch, changing his clothes and heading for the hayfields. He took a degree in agriculture and married Hilde in 1955. Two of their five children have taken an active part in the business: Stephen as the farmer, Michael as the cattleman.

The Roses have added to their original holdings, and at 33,750 acres (13,500 ha), the ranch is the second largest in the Nicola district. They have also made improvements, including an irrigation system that turned some 1,000 acres

(400 ha) of unproductive land into hayfields. Quilchena's basic herd of 1,500 mother cows are Herefords bred to Red Angus and then to Charolais. Calving takes place in March, and the cattle are turned out to graze in the high country in May. The small crew who stay with the cattle make their headquarters in an old homestead on the range. Calves destined for the fall market are weaned on the range and trucked to the home ranch; the rest are weaned in October and trucked in when the mature cows are driven home.

MICHAEL'S SON MATT ROSE PUTTING THE FINISHING TOUCHES TO A SET OF SPURS.

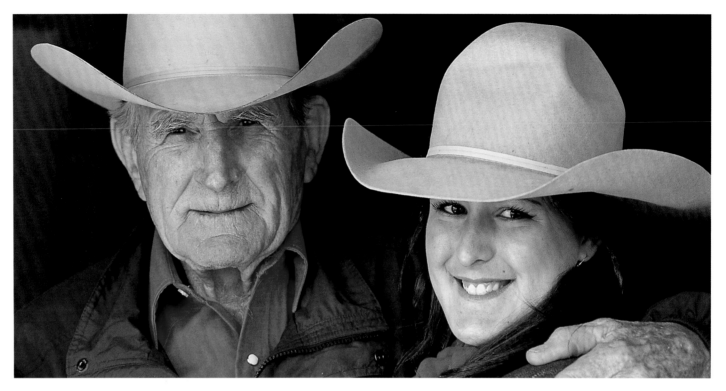

Sales are made by computer to markets in BC, Alberta and the US. "In the days when we had the cattle sales on the ranch," Guy recalls, "we used to barbecue two hips of beef and four hundred people would come. It was pretty romantic. Now it's all a flash on the screen and the cattle are sold by breakfast time."

Beef prices seldom keep up with production costs, and like many cattlemen, Guy believes the best way to make money from the ranch in the long run would be to sell it. But the Roses would not necessarily live happily ever after. "What would we do?" he asks.

The Douglas Lake Ranch ||| ↓

With over half a million acres in its control, the Douglas Lake Ranch, east of Merritt, is the largest cattle operation in Canada. It began in 1872 with a pre-emption by John Douglas on the northeast end of the lake that bears his name, but it was the second owners, a syndicate headed by Joseph Greaves and Charles Beak, who incorporated it in July 1886 as the Douglas Lake Cattle Company. Greaves and Beak were aggressive men. They cornered the beef market and bought up neighbouring ranches, increasing

TED WILLIAMS, RETIRED COWBOSS AT THE QUILCHENA CATTLE COMPANY; AND JENNIFER ROSE, GRANDDAUGHTER OF GUY ROSE.

The QUILCHENA RESORT

When Joe Guichon Jr. became business manager for the Guichon enterprises, Quilchena Hotel, built in 1908, was a going concern. The saloon, with its spittoons, brass foot rails and three authentic bullet holes, was the most popular gathering place in the Nicola Valley, and because cowboys were not generally allowed to have alcohol on ranch properties, it was often the most boisterous place, too.

Joe was his own bouncer, and when one of his customers overdid his merrymaking, Joe would stow him in the root cellar behind the hotel to sleep it off. Regulars who came empty-handed, looking for a drink, were set to work replenishing the hotel's water supply by means of a hand pump that filled a large tank in the attic of the hotel. The Quilchena was said to have the only whiskey-powered water system in the country.

As automobiles came into use and roads improved, fewer customers stopped over at the hotel, but the final straw for Joe was Prohibition. It annoyed him that his guests couldn't have a glass of wine with their meals, and he closed the hotel in 1917. It was reopened in 1958 after his nephew Guy Rose bought the Quilchena Ranch.

The hotel combines the elegant past with contemporary services, and guests can enjoy continental cuisine in the hotel dining room, water sports on Nicola Lake, trail rides in the hills and golf on the nine-hole course that was originally the polo fields.

Douglas Lake: THE NUMBERS

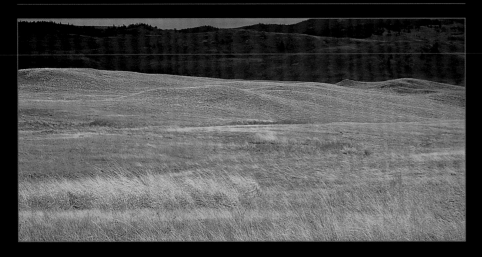

The size of the Douglas Lake Cattle Company almost staggers the imagination. It stretches nearly 60 miles (100 km) from its northeast to southwest corners. Six separate ranches comprise a total of 165,000 deeded acres (66,000 ha), and another 350,000 acres (140,000 ha) of Crown land are under grazing licence or lease. The ranch has 1,000 miles of fence and produces all its own winter feed on 6,000 cultivated acres (2,400 ha). It is a cow/calf operation with 7,000 mother cows: 4,500 Herefords and 2,500 crossbreeds. There are also 350 bulls—one for every 20 cows—and 250 horses.

Employees include a cowboss, a farm boss, twenty cowboys in spring, twenty farmhands in peak season, one mechanic, two and a half truck drivers, two cookhouse cooks, two seasonal camp cooks, two egg ladies, one manager, three office staff, one accountant, one purchasing agent/storekeeper, one and a half storekeepers, one teacher, one recreation manager and up to eighteen recreation staff in peak season.

their deeded land to more than 100,000 acres (40,000 ha) on which they wintered 10,000 head of cattle. In 1910 William Curtis Ward, one of the syndicate members, bought out his partners. He and his family had the longest tenure on the ranch—forty years—with Ward's son Frank managing it for most of that time, building up the land base and increasing the size and quality of the herd.

When Colonel Victor Spencer of Spencer's Department Stores bought the ranch in 1950 with his partner Bill Studdert (then owner of the Gang Ranch), its deeded land had grown to 143,250 acres (57,300 ha). Studdert was later replaced by Frank Mackenzie Ross, who became BC's lieutenant governor in 1955.

In 1958 the ranch passed into the hands of Charles "Chunky" Woodward, scion of the Woodward's Department Store family, and his stockbroker partner, John J. West. Woodward, whose passion for ranching stemmed from childhood summers on his maternal grandfather's Alkali Lake Ranch, began a quarter horse breeding and training program that produced cutting horses, which were in demand throughout North America. He also brought fame to the ranch in 1962 when HRH Prince Philip holidayed there.

The ranch's present owner, Bernard Ebbers, an Alberta-born resident of Mississippi who acquired it in 1998, is the first non-British Columbian to own the Douglas Lake Ranch.

Joe Gardner, the fifth ranch manager in the ranch's history, runs some 20,000 head of cattle. Calving is carefully

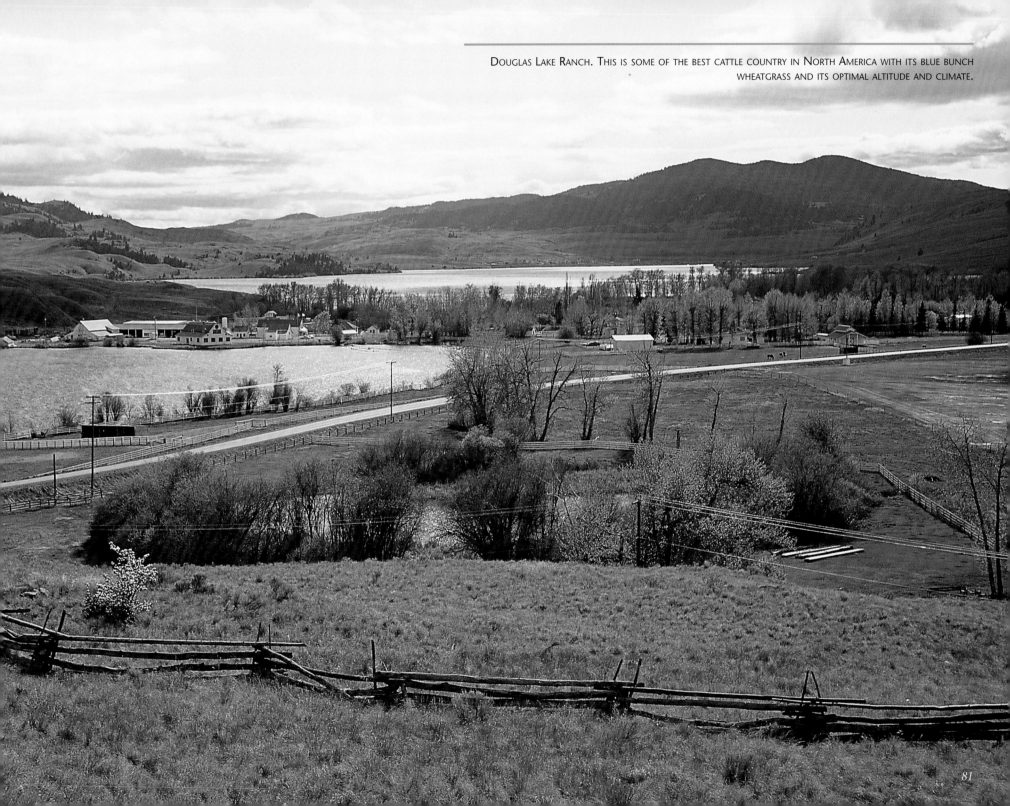

The Lauder Ranch JL ⚹ ⊞

The Lauder operation is a century ranch, and John Lauder is the fourth generation at the reins. The operation began with Joseph Dixon Lauder, who arrived from Ontario in 1876 and pre-empted land, then sent for his wife and three children.

The Lauders first raised horses and dairy cows, but within ten years they had several hundred head of beef cattle. The herd rustled in the lush valley bottoms all year-round, until the winter of 1886–87, when blizzards covered even the tallest grass with hard-crusted snow. Thousands of Nicola Valley cattle perished, Lauder's among them. That summer Joseph's son William made enough money skinning dead cows and selling the hides to buy his first saddle.

The Lauders rebuilt their herd and acquired more land for hay production. William took over the ranch in 1903 and added part of the Garcia Ranch just east of Merritt, and William's son Joe bought the outfit in 1948. The Garcia place grew good hay, so Joe drove cattle there to winter every year. It was a two-day drive, so the cattle stopped overnight at the Nicola stockyards.

The village of Nicola is now the Nicola Ranch, but in early days it was a major shipping point. Joe and his crew would start out with a herd in the early evening in order to arrive at Nicola at dawn. They penned the cattle in the yards, caught a few hours' sleep in the loft of the nearby livery stable, then loaded the cattle, some 25 head to each boxcar. In those days the ranchers sold directly to buyers who acted on

controlled with twenty-four-hour surveillance from a state-of-the-art maternity barn with fifty-four individual pens. The cowboys on watch are ready to step in and act as midwives if needed. Gardner also developed a program of integrated resource management that includes selective timber harvesting, and an extensive tourist operation (the ranch is a comfortable five-hour drive from Vancouver).

TERESA BREWER, COWGIRL AT DOUGLAS LAKE RANCH.

behalf of the meat packers in Vancouver. Most of the Nicola Valley cattle went to the buyer for Swifts, who insisted that large steers be weighed separately at a discount of $1/2$ cent on a 3-cent-a-pound price. On a 1,000-pound (450 kg) animal the difference came to $5, a tidy sum. "When I objected," Joe remembers, "he laughed that I'd finally caught on."

Joe was the first in the valley to sell yearling steers, one of the first to establish a cow/calf operation, and the first to install a gravity-feed irrigation system. Over the years he changed the shape of the ranch, selling the Garcia place and buying other properties to ensure continuous access to his summer Crown range. In 1972 he brought in five bulldozers to clear 250 acres (100 ha) of burned land near Glimpse Lake; the land was then reseeded by air in two and a half hours.

Along with creating a first-class ranch, Joe Lauder was a mover and shaker on the political side, working with the BC Livestock Co-op, the BC Cattlemen's Association and the Agricultural Land Commission.

John, the eldest of Joe and Mollie Lauder's sons, took over management of the ranch in 1977, and he and his wife Jean bought it eleven years later. The Lauders run a traditional cow/calf and yearling operation, using the original JL brand. (Joseph Dixon Lauder carved it into a turnip to make a pattern for the blacksmith). The Lauders put up their own hay in user-friendly round bales, and begin feeding in January. Calving begins in March. Their basic herd is British breeds, but heifers are bred to little Corriente bulls, so first-time moms have smaller calves. John flies a Cessna

THE FARRIER'S TOOLS, FOR SHOEING HORSES.

JEAN LAUDER AND HER SON IAN CHECKING SHEEP ON THE LAUDER RANCH. MANY RANCHERS KEEP SHEEP FOR AN
ADDITIONAL CASH CROP AND A SOURCE OF MEAT. IN EARLIER DAYS, BEFORE REFRIGERATION, SOME RANCHERS KEPT
SHEEP BECAUSE THEY ARE SMALL ENOUGH TO BE EATEN WITHIN A WEEK, AND LARGE ENOUGH TO FEED A FEW GOOD
MEALS TO A HAYING CREW.

170, in which he keeps an eye on the cattle when they are out on the range, but he and his main man, Marvin Alexander, do a fair bit of riding as well. Marvin sometimes startles visitors by wearing bright orange coveralls over his traditional cowboy garb.

It could be said that John and Jean Lauder have the best of all possible worlds, a rural lifestyle with the city amenities close at hand. Their ranch is off the beaten track, tucked away in the rolling hills between Quilchena and Douglas Lake, where they have the privacy and space of rural life. Erik and Ian, their youngest children, have animals in the 4-H club and Jean raises thoroughbreds, which she races in Vancouver with some success. The town of

CENTURY RANCHES

The provincial Ministry of Agriculture turned 100 years old in 1994, and as part of the celebration, the ministry recognized "century" ranches and farms—operations that had been in the same family for 100 years. The first awards, a ranch gate sign and a certificate to each outfit, were presented by then Agriculture Minister David Zirnhelt, who is a rancher himself. By 1998, when the program was dropped, seventy-eight ranches and farms had been honoured, and more have joined the ranks since then. The oldest century ranch families are Grant and Henry Machin, Circle Bar Ranch, Courtenay, BC (1862) and the Dougherty family at Maiden Creek (1862). Close behind were Catherine Watkinson and family at Fosters Bar Ranch, Lillooet (1864).

Merritt is just a half hour's drive away. The Lauder barn, built in 1910, is still in use, and Joe Lauder built the house a half-century later to replace the original family home. The view is spectacular, but Lauders are more apt to be participating in it than admiring it.

JOHN LAUDER STRIPPING SHOES. RANCH HORSES NEED NEW SHOES AS OFTEN AS EVERY FEW WEEKS.

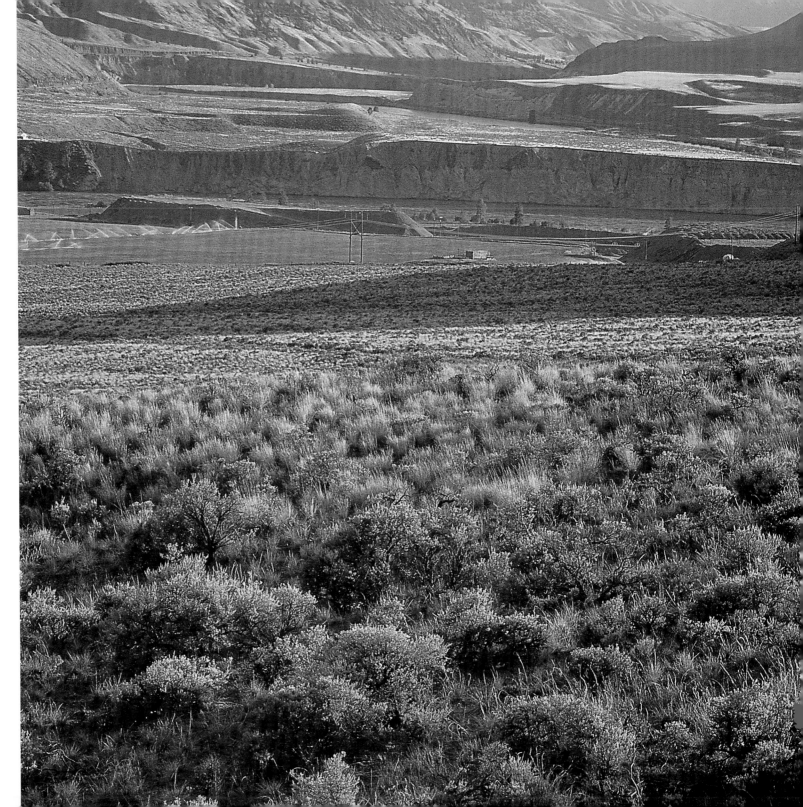

SAGEBRUSH AND RIVER TERRACES
DEFINE THE THOMPSON
RIVER VALLEY.

6

The Thompson Valley

Kamloops doesn't see itself as a cow town any more, but it is still the centre for the large Thompson Valley or "dry belt" ranching community. Although rangelands here are among the best in the province, many of the original ranches are gone. The Lewis Campbell Ranch is now a cement plant, water slide and game farm. The Cherry Creek Ranch raises ginseng. The Perry Ranch is a feedlot, the McLean Ranch at Hat Creek is a provincial heritage site and the historic Cornwall ranch has been purchased by the Greater Vancouver Regional District for use as a landfill site. However, historic ranches have endured, new ranches have appeared and the cattle industry is alive and well in both the North and South Thompson valleys.

The Back Valley Ranch

"It's regular about not raining" is how one old-timer describes BC's dry belt, an area that boasts 2,000 hours of sunshine a year.

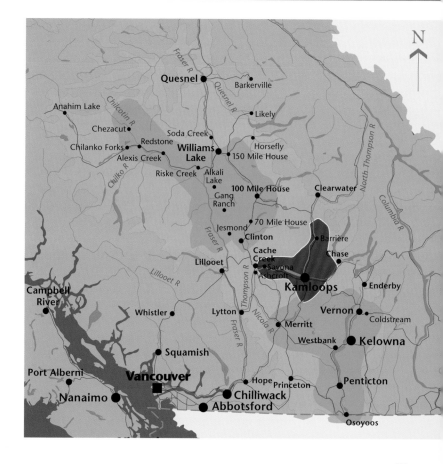

KNAPWEED, THE BANE OF THE RANCHER'S LIFE, THRIVING ON DISTURBED GROUND ALONG THE THOMPSON RIVER.

The valley of Deadman Creek, which empties into the Thompson River just west of Kamloops Lake, is one of the driest in the dry belt with an average annual rainfall of 10 inches (25 cm). The Steves family are newcomers to the area, having only arrived in Back Valley in 1976, but they are among BC's elite "century farmers." Harold, a retired schoolteacher and not-so-retiring political activist, is the great-grandson of Manoah Steves, who settled on Lulu Island in 1877 to operate a dairy farm and develop a vegetable seed business. Steveston is named for him.

Harold and his father, Harold Sr., continued the dairy operation until they were steamrollered out of business by progress, provincial and municipal regulations, and urban sprawl. The first blow came when the provincial Milk Industry Act ruled their barn was too small, but they couldn't get a building permit to enlarge it because the municipality had rezoned their land. They put on an addition without a permit. Then the dairy co-op outlawed the storage of milk in cans, and the Steves family couldn't get a permit to build bulk tanks. They switched to beef cattle, but the government expropriated 5 acres (2 ha) for new diking along the Fraser River. Another 8 acres (3.2 ha) went for a school, the CBC took land for transmission towers, and a chunk went for a road that was never built. In the meantime subdivisions had sprouted all around them, and the final blow came when the city levied residential property taxes on the land at ten times the farm rate. That was when the two Harolds began to look for greener pastures.

They found the Back Valley Ranch, originally homesteaded by a remittance man who worked on a short-lived orchard project at Walhachin before World War I. Harold Sr. died just a few years later.

The Back Valley Ranch, at Deadman Creek, includes 455 acres (182 ha) of deeded land and another 17,000 acres (6,800 ha) of Crown land. What remains of their Richmond property is 7.5 acres (3 ha) inside the Fraser River dike and 20 acres (8 ha) on the ocean side of the dike. Some of their cattle winter in Richmond and browse on the pasture outside the dike with the mighty Fraser River flowing beside them.

Jerry, Harold's son, has a degree in agricultural sciences and spends most of the year at Back Valley. Harold's wife Kathy is in charge at Richmond. Harold commutes between the two. A former NDP MLA (1972–75) and a twenty-seven-year veteran of Richmond city council, Harold takes on causes ranging from protecting the Pacific coast salmon fishery to preserving local heritage sites.

In its original beef operation, the family bought yearlings at the coast, raised them between Richmond and Back Valley and sold them at Kamloops. Then a belted Galloway cross heifer in one bunch caught Harold's eye. Nicknamed Oreos or belties, these cows have black hind and front quarters separated by a wide white belt. They are rare in Canada. Harold did some research and became convinced they would be ideal for BC because they have thick fur under their long outer hair; he reasoned this would insulate the animals from cold in winter, heat in summer. The meat

Though Harold and Jerry use modern methods for breeding cattle, they have a different attitude to machinery. "A machine's only purpose is to put people out of work," Harold says flatly. They don't buy new if old will do, and they find great bargains at auction sales.

Back Valley is less than an hour's drive from Kamloops but years away in lifestyle. There is little passing traffic. No hydro, no telephone, no mail service. No secure water supply, either, and this is a problem. An irrigation system with 4-inch pipes hooked into a mountain stream above the ranch provided an ample supply until 1991, when the high area was clearcut. The following spring, water gushed through the pipes in a single spurt, then disappeared. Most years since there has been enough water in the snowpack to support vegetation on the clearcut, but even that failed in 1998.

Jerry is ready to select log the ranch's treed land with horses when the price is right. "There is nothing wrong with logging," he says. "Logging can work well for all land users and enhance grazing if it's done right." But the ranch's very existence was put in jeopardy by the 1991 clearcut. Had the Forest Practices Code been in place then, the cut would never have been allowed.

The Steves family live in harmony with the land. They grow heritage seeds on both properties and work with nature in every other way possible. When the lake on the ranch began drying up in 1991, they transplanted bulrushes and other plants to keep the marsh intact. This action couldn't keep the frogs and muskrats from disappearing for

is well marbled with little fat over the rump or shoulder, a plus in today's diet-conscious market. He tracked down and bought a purebred belty cow in Saskatchewan, imported semen from Scotland and began building a herd with artificial insemination and embryo transplants. The cows are surrogate mothers chosen for their maternal instincts and milk supply, not for looks. One lanky old girl named Sage (because of her peculiar colour) has personality problems but she raises beautiful little belties so the Steves put up with her.

a number of years, but now they are making a comeback. After deep snows in the winter of 1996–97, followed by a wet spring, the hayfield beside the lake was so boggy the family couldn't get on it until late summer, and by then the grass was taller than the tractor. Passersby were startled to see what appeared to be an unattached exhaust pipe moving through the meadow. The tall grass had encouraged a number of deer to take up residence, and Jerry mowed around them. The deer got used to having humans close by. Now they are a nuisance: apparently they think the Steves family have planted the alfalfa field for their use.

A Community Cattle Drive

The "dry belt" was not living up to its reputation on June 26, 1999, when the Back Valley Ranch's cattle made their annual 10-mile (16 km) trek to their summer range in the Arrowstone Hills. The whole month had been rainy and the ground was saturated, but Harold Steves and his son Jerry didn't mind. The rain was solving their irrigation problems.

Harold, driving a 4x4 pickup, Jerry on an elderly mare, a couple of drovers on foot and 45 head of cattle set out from the ranch in a fine drizzle at six in the morning. Both men are laid-back people, particularly Jerry, and the cows reflect the Steves approach to handling stock—a method that might be called "cow whispering." The animals would probably faint from fright if anyone yeehawed at them. On this June morning the cows were even a bit more leisurely than usual; they'd been penned up all night and wanted to

munch, not walk. As the drive proceeded slowly down the Back Valley road, the biggest problem was keeping the animals from wandering off to graze.

A neighbour's downed barbed-wire fence posed the first problem. Barbed-wire fences are fine when they are up but perilous when down, because the wire can wrap itself around an animal's legs. It took all the drovers to get the cows back on track. A few miles down the road, a neighbour on a mountain bike joined the drive.

The trail to the range passes through three distinct zones, grassland along the valley road, forest on the way up the mountain, and sagebrush desert on top. Along the way, the drive was to pick up some cattle owned by the Steves' neighbour, Carey Jules, but Carey showed up instead and explained that the creek had risen in the night and he couldn't get the cattle across. His wife and three young foster kids were in the pickup with him and they joined the drive.

While the expedition paused for lunch, enjoyed by both cows and drovers, Carey's five cowboys arrived. Once they got underway again, the cows were legging right along so the work was mostly a matter of keeping up with them. Harold and Jerry took turns riding or leading the mare and driving the 4x4, the foot drovers riding in the back.

The mountaintop is a surprise to strangers, a huge, flat, golden desert, lumpy with rocks and sagebrush. The sky reaches right down around the edge and it is hard to believe the Trans-Canada Highway lies just below. The youngsters dug their bikes out of the pickup and began

The Community Cattle Drive:

WITH COWBOYS, KIDS AND NEIGHBOURS...

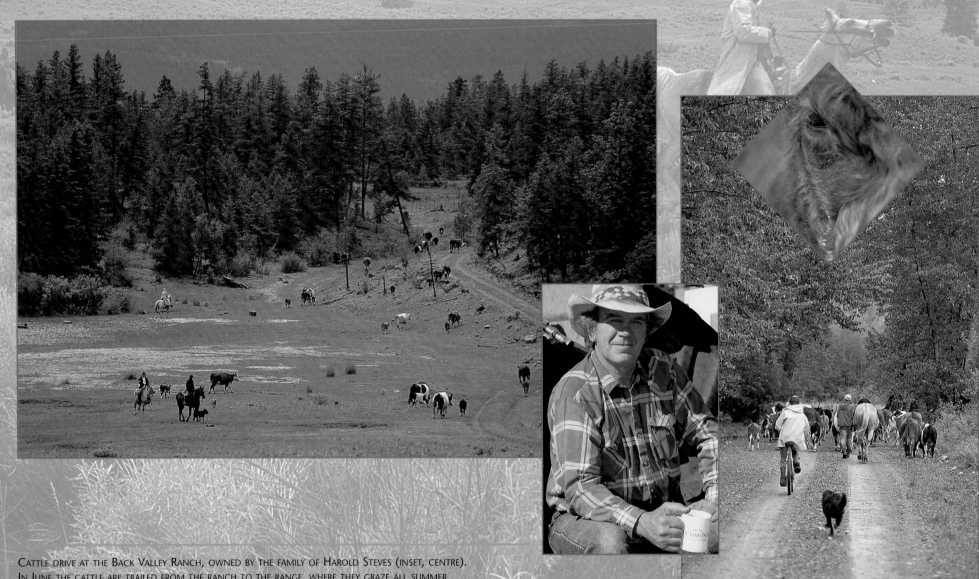

CATTLE DRIVE AT THE BACK VALLEY RANCH, OWNED BY THE FAMILY OF HAROLD STEVES (INSET, CENTRE). IN JUNE THE CATTLE ARE TRAILED FROM THE RANCH TO THE RANGE, WHERE THEY GRAZE ALL SUMMER.

riding around. The chain had fallen off the mountain bike and that biker had joined the foot drovers.

Halfway across a neighbour's range, a clutch of black Brahma rodeo bulls burst onto the scene, hell-bent for the cows. This crew may not have looked like traditional cowboys but it was obvious they were. The 4x4 and the six riders flew out to head off the bulls. The foot drovers didn't participate. There was some yelling before the bulls were vanquished.

That was it for excitement. When the cattle were settled at their summer home, all hands retired to Back Valley Ranch, where another crew had been busy hand-turning a pig on a spit. It was raining again by the time the barbecue was ready. Nobody noticed. You wouldn't know from the comfortable camaraderie that most people in the group had never even met before that day.

The 2 Lazy H Ranch

The Steves family and their neighbours on the 2 Lazy H spread, Carey and Diane Jules, have worked together for years. "We've never had anything on paper," Carey explains, "but it works."

Carey and Diane are members of the Skeetchestn Band. In earlier times almost every family on the reserve ran cattle, each with 50 head or more. Now Carey and Diane are among the few who still have cattle. Carey came by his ranching and farming ability from his grandmother, Celina Jules, who raised him and taught him the traditional

CAREY JULES OF THE 2 LAZY H RANCH.

ways of training and healing animals. The two spent part of every year on a farm near Bellingham, Washington, where Carey helped in the farmer's shop maintaining the equipment.

When he was older, he cowboyed on several spreads in the Cache Creek/Kamloops area. "I'd ride at least one bronc before breakfast," he says with a grin. This led to six years riding pickup for the stock contractor, Renegade Rodeo. Riding pickup—getting a bronc or bull out of the arena after a ride—is not a job for the timid. It is often more difficult than riding the animal, so the pickup man must be a top-notch horseman with nerves of steel, an excellent knowledge of animal behaviour, and superb timing. He is responsible for the safety of the rider and the well-being of the bucking stock, which is worth thousands of dollars. A contractor cannot afford to have his animals injured or spoiled. Carey had his share of injuries during those six years. "I still watch out for anything that kicks," he says. He was once badly hurt when a bull ran over him.

The Fennell Ranch ИW

Norman "Bud" Fennell, owner-operator of the Fennell Ranch, is carrying on a tradition begun by his father more than a century ago in the North Thompson valley. The Fennell story is one of success, disaster and rebuilding.

George Fennell, who founded the ranch, came from Ontario in the early 1890s and went prospecting in Knight Inlet on the BC coast. He had no luck, and he and a part-

ner walked out at the first snowfall, crossing the rugged Chilcotin plateau to the Fraser River and hiking into the Clearwater country. When spring came, he prospected along the North Thompson, and was unsuccessful again. So he pre-empted what is now part of the Fennell home place near the First Nations community of Chu Chua. He didn't settle on it right away, but drove logs on the river for a Kamloops logging company. After he nearly drowned doing that, he and his wife Margaret moved to the pre-emption and began building a remarkable and diverse empire there.

Fennell raised cattle and sheep, bought furs from Chu Chua trappers, and built a store, a stopping place for the stage to Blue River, and a landing for the paddlewheel steamers that plied the Thompson. When the Canadian National Railway was built through the North Thompson in the 1880s, he built a new store by the tracks, using lumber from his own sawmill. Buildings sided with lumber from that mill still stand in this area: the wood is clear, not a knot in it. George also served as special constable and justice of the peace.

As the valley population grew, so did the Fennell enterprises, and George hired more and more workers, including many from Chu Chua. He began a fruit tree nursery, selling to settlers from miles around, and some of those trees are still producing fruit. He grew acres of potatoes and sold them. He never lost his interest in minerals and never stopped prospecting. One of his finds, a green stone, was named for him.

BUD AND GRACE FENNELL OF THE FENNELL RANCH, WITH THEIR GRANDCHILD.

In 1924 George acquired three 100-year timber leases and built a large sawmill near the railway siding at Mile 34, where he produced poles and planed lumber, shipping it out by the carload. One tinder-dry summer a lightning strike started a forest fire and the mill crew went to fight it. While they were gone a spark from an abandoned campfire set the mill afire and it burned to the ground. There was no insurance, and the loss nearly bankrupted the Fennells. When the Depression hit, the Fennell enterprises suffered along with the rest of the country. But there was worse to come.

One bitterly cold night in 1935, when the temperature dropped to –40 degrees F, the kitchen stove went out and the water in the cast-iron water jacket froze. When the stove was lit in the morning, the ice thawed, and the resulting steam built up enough pressure to blow the water jacket to bits. George was sitting near the stove and pieces of cast iron smashed his leg, cutting an artery. He bled to death. He was sixty-nine years old, but had still been strong in mind and body. His son Bud remembered racing with George the summer before and watching his father leap over a fence.

Margaret Fennell suffered facial injuries in the blast. She had surgery, and she and the older boys tried to keep the businesses going, but everything worked against them. They had to sell property to pay debts and they lost the timber leases when they couldn't pay the taxes. Times had changed, and the store and fur business were no longer prosperous. World War II came and went, and still the family struggled.

When the war was over, the ranch was divided between the children; Bud, the youngest son, got home place. He was the only one to keep his portion. Like his father, he had a vision, and he began rebuilding. He worked as a timber cruiser for the forest service, he logged, and in the 1960s he ran his own sawmill, but he credits his wife Grace with their success. She kept things going at home while he was away, as well as bringing home a salary from teaching school. Over the years the Fennells restored the ranch, and although they haven't regained all the original land, they did acquire an island in the North Thompson. They have a range permit in the same mountains George Fennell used a hundred years ago. It is excellent range and the cows come home in superb shape.

Calving is a bit different on the Fennell Ranch. The Hereford/Angus cross herd is divided, with a third of the calves born in November and the rest in spring. There are no special maternity arrangements for the November births. "The cows are a hardy strain," Bud says. "They find a tree to get under." The two calving seasons split the work and the marketing, he explains. "It means some income in the spring, and we keep some yearlings over and peddle them off around the end of March." The Fennells still have "a few sticks" of private timber, Bud says, and when cattle prices are low, they do some selective logging to pay the bills.

When the family began using bikes and ATVs to handle cattle, Bud sold all but two of his horses because there was no one to ride them. The six Fennell children are all on their own, but according to their dad "they all have their fingers in it," helping with the farming and the haying and taking cattle to the range.

WEEDS

Weeds are the bane of grassland ranchers. There's sow thistle, a common yellow-flowered, milky-sapped roadside weed with silk-tufted seeds that blow in the wind, and yellow toad-flax, another yellow-flowered pest that spreads rapaciously. Then there are the knapweed "brothers." The spotted knapweed (*Centaurea maculosa*) has a single stem branching in the upper half and pinkish flowers with black tips. The more common but equally harmful diffuse knapweed (*Centaurea diffusa*) has a single stem with numerous spreading branches, and white or purplish flowers. Knapweed is sometimes mistaken for a type of thistle, but its leaves don't have thistle-like spines. Knapweed is causing major environmental deterioration and loss of grasslands in BC's southern Interior. So far 100,000 acres (40,000 ha) in BC are infested, with forage reductions of up to 90 percent. It is estimated that the economic loss in equivalent hay production in BC is $500,000 annually.

An import from eastern Europe, knapweed has no natural enemies. Its seeds cling to the hooves, hair and fur of animals, the boots and trousers of humans, and the tires of trucks and ATVs so that it spreads like magic from place to place, crowding out the natural grasses. In certain parts of the Thompson Valley, knapweed has made acres of pasture-land unusable; if it is not checked, the spread of this plant will be disastrous to the beef cattle industry as well as to the grassland recreation value and wildlife habitat. More than one rancher carries a shovel and sprayer in the back of the pickup to attack every knapweed plant he spots.

Fifty years ago, knapweed caught the eye of a very proper English spinster lady with a Bachelor of Science degree from Redding University in England. She was Miss Jean Bostock, the daughter of Hewitt Bostock, MP for Yale-Lillooet for eight years, founder of the *Province* newspaper and owner of the Ducks Ranch at Monte Creek. Miss Bostock became determined to annihilate knapweed before it destroyed the grasslands. She hired boys to help her dig it up from the sides of highways. She nagged the Ministry of Agriculture men in Kamloops to "do something," but they tried to avoid her. After waging a vigorous public awareness campaign, Miss Bostock won a provincial award for her efforts, but she didn't stop the weed.

Except in very limited areas, spraying hasn't produced lasting results. Scientists are trying to recruit insects and diseases that are known to prey on this plant in its eastern European habitat. Among them are a seed-displacing fly, a seed-eating moth and a fungal disease that attacks the leaves.

The Napier Lake Ranch ∧X

Roy and Agnes Jackson have owned and operated the Napier Lake Ranch, 22 miles (35 km) south of Kamloops on Highway 5A, since 1975. Agnes is one of the pioneer Foley family. Her father Percy, a well-known Kamloops area cowman, once worked for the McDonalds, who founded the Napier Ranch, so she already knew something about the business. Roy didn't have a ranching background (he was with the engineering department of the Ministry of Highways), but he learned quickly.

Feeding season is short at Napier Lake—at most 120 days, as few as 60 days—between January and March. The Jacksons see themselves as "grass managers." Their grazing program, set up with the help of Alf Bawtree, a range specialist, is labour-intensive but it is designed to get maximum benefit from the available land. It makes use of 35 miles (56 km) of perimeter fence and twenty separate pastures between which the cattle are rotated.

Where the Jacksons' operation differs from most others in the province is in their method of marketing. Their animals go to a number of feedlots, some in BC, some in

Roy Jackson at the historic Napier Lake Ranch. The barn was built by the McDonald family, who founded the ranch in the early 1870s.

Alberta, but the Jacksons retain ownership right through to slaughter. The animals are sold from the feedlots when the price is right, and sales are staggered so that income is spread to three times a year. "The cost of grain is better than losing out at an auction," Agnes explains.

The business of ranching never stands still. When new government regulations required the Jacksons to fence their cattle away from the lake, they had to install an alternate watering system. To prevent the water from freezing in the lines, they warmed it and discovered that their calves did better on it. Now their only problem is that the water system depends on the performance of BC Hydro: a long outage could put operations at risk.

More and more ranchers are finding woodlots and ranching to be complementary, and the Jacksons were among the first in the ranching community to have a woodlot. However, they take their operation a step further than logging: they have developed an innovative program of "raising" trees.

Although Highway 5A is a busy thoroughfare today, it was somewhat isolated in the 1970s when the Jacksons bought the ranch. There were no neighbours nearby. "We could hardly get radio," Roy remembers. The Jackson daughters, Jennifer and Holly, rode the school bus to Kamloops, making the school day nine hours long. They had to miss out on after-school activities, but neither felt deprived. "We belonged to 4-H," Holly says, "and we had horses to ride and books to read." Ranch kids also have chores. They take responsibility for animals, work with

NAPIER LAKE RANCH LIES IN THE ROLLING GRASSLANDS BETWEEN KAMLOOPS AND THE NICOLA VALLEY. ROY JACKSON (PICTURED HERE) AND HIS WIFE AGNES ARE THE THIRD OWNERS OF THE RANCH. THEY RAISE CATTLE, HORSES AND TREES.

machinery, inevitably get into situations where they have to think for themselves. Holly recalls "driving" the pickup truck around the feeding lot with the steering wheel tied in place while her mom and dad pitched square bales of hay off the back to the waiting cattle. (Now it's a one-person job with a chopper spitting out the hay.) Not all ranch kids go ranching themselves when they grow up, but they tend to find careers in compatible fields. Jennifer is a veterinarian practising in Kamloops; Holly works for Ducks Unlimited while she works on her master's degree in history.

Napier Lake: THE FIRST HUNDRED YEARS

The saga of the Napier Lake Ranch near Kamloops has been more thoroughly documented than some because it was put down on paper by two of the founder's daughters. In their story, Jessie and Jean McDonald describe the arrival at Napier Lake of their father William—a Scots immigrant—and his partner, Thomas Trapp, in 1874. The two raised sheep on their pre-emption until the bitter winter of 1879 put an end to that operation. After trying to raise horses and then cattle, Trapp left, disheartened, but McDonald stayed and prospered, extending his holdings to the upland benches on both sides of the valley. He farmed with a homemade hay rake, seed roller, disk and plough. Cropping was done with a scythe and the hay was tied in sheaves by hand. "Much of the family help," the sisters wrote, "depended on men walking the roads from one area to another, particularly from the Cariboo, and many times they saved the day for ranchers, particularly just before a rainstorm, which at times didn't know when to stop."

When William died in 1915, Fraser, his eldest son, took over management of the ranch, and Jessie returned from Kamloops to keep house for him. Together the brother and sister managed the ranch for the next forty-six years. Jessie, who became known as "the lady of the lake," fed and housed travellers and on one occasion assisted in a birth. And as they had the only telephone in the area, she travelled on horseback to deliver messages to neighbours.

ABOVE: THE MCDONALD BRAND. THE "T" IS FOR TRAPP AND THE "M" IS FOR MCDONALD.
OPPOSITE: HAY MEADOWS ON THE CRAIG RANCH, NESTLED BELOW THE HILLS IN THE RICH BOTTOMLANDS OF DEADMAN CREEK VALLEY.

COWBOYS BRINGING HORSES TO
THE RANCH DURING WINTER SNOW
FLURRIES.

7

Cariboo: The River Road

From Kamloops, the first drovers trailed their herds to Savona, crossed the Thompson River, then continued to Cache Creek and along the Bonaparte. The trail they followed, used for centuries by the First Nations canyon people and later the fur brigades, roughly paralleled the Fraser River to Canoe Creek and Dog Creek. From there it followed the river benches to Fort Alexandria and Quesnel, then turned east to Barkerville. This back route from Clinton to Williams Lake is now known by a series of names: the Jesmond Road, the Meadow Lake Road and the Dog Creek Road.

The Alkali Lake Ranch 27 ✕ ✢

For starters, Alkali Lake isn't an alkali lake. The name came from a scar of white earth (the First Nations people called it Esket) on the valley's western face. The first white men called the place Paradise Valley, and when Herman Bowe, a German-born man,

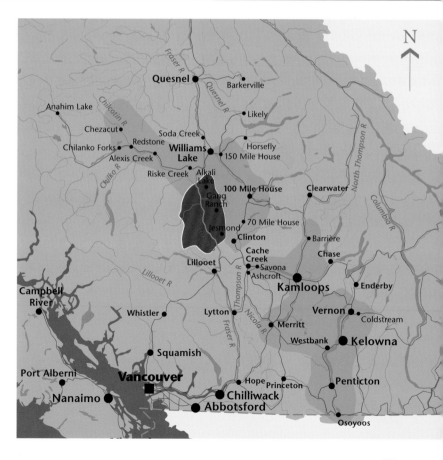

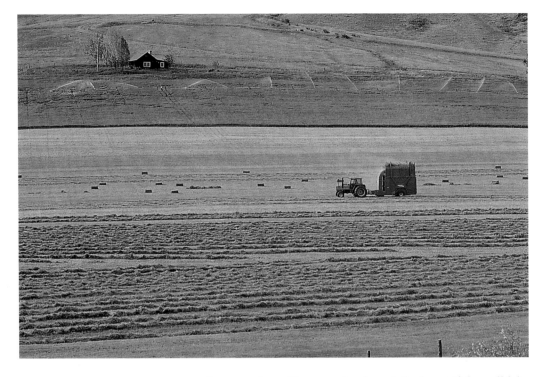

to Bowe and pre-emption records, this is the oldest beef cattle ranch in western Canada.

In 1909 the ranch was sold to an Englishman named Charles Wynn-Johnson, grandfather of Charles "Chunky" Woodward of the Douglas Lake Ranch. He acquired more land and consolidated the earlier holdings into the present complex. In 1939, when he sold the ranch to Mario von Riedemann, a Swiss man, it was a thriving concern running 3,000 head of cattle. Von Riedemann's father was so concerned about his daughter-in-law living in the wilderness that he designed and had built for her a magnificent fourteen-bedroom home. It was the wonder of the Cariboo.

Mario von Reidemann and his wife Elizabeth retired in 1963, leaving their son Martin in charge of the ranch. His two sisters, Sophie and Myra, remained on the ranch with him. Martin was a dashing young man, a magna cum laude university graduate, an all-round athlete and a licensed pilot. He served as founding director of the Cariboo Regional District and he was an active member of the Cariboo Cattlemen's Association. His progressive attitudes on human rights and environmental concerns and his innovative approach to ranching often startled his more conservative colleagues.

In 1975 Martin hosted a Halloween party for his neighbours on the shores of Alkali Lake. After dark he went on the lake alone to launch fireworks. Wind capsized the boat, throwing him into the frigid water. John Rathjen, the school principal, attempted to rescue Martin but both men

first saw the rolling grasslands and the beautiful small lake he must have agreed, because he settled there.

A veteran of the California gold rush, Bowe arrived in this country in 1858 and followed the miners northward from the first diggings on the Fraser into the Cariboo, but he chose to provide for miners, not join them. He and partner Philip Grinder established a series of stopping places, moving on from each one as soon as the miners moved on. The partners established their last stopping place at the head of Alkali Lake. They bought 500 Texas longhorns from a passing drover, and they were well established when the pre-emption was registered in March 1861. According

Putting up hay at the Alkali Lake Ranch. It used to take an army of men working all summer to put up one crop of hay. Today two crops are harvested by a small crew of men with a few machines.

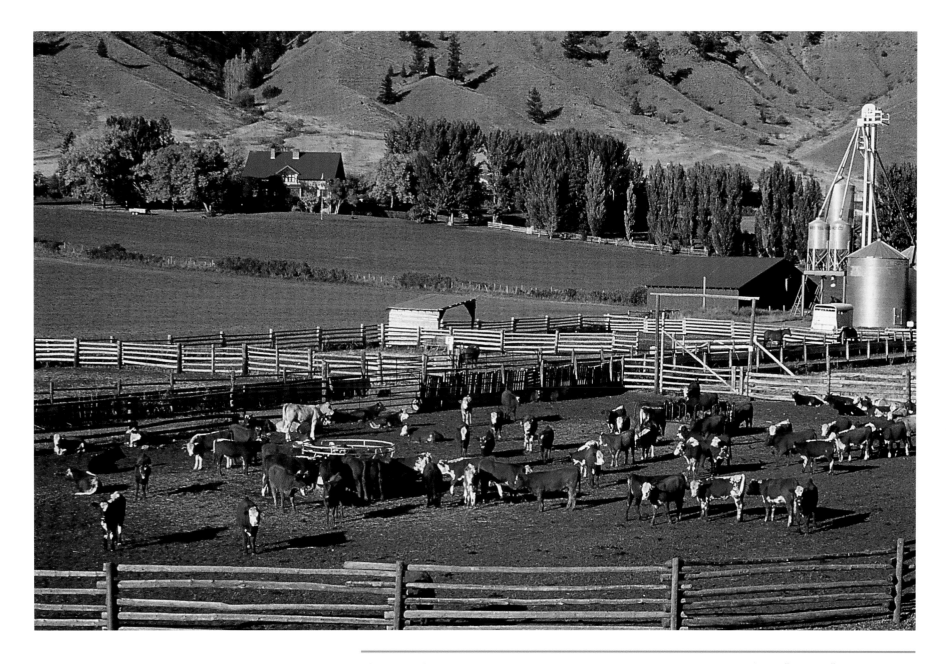

ALKALI LAKE RANCH, FALL. AMONG THE TREES IN THE BACKGROUND IS THE FOURTEEN-BEDROOM "MANSION" BUILT BY THE VON RIEDEMANN FAMILY IN THE 1940S. AT THE TIME THE LARGE, GRACIOUS HOME WAS THE TALK OF THE CARIBOO.

Kitchen Patrol

In the early days, most Cariboo ranches, even the small ones, had a Chinese cook/general factotum whose job it was to cook, chop wood, milk cows and do everything cowboys wouldn't do. (No cowboy would milk a cow—it was against some unwritten law.) The Gang Ranch crew once threatened to quit unless the manager fired the Chinese cook. They claimed, among other things, that he cooked the breakfast hotcakes the night before. The manager checked his books, and when he saw that the cook had been there for years and the crew for months, he told the crew they could go.

LOOKING AFTER THE LAND

The Mervyns were among the first ranchers in BC to finish their own calves. They brought in grain for winter feeding from the Peace River country and built a feedlot on a plateau away from Alkali Creek. It was a costly project but it ensures that the water quality of the creek will not be compromised by seepage from the feedlot. For the design and operation of this feedlot, they were given the 1996 BC Cattlemen's Association Environmental Award, presented to producers who use natural resource stewardship practices to enhance the environment. "We love this land," Marie Mervyn says, "and we want to stay on it, so we have to look after it."

perished. Martin's sisters and his widow Rebecca operated the ranch until it was sold two years later.

The buyers were Doug and Marie Mervyn, who had just sold their ski operation at Big White, near Kelowna, when they heard the ranch was for sale. Neither had a ranching background. They had developed the ski business and Doug had operated a successful Volkswagen dealership, served in the RCMP and acquired a commercial pilot's licence. But he had worked on a ranch as a youth and had always dreamed of owning one. The Mervyns visited Alkali and it was love at first sight.

They took over a well-run operation. Bill Twan, who had worked on the ranch for forty years and knew every inch of it, became ranch manager. Twan "knew cattle": like other cowmen he could single out an individual cow from a herd of hundreds and announce with certainty, "She's breachy like her mother." When asked to explain, such a cowman says, "They're all different, just like people."

In the early days, Alkali cattle rustled for themselves all winter on the low land beside the river. Cattle took a long time to fatten up then, and they weren't sold until they were three or four years old, but there were problems with this system. One deep-snow winter, Bill spent weeks shovelling snow by hand to clear enough grass for them.

Bill Twan was kind to his crew, but he didn't put up with any nonsense. "He was even nice about it when he fired you," one former Alkali cowboy recalls. When Bill retired, his son Robert ("Bronc") became manager. Bronc has a crew of up to eighteen cowboys and farmers. Along

ALKALI LAKE RANCH, THE FIRST CATTLE OPERATION IN BRITISH COLUMBIA.

with their other duties, Alkali cowboys spend a lot of time in the saddle, sometimes riding as much as 30 miles (48 km) in a day, checking the herd and inspecting the 385 miles (640 km) of fences. Calves are weaned and the cows pregnancy tested in the fall. Meanwhile, the farm crew have been busy irrigating and harvesting hay from the 705 acres (283 ha) of cropland. It took an army of men in Wynn-Johnson's day—cutting, raking, shocking and stacking hay. Now a small crew does the job, with the help of machinery, and they get three crops of hay from land that used to provide one.

With the cattle in good hands, Doug Mervyn focusses on the business end of the operation. With 40,000 acres (15,978 ha) of deeded land and 152,000 acres (60,705 ha) under grazing licence, Alkali is one of the largest in the province. Knowing that its continuing health as a business depends on the health of its grasslands, the Mervyns introduced innovative forage management practices, range improvement and preventative weed control methods to make the ranch a model of modern efficiency and land stewardship. Every development is undertaken with an eye to balancing environmental values with economic benefits. Controlling noxious weeds has gone hand in hand with reseeding the low-producing grasslands. Some 2,500 acres (1,000 ha) have been planted with crested wheat grass and alfalfa. Alkali Lake is not only a source of water for ranch irrigation, but also the site of the Martin Riedemann Wildlife Sanctuary, which was until 1999 the only feeding area for pelicans east of the Fraser River. A

pheasant population has also been established here, as well as quail and chukars.

Herefords were the breed of choice at Alkali for ninety years, but the Mervyns have developed a cross-breeding program. Some of the animals are sold in local Williams Lake markets, but until recently the bulk went to BC's only large slaughterhouse and from there to BC supermarkets. In January 2000, the slaughterhouse went into receivership, sending shock waves throughout the industry. Many ranchers had not been paid for the cattle they had delivered, and although the Mervyns were all right on that score, they had to find a new way to market. "We're being flexible," is how Marie puts it.

The Gang Ranch

The Gang Ranch once rivalled Douglas Lake for the title of biggest ranch in the province, but it was in a sorry state in 1989 when Larry Ramstad took over as ranch manager for the new owner, Sheik Ibraham Afandi of Saudi Arabia. Located south of Alkali Lake Ranch on the west (Chilcotin) side of the Fraser River, the Gang, probably named for the number of workers it took to run the place in the old days, has a rocky history. It has fallen on hard times twice, once in 1888 and again ninety years later. The ranch changed hands several times in the 1980s—twice in 1984 alone—and when the dust settled, Sheik Afandi was the sole owner. Some old-timers were convinced the ranch had a hex on it, but if there

TOP: KELLY BUELOW, A COWBOY AND POET AT ALKALI LAKE. HERE HE DRIVES A SILAGE TRUCK DURING WINTER FEEDING. BOTTOM: DOUG MERVYN, ALKALI LAKE RANCH, CHECKING THE BOUNDARIES OF THE FIELDS. UNDER AN AGREEMENT WITH THE MINISTER OF FORESTS, BC RANCHERS TRIM FOREST GROWTH AT THE EDGES OF THEIR MEADOWS AND OTHER OPEN COUNTRY. IF THEY DIDN'T, THEY WOULD LOSE AS MUCH AS 100 ACRES (40 HA) A YEAR.

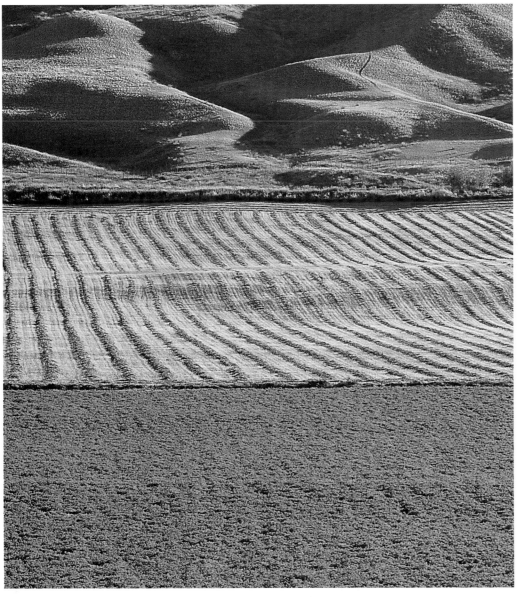

ABOVE: HAY MEADOWS AT THE GANG RANCH.
RIGHT: DON STEWART, MECHANIC AT GANG RANCH. THE LARGE RANCHES HAVE THEIR OWN MECHANICS,
WHO FIX EVERYTHING FROM TRUCKS TO BALERS TO BICYCLES.

THE UPS AND DOWNS OF A MAJOR BC RANCH

Jerome and Thaddeus Harper, the brothers who founded the Gang Ranch, were among the first batch of drovers to trail cattle to the Cariboo goldfields. Their first land acquisition was the Harper Ranch at Kamloops, and they went on to buy the Perry Ranch near Cache Creek, the Kelly Ranch near Clinton and land in the Riske Creek area. The brothers ran other businesses as well, and Jerome acted as a banker, there being no financial institutions in the Interior in the early days. Jerome went into partnership with the three Dutch von Volkenburgh brothers, who were running slaughterhouses and butcher shops, and between them they controlled the BC cattle market for the next twenty years.

Jerome died in 1874 and Thaddeus became sole owner of the empire. He gained fame in 1876 when he undertook a reverse cattle drive, trailing some 1,200 head of cattle to San Francisco, a trip that took eighteen months. In 1883 he completed the ranch's land acquisitions with land 50 miles (80 km) south of Williams Lake, which became the Gang's home ranch. Thaddeus's fortunes changed abruptly after that: he made some poor investments, defaulted on a contract to supply beef to CPR construction crews, then became incapacitated when he was kicked by a horse. Near bankruptcy, he sold the Gang in 1888; the bill of sale included 38,472 deeded acres (15,400 ha), 700,000 under lease (280,000 ha), and 7,000 cattle.

The new owner was the British-owned BC Land & Investment Company, making the Gang the only foreign-owned ranch in the province at that time. A subsidiary company, Western Canada Ranching, was created to operate it. Records show that the Chinese farmers and irrigators they hired were paid $25 a month; white and Native cowboys received $35 in summer and often worked for their board in winter. Old-timers claimed there were always three crews of cowboys at the Gang in those days: one coming, one going, one working.

The Gang Ranch was running 8,000 head of cattle in 1947 when two Americans, Bill Studdert and Floyd Skelton, bought it for $750,000. They had either inside information or incredible luck because they took over just as an American embargo on BC beef was lifted, and cattle prices jumped overnight by 10 cents a pound. Studdert was a canny businessman. He told his neighbour, Henry Koster Jr., "Never let money change hands between us or we won't stay friends." When Studdert died in 1971, Skelton and Studdert's heirs had to sell off large tracts of land, including the Riske Creek property, to settle estate taxes. It was the beginning of the Gang Ranch's downsizing.

The estate found a buyer six years later. The Alsager family of Alberta, who paid approximately $4 million for it, were the first Canadian owners in the ranch's history. Early in the Alsager era came a highly controversial attempt to raise plains bison, then a dismal family row that ended in the courts; finally there was a bank takeover in the fall of 1982. To recoup their investment and cover debts, the bank sold off more land, including both the Perry and Kelly Lake ranches.

was one, it was broken by Larry, a veteran stockman, and his wife Bev. They have brought the Gang back to its standing as one of BC's foremost cattle operations.

Even after the numerous land amputations, the ranch is huge—87 miles long and 40 miles wide (145 x 65 km), some of it owned, some belonging to the Crown. Along with some 3,000 Hereford/Angus cross cattle, there are more than 100 horses. They are necessary because parts of the summer range can only be reached by packhorses and riders stay out there for weeks at a time. Although the Gang's home ranch is a much smaller village now than it was in the old days, in summer twenty-eight employees still live there, including a cowboss, a ranch boss, a mechanic, two cooks and eight or ten cowboys. The farm crew, including irrigators, puts up 5,500 tons (5,000 t) of hay. Barley and alfalfa are grown on about 1,200 acres (480 ha) of farmlands, with some fields yielding one crop, some three.

The BC Cattle Company and Empire Valley Ranch

The history of the Koster family goes back to the early days of the gold rush when John Koster was one of Herman Bowe's partners. Years later his son Henry was Bowe's partner when the Alkali Lake Ranch was sold. In 1913 Henry returned to the Cariboo with a wife and family and bought the Crow's Bar Ranch at Big Bar Mountain. Over the years, in partnership with Mrs. Kenworth, he bought ranches

south of the Gang Ranch on the west side of the Fraser River, and the BC Cattle Company Ranch at Canoe Creek on the east side. The end result was a magnificent spread of some 50,000 acres (20,000 ha) with more than 3,000 head of cattle. When Henry died in 1947, his two sons took over management and bought out the Kenworth interests. They divided the property, Jack taking the Canoe Creek operation, Henry Jr. the land on the west side of the Fraser, which he registered as the Empire Valley Cattle Company. Their sister Dodie held a share in each. The BC Cattle Company is still in the Koster family. Jack has retired, but the ranch's management is in the capable hands of his son Warren. Jack has, however, a unique place in Cariboo history, and although his story is not well known, he played a major part in revolutionizing the industry.

After the Pacific Great Eastern Railway (PGE) was extended to Williams Lake in 1919, getting Cariboo cattle to market was simpler, but cattle drives had not been eliminated because the animals still had to hoof to the shipping point. Stock from the Gang Ranch/Canoe Creek area boarded the PGE at Chasm, halfway between Clinton and 70 Mile House. It was a good hike, but the cattle arrived there in fine shape. Unfortunately they were held overnight without food or water before being loaded into the PGE boxcars for the bumpy ride south.

The PGE did not go to Vancouver: its southern terminus was Squamish, and from there the boxcars were loaded onto barges, which were towed to Vancouver. Late trains and tides caused delays, keeping the cattle cooped up even

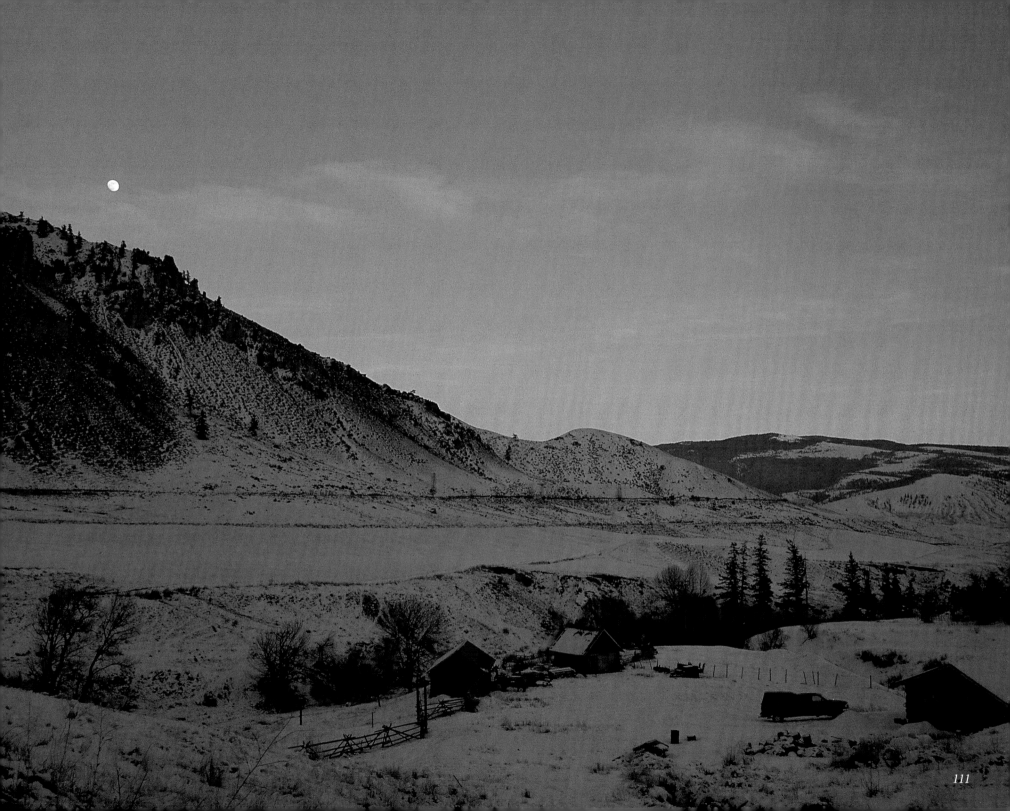

longer. Fall weather often caused rough water, which did nothing for the animals' well-being, and after some thirty-five to fifty hours en route, they arrived at the slaughter-houses dehydrated, battered, bruised and worth considerably less money than when they had started out. All of this was bad enough, but what really galled Jack was that Nicola Valley and Kamloops area cattle were riding the Canadian Pacific in comparative luxury and arriving in Vancouver in fine condition within a single day.

When PGE crews threatened to go on strike one autumn shortly after World War II, Jack was spurred into action. He owned pasture land at Rocky Springs, some 20 miles (32 km) from his home ranch and 34 miles (56 km) short of Clinton, and he decided to trail his cattle there, then haul them by truck to the CPR yards at Ashcroft. He put his idea to Fred and Lawrence "Baldy" Boyd, sons of Sam Boyd, the famous BX stage driver. The Boyds operated a garage and trucking business out of Clinton, mostly transporting fuels and supplies from the CPR station in Ashcroft to the PGE at Chasm, but Baldy had hauled bulls to and from the annual Kamloops bull sales, and he saw no problems with the idea. A truck could carry only eight or nine cows at a time, but they could make a number of trips.

They began loading early one crisp fall morning. The cattle didn't like any part of the operation and it took some time to get them aboard. Before starting off, the drivers waited for them to settle down. The trucks were light little things, a far cry from today's powerful cattle liners, and the roads were so potholed and winding the drivers couldn't

make good time without bumping their passengers around. At Ashcroft the animals were unloaded and poked into the boxcars. It was slow, but with the three vehicles running fourteen hours straight, they filled three cars with Koster cattle, which arrived in Vancouver in excellent condition.

Trucking didn't catch on immediately with other ranchers. Many who might have followed in Koster's footsteps couldn't because a trucking business required an initial outlay of cash, something that wasn't always handy, and conservative ranchers thought it would be too hard on the animals. But it was the beginning of the end for cattle drives in BC. Public works crews brought matters to a head a few years later when they began gravelling the dirt roads. Walking on gravel gives cattle sore feet and even the diehards had to give in. Other truckers went into the business, ranchers bought their own rigs, and soon every truck in the countryside was busy throughout the fall. By the 1960s, cattle hauling was an industry in itself, and the Boyd trucks—bigger and better all the time—were hauling cattle all over the province and to Alberta and the US. When cattle drives take place now, the animals are moving to or from the range, not to market.

The Coldwell Ranch

In 1913, when Harry Coldwell bought the Mountain House Ranch south of Canoe Creek in the Big Bar country, it included a thriving business that provided meals and overnight lodging for travellers on the stage run between

EMPIRE VALLEY/CHURN CREEK PROTECTED AREA

In the early 1990s the Churn Creek area, an ecological gem lying within traditional First Nations territory on the west side of the Fraser River near the Gang Ranch, had become an area of special concern to the province's NDP government due to it being one of the few remaining natural grassland habitats in North America. It is a spectacular landscape with rolling grasslands that seem to go on forever, mountains and hills, canyons and gullies. It has a bit of everything, and everyone—ranchers, recreationists, mining interests, Native groups—wanted a piece of it. To save it, in 1995 the Cariboo Chilcotin Land Use Plan (CCLUP), which had been developed with input by local resource user groups and individuals, designated it a protected area, and strategies were developed to maintain its special features while respecting local cultures and economic realities.

The CCLUP also recommended the acquisition of the nearby Empire Valley Ranch to add to the Churn Creek Protected Area. Empire Valley had been the property of Henry Koster Jr. until 1956 and since then had been bought and sold numerous times. When in 1997 it came into the hands of Vesco Contracting, a logging and ranching company from Prince George, and they began logging operations, the province stepped in to acquire it. Fortunately the Forest Renewal Fund had been set up by this time, and the government had this funding as well as land swaps to offer. It was the largest single land acquisition ever undertaken by the province to preserve grasslands, and it brought the total of the protected area to 90,000 acres (36,000 ha).

The Ministry of Water, Land and Air Protection manages the area, focussing on the protection of the grasslands—which includes blue bunch wheat grass, June grass, big sagebrush and prickly pear cactus—and wildlife, including spotted bats, long-billed curlews and California bighorn sheep. But their strategies also take into account range and grazing use, grassland conservation, eco-tourism, First Nations interests and recreation. From the neighbouring cattlemen's viewpoint, the most important outcome of this entire project is the fact that the Empire is still a working ranch. It is now operated by John and Joyce Holmes, who lease the land under stringent use rules for their cow/calf operation.

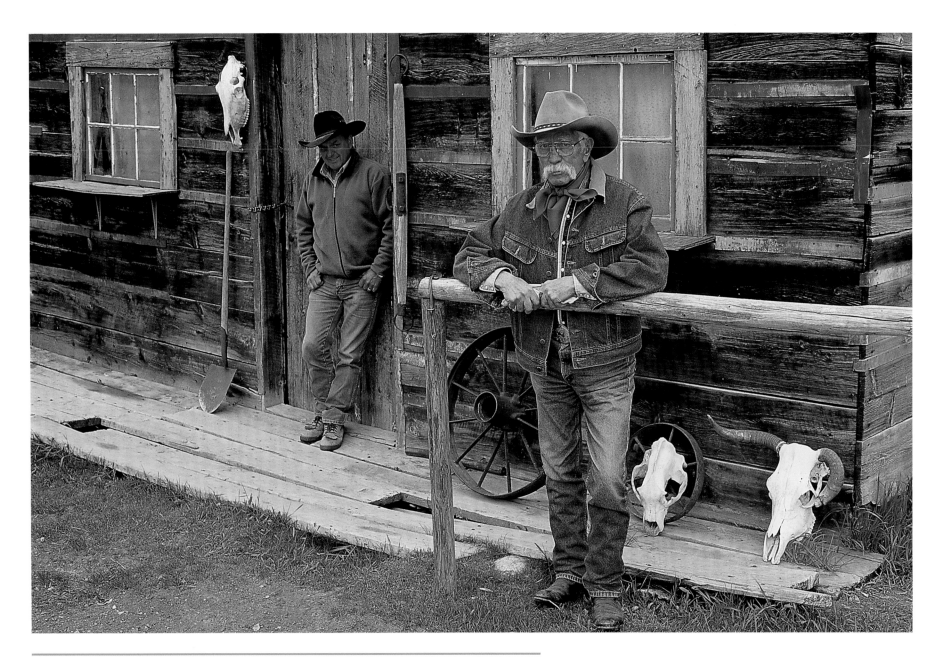

CHARLIE COLDWELL (LEFT) AND HIS FATHER-IN-LAW FRANK DRAYTON AT THE COLDWELL RANCH AT JESMOND.
THE RANCH BEGAN AS A STOPPING PLACE IN 1859 FOR PACK TRAINS HEADING FOR THE BARKERVILLE GOLD RUSH.

Clinton and Dog Creek. It had been started around 1859 by Herman Bowe and Philip Grinder. Coldwell was a carpenter by profession: some of his buildings in the Cariboo are still standing. In 1919 the Coldwells acquired a post office and mail route, but there already was a Mountain House post office, so they named theirs Jesmond, after Harry's home in England. Thereafter the ranch and stopping place were called Jesmond, and the road passing through the ranch became the Jesmond Road.

Harry's son Peter added a hunting camp and guiding business to the operation and became one of the Cariboo's better-known game guides. His territory extended into the Bridge River country and he kept horses at Empire Valley Ranch. Peter's son Ray now operates the guiding business, while his son Charlie and his wife Pat run the ranch.

"If I had a choice, I'd have taken land by the river," Charlie says ruefully. The Coldwell Ranch is on high ground, some distance from the lower, more friendly river land. Like many who ranch in the high country, Charlie favours Herefords. "Dad had shorthorn/Hereford cross, then straight Hereford," he explains. "Then we went to Hereford and Simmental, but now we're back to Herefords. They are just the best for this country." Other breeds don't know how to rustle, he says, and when the first snow falls, they head for the stack yards, where the winter feed is kept.

The Coldwells put up some hay and buy the rest from the Vanderhoof area. "With just the two of us, we don't have much time to do the farming end of it," Charlie says. "And, since we only get one crop, it doesn't make much sense to have a lot of money tied up in equipment." It was different for his dad: "There were eight of us kids to do the work."

The Coldwells start feeding around the first of January, and it's usually mid-April before the grass greens up enough on the lower range to turn the cows out. They range first on the low land, move up to the forest meadowland, then in summer head up to the alpine meadows. Logging has been a plus on this range because the clearcuts opened up the country and improved the land.

In years gone by, ranchers in the Big Bar area got together for branding and it was quite a gathering, but now the Coldwell calves are branded on the open range, where they are also ear-tagged—no more ear marks or wattles. Charlie carries a small rechargeable dehorner in his pocket and catches the little guys when their horns are small. Calves are weaned in November and sold the next fall. "At one time they were driven to Kelly Lake," Charlie explains. "Then buyers came to the ranch and the cattle were trucked out, but now they are trucked to auction at Kamloops or sometimes Williams Lake."

Both Charlie and Pat have worked with horses all their lives (Pat's family, the Draytons, are also Cariboo pioneers), and their daughter Lisa is a professional horse trainer. They run twenty horses, some saddle, some pack animals, and although this sounds like a lot of horses for a family operation, they use ten or twelve of them for the four-day pack trips they do in the summer for guests at the neighbouring Echo Valley Guest Ranch. Charlie has another occupation: he has driven the Big Bar school bus for twenty-eight years.

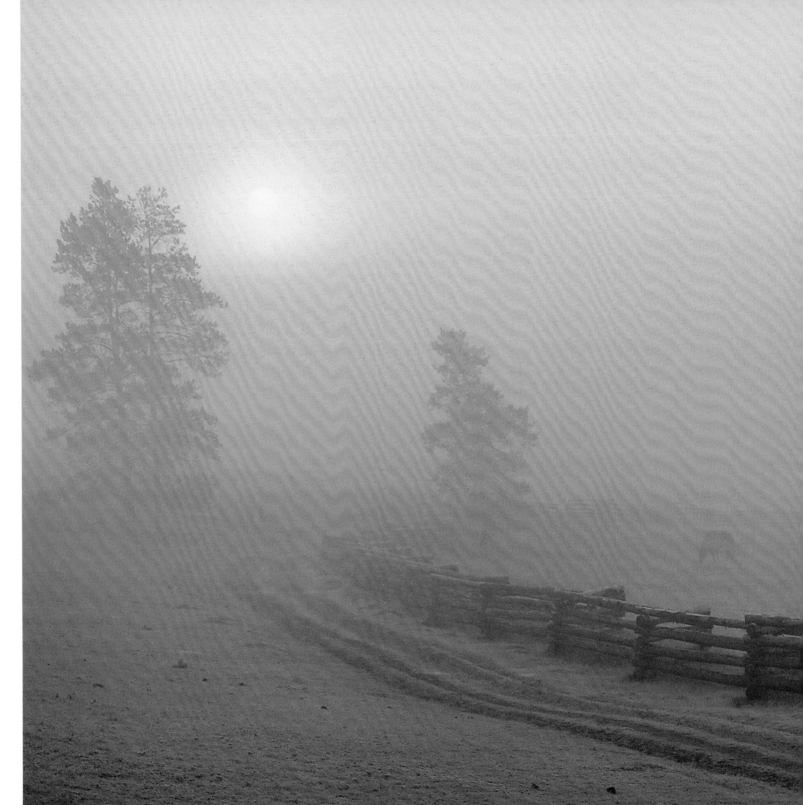

EARLY MORNING FOG IN THE
CARIBOO RANCHLANDS.

8 Along the Cariboo Road

Cariboo tourist promotions tend to focus on the gold rush, a momentous period in BC history, to be sure. And today the logging trucks that pound along Highway 97 between Clinton and Quesnel tell travellers that the lumber industry has become king. But the park-like meadows and open hillsides bordering the highway tell another story. This is cattle country, just as it has been since the early 1860s. The Cariboo is a huge area with almost every type of range—from semi-arid deserts to wet-belt forests, from swamp meadows to alpine meadows. Its rolling plateau is cut by several major rivers. Lakes, creeks and potholes are plentiful. And like the landscape, the people of the Cariboo are of infinite variety.

The Maiden Creek Ranch 4♡ C/D

The grandmother of all crabapple trees oversees activities at Maiden Creek Ranch. It stands in solitary splendour, keeping an eye on motor vehicles speeding by on Highway 97 between Cache

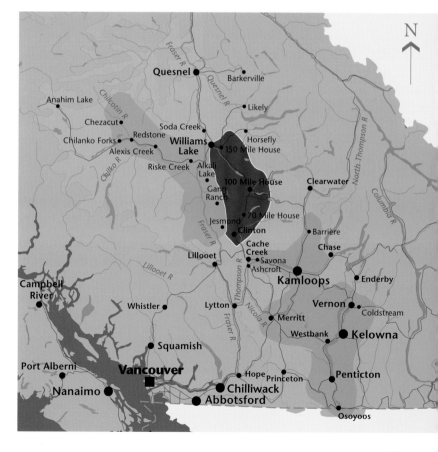

A CATTLEWOMAN'S SPUNK

When Charlie Dougherty inherited the Maiden Creek Ranch after his father Edward died in 1897, he was already well known as an exceptional horseman and considered by his peers to be "tougher than a boiled owl"—a compliment of the highest order. Charlie expected his workers, his animals, one son and his nine daughters to toe the mark. Family lore tells that when the phone rang, the girls were required to line up with their backs to the wall and not make a sound while he took the call. But Charlie Dougherty met his match when his son Charles married Helene, an Ashcroft schoolteacher with a mind of her own. He had never allowed his daughters any leeway and he was taken aback by Helene's spunk, but he ended up admiring her for it. As it turned out, she was to need that spunk. In 1973, five years after old Charlie died, her husband was killed in an accident, leaving her to run the ranch. Her two eldest sons—Chuck, age sixteen, and Ray, age thirteen—had always worked with their father, and they did the outside work while she managed the business side of the operation. In the 1970s ranching politics were very much a male affair, and when Helene became an area director for the Cattlemen's Association, she was one of two women in the group. "Having spunk" there was a decided asset. She also became involved in the Cattlebelles, a group affiliated with the Canadian Farm Women's Network.

Creek and Clinton, as it once watched the slower traffic on the Cariboo Wagon Road. The crabapple also keeps an eye on the Dougherty family, just as it has done since 1887 when Edward Dougherty planted it to mark the birth of his son Charles. Edward came to BC from the Isle of Man. He bought the property in 1862 from a pre-emptor and established a farm and a popular roadhouse, so the Maiden Creek Ranch is probably the oldest "century ranch" in the province.

Ray Dougherty, the fourth generation of his family at Maiden Creek, manages the ranch for his mother, brothers and sister. Fifth-generation Doughertys, including Ray's son Tyler, live there too. Maiden Creek is a traditional cow/calf operation with a value-added element. The calves have a winter job and are sold as long yearlings the next fall. Ray is a team roper and his partner Jody Ambler is a barrel racer, and when they were looking for ways to diversify, they came up with the idea of building an indoor arena where ropers, barrel racers and cattle penners could compete in the winter months. This is where the spring calves, husky seven-month-old animals by October, do their double duty. In June they go out on the range with the rest of the herd to fatten themselves up for sale in November.

Cattle penning, though relatively new as a rodeo event, has its roots in ranching, and it attracts contestants and teams from BC, Alberta and Washington state. The Maiden Creek arena, the only one of its kind between Williams Lake and Kamloops, is open from October to May. For ranching folk like the Doughertys, with their ongoing

HELENE AND CHARLES DOUGHERTY WITH SON CHUCK, 1959.

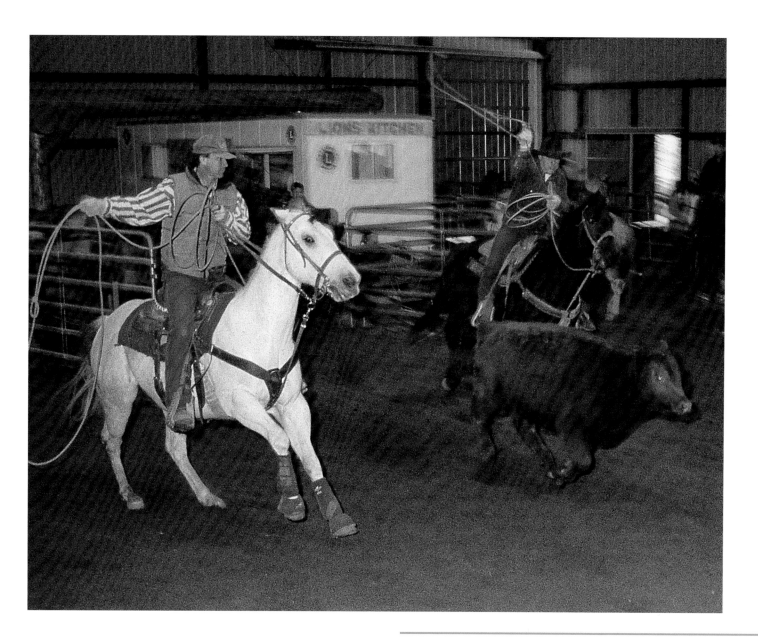

RAY DOUGHERTY AT THE MAIDEN CREEK RANCH. THE FAMILY'S INDOOR ARENA IS USED FROM OCTOBER TO MAY FOR CATTLE PENNING, TEAM ROPING, BARREL RACING AND OTHER WESTERN SPORTS.

rodeo interests, this is the best of all possible worlds because their arena operation fits right in with their ranching schedule. "We have to be here from fall to spring for feeding and calving, anyway," Ray explains.

Although he prefers an Angus cross, Ray has stayed with the basic Hereford herd his father preferred. The hayfields used to be irrigated by ditches, but now Ray usually hires a student to help with the never-ending job of moving irrigation lines. "When we put in the pipe irrigation, we missed the crabapple orchard," Ray says. The other trees died but the dowager crabapple survived to keep vigil over the passing scene.

The Horn Ranch AH

"A rancher has to be a farmer," says Helen Horn, "but a farmer isn't necessarily a rancher, and it isn't so much a matter of family farms as it is farming families." Helen and Chris Horn and their son Gus are a farming family, and their ranch in the Interlakes District near 100 Mile House is a certified organic farm. All crops and cattle are raised naturally—no herbicides, pesticides or fungicides on the crops, no growth hormones in the cattle. Animals that must have medication are separated from the herd.

The Horns weren't always organic farmers. They never used chemicals on their crops but they did use commercial fertilizers, some specially formulated for them. Then Gus came home from university with ideas of a better way to care for the soil. They started on a program of crop rotation, utilizing green crops and manure to replace the commercial fertilizers.

Organic farming—or, perhaps more correctly, natural farming—is labour-intensive, time-intensive, and "think"-intensive, and there are no instant magic results. The Horns grow barley, wheat and rye, although with an altitude of 3,200 feet (960 m) and a short growing season, their ranch isn't in what's considered grain-growing country, and their grain doesn't always mature. Cattle help fertilize the fields in early spring, but the Horns also buy chicken manure from the Lower Mainland. "They can't get rid of it down there," Helen explains, "and we have good use for it here."

Calves arrive in February and early March, not too long before the grass greens up, but while it is still cold enough to keep infection down. By the time the calves are branded and turned out with their mothers, it's time to start farming. The ranch has a modern and efficient irrigation system, but in 1999 it rained so much that they didn't use it once. On the other hand, all that rain meant that their usual crop and a half of hay and silage all had to go to silage, instead of just the half-crop. Another year the grain grew so high that the Horns' elderly combine couldn't cope with it.

By the time the crops are harvested, it's roundup time. It's also time to "turn over" the old crops and plant the green manure or "nurse crops." This intensive farming is all part of the good stewardship process, says Chris. "The land will co-operate if you treat it well." The Horns' yearling steers are sold in a variety of ways: some electronically, some through auction, some privately. They keep their

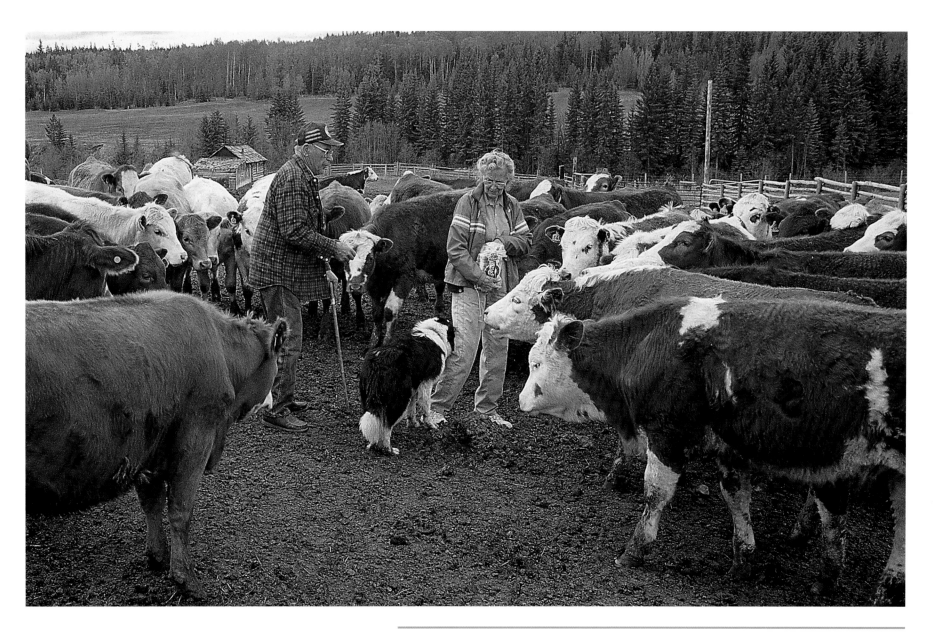

HELEN AND CHRIS HORN AT THE HORN RANCH IN SPRING. THE HORN CATTLE ARE SO GENTLE THAT THE RANCHERS CAN HANDLE THEM ON FOOT.

EARLY DAYS ON THE HORN RANCH

Chris Horn's arrival on BC's ranching scene is a snapshot of pioneer life. In 1922, when he was born, his parents operated a hotel at Lone Butte, a small community east of what is now Highway 97. Chris was born in Ashcroft; to get him home to Lone Butte, his mother took him to 70 Mile House by stage, his father met them there with two saddle horses, and the family rode the 20 miles (30 km) home, the newborn Chris in his father's arms.

As a young man, Chris worked for his rancher uncle; when the uncle died, Chris and his two brothers inherited the ranch. Chris was the one who stayed. He married Helen Granberg, the daughter of another Interlakes pioneer, and together in 1947 they acquired more land, including what is now their home ranch on Horse Lake Road. Only 10 acres (4 ha) of this new land was cleared, with the remainder covered in poplar and pine, considered little better than weeds in those days. They felled them, piled them up and burned them; today they would be logged and sold for a tidy sum. With the trees gone, they got to work grubbing out the brush and stumps to clear it for hay land.

yearling heifers. Feeding starts in the first week of October; soon after that, the calves are weaned.

The family has always had outside activities as well, Helen busy with 4-H clubs and the Interlakes Cattlebelles, Chris with cattlemen's associations, and Gus with the Cariboo Organic Farmers Association and the Agricultural Land Commission.

The Jacobson Ranch

Some ranches are situated beside Highway 97; others are on well-travelled secondary roads, still others are tucked out of sight on back roads. In the backcountry, nameless roads branch off who-knows-where. Few ranchers put their name on a gate and there are no mailboxes. Strangers are often confused when given directions to one of these places. "It's just a piece down the road; you can't miss it" can mean 3 or 4 miles down the road, and you can so miss it! Or they may be told, "Cross the cattle guard with the steel gate. If you get to the barn with the red roof, you've gone too far." Probably 3 miles too far.

The Jacobson Ranch in Beaver Valley is three roads off Highway 97, two roads off the Horsefly Road. Just keep left. Beaver Valley is a peaceful place, but seems lonely because many of the ranches are hidden away. Gloria and Bonnie Jacobson live at the end of one of these roads, and although their ranch is an hour's drive from Highway 97, it might as well be a hundred miles away—there isn't a neighbour in sight. There are no power lines to follow because there is no hydro on the ranch. Nobody was living on their homestead when hydro came to Beaver Valley some years ago, and the cost of running a line to it now is prohibitive. They have a telephone, but the line is buried so there is no sign of it.

The Jacobson sisters live on the land their grandfather took up in 1921. Antoine Jacobson was one of several miners who settled in Beaver Valley. They left their families on the homesteads during the good weather months while

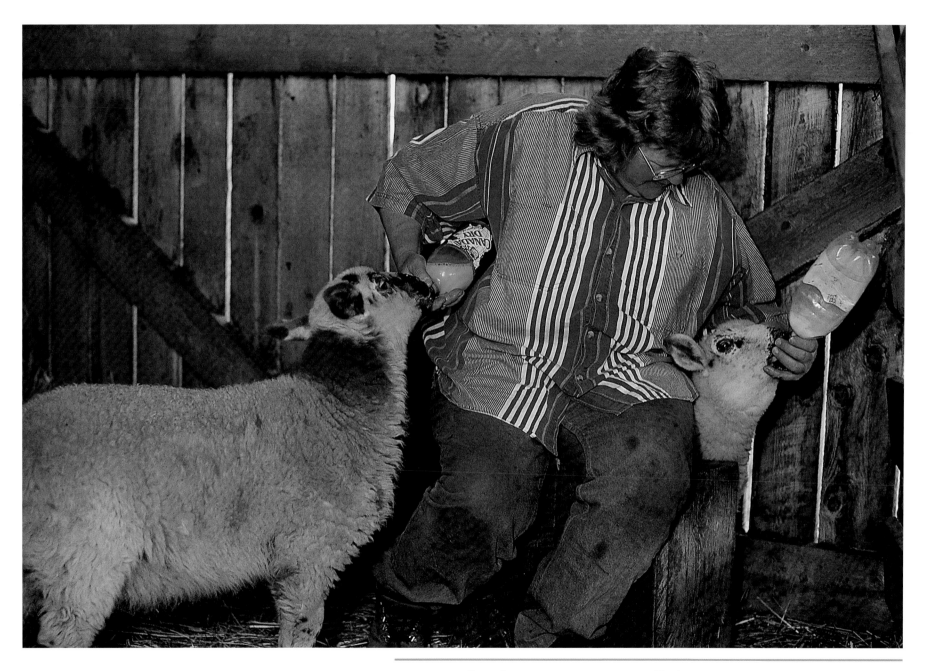

GLORIA JACOBSON BOTTLE-FEEDING LAMBS. THE JACOBSON SISTERS RAISE HORSES, SHEEP AND CATTLE.

they went off to work in the mines. When mining activity slowed down, the others packed up and left the valley, but the Jacobsons stayed. Antoine's son John inherited the land, and when he died a few years ago his two daughters remained there on their own. "Well," says Gloria, "not exactly on our own." She runs to the neighbours for help when she "gets stuck," but David and Susan Zirnhelt—their ranch is on a side road before you get to Jacobson's—say that doesn't happen very often. Between them Gloria and Bonnie take care of all the ranch chores. They run a herd of commercial cattle, and in calving season Bonnie keeps watch over the expectant moms, calling on Gloria for help if there is trouble. Gloria finds winter chores tiresome. As there is no shed for the tractor, starting it in cold weather is difficult, and sometimes it is afternoon before she can get it going with a tiger torch. "I put out lots of hay when I do get out there to make sure the cattle have enough to last in case I'm late the next day." Occasionally the sisters hire short-term help for chores such as haying, and a neighbour logged some bug-infested trees for them a few years back. Gloria is no slouch with a chainsaw. She does just fine cutting firewood, but she isn't strong enough to lug the saw around a logging project. "If I was, I would," she says.

The sisters also raise sheep. "We always had sheep for meat in the summer because the hay crews could eat a whole sheep before it spoiled," Gloria explains. "A beef was too big." They have a large garden, and they are known for their homemade bread: visitors in the know like to drop in on baking day.

The Jacobsons' cattle are used to people on foot, so they are gentle animals. So are their horses, who come when they're called. The sisters do a fair bit of riding, both for work and for pleasure, accompanied by an older trained cowdog named Tilly and a pup that arrived at Christmas 1999. Gloria is a crack shot and anything that bothers her animals is in peril.

Gloria remembers that when she was a child, before the climate changed, wild berries grew all over Beaver Valley and she and Bonnie went berry picking with the family. She didn't do very much picking, though: "I used to hide under the bushes and watch the grasshoppers making music," she says. When she has time, Gloria paints. Her work reflects her keen eye for detail and love of the natural world around her.

The Bear Claw Ranch

In 1990, when Kristy Palmantier and her late husband Gerry decided to go ranching, she headed for Olds College in Alberta to study ranch management, and Gerry went logging "to make the big money to get us started." Gerry's death from cancer a few years later left her with five children, some 2,000 acres (800 ha) of land, and a small herd of Charolais/Hereford/Angus cows. She managed on her own until a few years ago, when she teamed up with Ted Moses.

Kristy is a member of the Sukwekwin Band and her home reserve is at Sugar Cane, near 150 Mile House some 7 miles (11 km) from Williams Lake. Ted, a truck driver by

profession, is a member of the Shulus or Lower Nicola Band. Together they run the Bear Claw Ranch. One of their recent changes is importing Saler bulls from Alberta to breed with their black Baldy and Angus cross cows. Saler calves are long and lanky, making delivery easier, but they fill out nicely, selling at 550 pounds (250 kg) or more in September.

Salers are hardy in cold weather, but Bear Claw is in what Kristy describes as the banana belt—"We're the last in the area to get snow in winter and the first to have bare ground in the spring"—so the cattle can stay on the hay-fields in spring and fall. They put up round hay bales for winter feed.

They also raise horses, and both have rodeo back-grounds. Kristy is a former Williams Lake Stampede queen, and her daughter Davee is the fourth generation Palmantier to enter rodeo competition.

Small ranches are not economically viable, especially when they start up, so ranchers have to turn their hands to outside jobs to keep bread on the table. Kristy Palmantier and Ted Moses found their sideline at an unlikely place—a funeral. The family of a deceased friend made a sixteen-hour trip to Washington state to buy a custom-made casket because no one in BC carried the one they wanted.

Kristy was on maternity leave from her job with the Sukwekwin Band and had time to do some research. She and Ted got funding from the local Community Futures Development Fund to take courses in business planning and marketing, and Ted took an upholstery course and the

Master Woodsman program at Wood Enterprises in Quesnel. Kristy brushed up on her artistic skills.

They secured a start-up bank loan—not always easy for reserve residents—and Ted converted their garage into a workshop. Then BC Custom Wood Caskets went into busi-ness making pine and cedar caskets. Purchasers choose the artwork, lining and handles—horseshoes and deer horn are the most popular options. Their motto is: "With respect."

KRISTY PALMANTIER, BEAR CLAW RANCH. SHE AND HER PARTNER TED MOSES HAVE A UNIQUE SIDELINE: THEY PRODUCE CUSTOM-MADE COFFINS.

Fences:

KEEPING 'EM IN . . . AND OUT

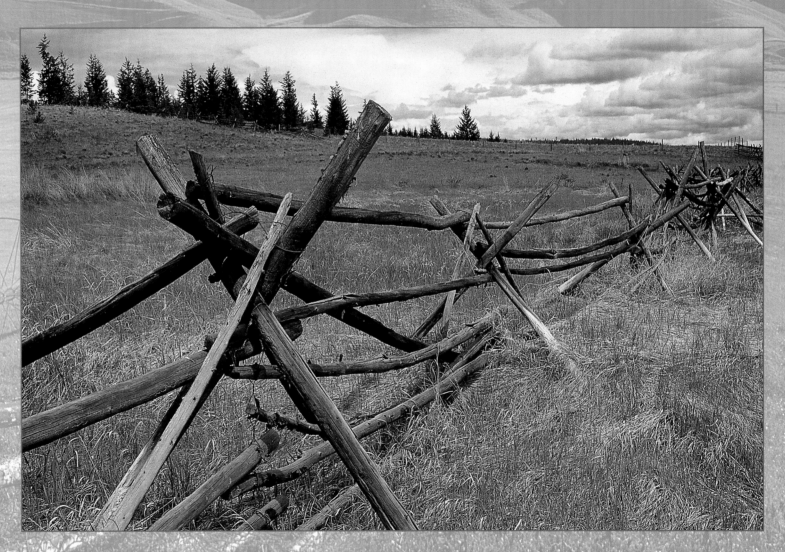

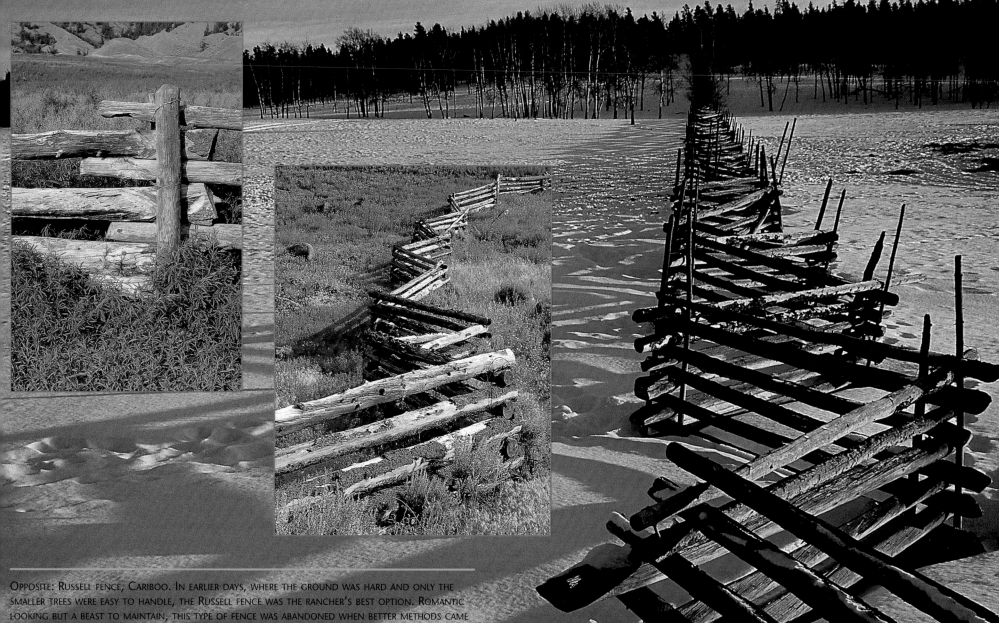

OPPOSITE: RUSSELL FENCE, CARIBOO. IN EARLIER DAYS, WHERE THE GROUND WAS HARD AND ONLY THE SMALLER TREES WERE EASY TO HANDLE, THE RUSSELL FENCE WAS THE RANCHER'S BEST OPTION. ROMANTIC LOOKING BUT A BEAST TO MAINTAIN, THIS TYPE OF FENCE WAS ABANDONED WHEN BETTER METHODS CAME ALONG, LEAVING ONLY A FEW SKELETONS. THIS PAGE: FENCES MADE FROM HEAVY LOGS LAST ALMOST FOREVER. LEFT TO RIGHT: A FENCE DESIGN THAT TOOK FEWER LOGS; A ZIGZAG "SNAKE" FENCE STILL DOING ITS DUTY (MOST WERE BUILT SEVENTY-FIVE OR MORE YEARS AGO); A SNAKE FENCE WHOSE CORNERS HAVE BEEN REINFORCED WITH STAKES TO KEEP THE TOP RAIL FROM BEING KNOCKED OFF WHEN MOOSE JUMPED OVER (A COMMON OCCURRENCE IN MOOSE COUNTRY). LOG FENCES TOO ARE A THING OF THE PAST AS THE BIG LOGS ARE HARD TO COME BY AND THEY ARE MORE VALUABLE WHEN SOLD AS TIMBER THAN WHEN USED AS FENCE LUMBER. MOST RANCH FENCES TODAY ARE MADE OF WIRE.

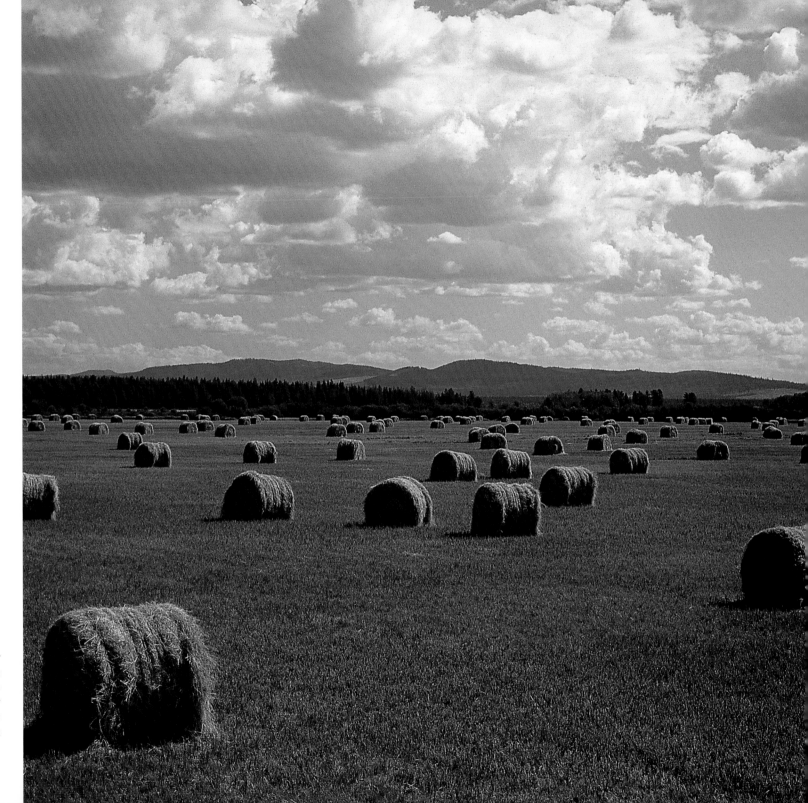

THE DIAMOND 4 RANCH, LATE
SUMMER. THE RANCH USES ROUND
BALES, AND THE HAYING CREW
CONSISTS OF ROY AND GWEN
MULVAHILL, OWNERS OF THE
RANCH, WHO DO IT ALL.

9 The Chilcotin

The Chilcotin country is so big, many say it is a state of mind, not a place. The vast plateau stretches west from the Fraser River for 300 miles (500 km) until the land rises to form the Coast Mountains, north to the Nechako Plateau and south to the Bridge River country. It is high country, wild country, good for raising kids and cattle and horses and, some say, not much else.

The Mulvahills ⌒ ∿ ◇4

Randolph Mulvahill, a man in his eighties, is the classic Chilcotin cattleman. He has always dressed "western"—shirts with snaps, snug jeans, short jean jacket, cowboy boots and a cowboy hat. He has the rolling walk of a man who has spent more time with his seat in the saddle than his feet on the ground. He is a big man and a strong one. It took a brave cowboy to cross him in his younger days.

He was born and raised at Chezacut, one of the handful of people who can make that claim. Chezacut is at the end of one of Chilcotin's back roads, some 20 miles (32 km) off Highway 20, about 144 miles (240 km) west of Williams Lake. With its willow-winged meadows lush with natural grasses and its undulating hills studded with jackpine and aspen, it is perfect cattle country. Randolph's father Charlie Mulvahill, a horse trader and freighter from south of the border, arrived in the Cariboo in the early years of the twentieth century. He met two Chilcotin pioneers,

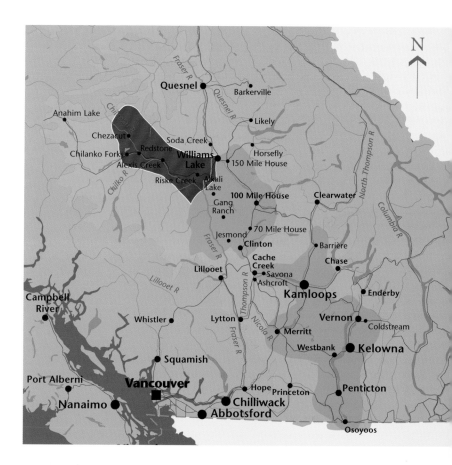

Will and Fred Copeland, married their sister Martha and settled in Chezacut around 1914. He raised cattle, but he was better known for his horses. When he and Martha retired, Randolph and his older brother Bill kept up that tradition, raising top-notch horses and becoming top-notch riders. Mulvahill horses were immortalized in a rodeo song written by Allan Moberg, with the line: "Those broncs of Mulvahills will always give you thrills."

Randolph kept the Brush Meadow part of the original ranch and renamed it Spade Ranch. He was saddle bronc champion three times at the Williams Lake stampede, and when his five sons were in their teens, he had them stage impromptu rodeos for the neighbours on Sunday afternoons. None of the boys stayed with it, but grandson Lance did, and he places in the top ten on the professional circuit. Randolph sold Spade Ranch to the Nature Trust in 1980 and the huge hay meadow is now a Ducks Unlimited waterfowl project. He and his wife Cathy retired to Alexis Creek.

"Wild Bill" Mulvahill and his first wife Vi raised three sons and two daughters on their ranch, Char Meadow. With his second wife, Mary, Bill raised another four sons and two daughters. Bill was also a rodeo star, and his sons all rodeoed at one time or another. His widow Mary and son Will operate Char Meadow, and true to tradition, Will raises horses as well as cows, and he rodeos.

Bill's eldest son Roy and his wife Gwen have operated the nearby Diamond 4 Ranch since 1964. Roy must have a horse tied to his family tree, because although he and Gwen run about 180 head of cattle, they specialize in horses. "The

Left: Roy Mulvahill, Diamond 4 Ranch. He and his wife Gwen specialize in buying, selling, raising, training and riding horses. Right: Cameron (background) and Alissa MacDonald boarding the Chezacut school bus. For children, part of ranching life is the commute: going to and from school can take a couple of hours every day.

cows don't really pay their way," Roy says. "There's no way one crop of cows will ever pay for a new tractor." They have about eighty horses, which they raise, sell, buy, trade, train, shoe—Roy can shoe about six head a day—and, of course, they ride them. Dual- or triple-purpose horses are in demand today, Roy says. His customers want a medium-sized horse that can pull a wagon or a sleigh, can be used for packing and can be ridden if necessary. Roy's pride and joy is a magnificent matched pair of Belgians, which are the envy of every horse lover who spots them. One fellow who saw the team in Williams Lake drove all the way to Chezacut to offer $20,000 for them. They aren't for sale.

Roy competed in rodeos when he was younger—bronc riding, of course. He has been on the wrong end of a horse on numerous occasions and was out of commission for a year after a horse kicked him in the head. For some years he and Gwen contracted stock to rodeos, even trailing broncs across the wild backcountry to the Anahim Stampede for a few years. Their three daughters are all involved in rodeo and Roy keeps his hand in managing local rodeos.

Along with ranching, Roy and Gwen guide hunters into the Itcha Mountains, taking the saddle horses and three or four horse-drawn wagons to their base camp. One group of hunters has returned every year for thirty years, but Roy notes younger people "aren't so much into hunting these days." The Diamond 4 also organizes wagon train expeditions of up to thirty wagons for treks through back-country to Quesnel for Billy Barker Days or to Williams Lake for the stampede.

The Chezacut Ranch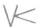

Ollie Knoll held the reins at Chezacut Ranch for over half a century. He held them tightly until he died in 1999. He was typical of the ranchers of his era. Fiercely independent, he brooked interference from no one. He considered the land to be his, and what he did with it and on and to it was nobody's business but his own. Government officials seldom saw it that way, but Ollie won most disputes.

His parents, Arthur and Anna Knoll, settled at Chilanko Forks in 1912. They bought the Chezacut property (pre-empted by Will Copeland around the turn of the century) so that Ollie and his four siblings could go to school. In 1947 they bought the adjacent Maxwell ranch. When Ollie and his brothers, Max and Alfred, took over operation of the ranch in 1947, it was running 1,000 head of cattle, 100 horses and some sheep. Max was killed in a bulldozing accident a year later, and Alfred sold his shares to Ollie.

Ollie had a dream to have his own hydro system, and he began collecting bits for it in the 1950s. It was a massive undertaking that included damming a creek 6 miles (10 km) from the home place. He didn't bother getting government permission: Chezacut is so far off the beaten track it was a done deal by the time officials found out about it. Whenever they dared make a suggestion regarding his dam, Ollie threatened to let the water behind it go all at once and flood the countryside. There have been major battles with bureaucrats and beavers since then, but the

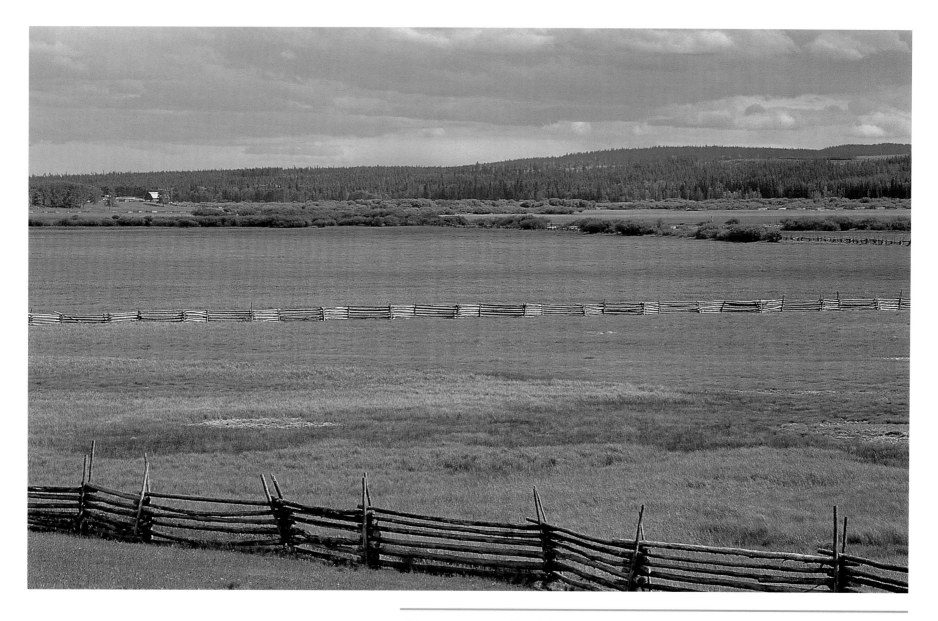

THE MAIN HAYFIELD AT KNOLL'S CHEZACUT RANCH IS ONE OF THE LARGEST NATURAL MEADOWS IN BC. IT IS ABOUT 8 MILES LONG AND A MILE WIDE (13 X 1.5 KM). IN SPRING IN MOST YEARS, THE CHILCOTIN RIVER FLOODS THE MEADOW, PROVIDING NATURAL IRRIGATION AND FERTILIZER.

FAY AND HER WATCHCALF

When Fay MacDonald was growing up on Chezacut ranch, she was the cow milker. The cow milker got to keep any orphan calves, and Fay kept one orphan named Buster until he was over twelve years old. Buster was huge. His horn spread was 3 feet, and while he didn't mind kids riding him, his horns would send them sailing when he turned his head. He spent most of his time hanging around the ranch house door, and he was an excellent watchdog—strangers mistook him for a Texas longhorn bull. Fay sold him to the Gardner Ranch in Merritt, where he was on show for some years.

ranch has benefited from one of the largest privately owned hydro systems in the province.

In 1951, when Ollie built a freezing plant, he accidentally inhaled ammonia fumes. He spent the summer in hospital and came home that fall with a new 5-ton GM cab-over truck and plans to haul his cattle to Williams Lake. After a few trips over the dirt road, he realized the truck ride was too hard on the animals and he went back to driving them in the old way. But he made his last drive in 1960. The gravel roads were so damaging to the animals' hooves that Ollie went back to trucking.

Ollie wasn't much for show, so strangers never dreamed he owned one of the bigger ranches in the Cariboo. He didn't like "giving money" to big corporations, so he would buy a brand-new piece of equipment and keep it. Forever. The cab-over still runs, and a thirty-year-old Versatile tractor sees service every summer. It still has its original tires. Ollie's wife Mary had one of the first sedans with an automatic transmission; she drove it for twenty years. Ollie liked bulldozers. If there was earth to move anywhere, he wanted to move it. He started with a Cletrack (bulldozer) in the 1940s, then graduated to a D7 and worked that until he was eighty-four. Ollie was a skilled blacksmith, and as he acquired machines he turned his talents to keeping them in running order. He made his own tools and parts and never threw anything away. He paid for everything up front and salespeople who didn't know him were startled when he wrote a cheque for a honking great sum or pulled hundred-dollar bills out of his shirt pocket.

A few of his projects bombed. During the Depression he trailed 200 two-year-old steers some 150 miles (240 km) through the bush and down the mountains to Bella Coola to ship them by scow to Vancouver. He lost money on that scheme and didn't repeat it. In the 1950s he owned a meat plant in Williams Lake, but it burned down. He rebuilt it, then sold it.

Other projects took time. His long-term plans included piping water to the home place from a spring on the Maxwell place, but the pipeline had to cross 3 miles (5 km) of hay meadow. The ditch couldn't be dug in winter, or during spring flood, or in summer until after the hay was cut. In the fall everyone was too busy. Consequently, the pipeline took five years from start to finish, but the end result was an excellent gravity flow system.

Mary Knoll didn't do outside work on the ranch. In the early days her job was feeding the crew year-round, with an extra twenty haying hands in summer—three big meals a day for each person. Before refrigeration, meat was scarce on the ranch in springtime, but Mary was good with sauces: she could make a tasty meal out of sprouted potatoes and spam. She was never caught without vital pieces of equipment, and no matter what anyone needed, be it felt innersoles or lighter fluid, she always had it on hand. Except for one thing. "If anyone wanted tobacco," she says, "they were out of luck."

Shortly before he died, Ollie put the ranch up for sale. Mary and their four daughters, who share ownership, have not taken it off the market. Their second daughter Fay MacDonald and her partner Bill Coulthard have been working on the ranch for more than twenty years. Son Kyle, who is at university and intends to be a veterinarian, was raised on the ranch, as was Fay's older son Fred, who joined them a few years ago. "It is hard to find anyone to work here," Bill comments. "If we weren't family, we probably wouldn't either." Chezacut Ranch is a good two-hour drive from Williams Lake, more when the roads are bad, making it too isolated for most people. Other than trips to town, usually on ranch business, they work six, sometimes seven days a week. Holidays are taken between turning out in June and haying in July.

Even though Ollie sold the Chilanko property in 1970 to the Second Century Fund for a Ducks Unlimited marsh project, Chezacut Ranch still covers some 4,000 acres (1,600 ha) of deeded land and one lease. It is a lemon-shaped territory, 67 miles long and 29 miles wide in the centre (112 x 48 km). No one knows how many miles of fence it has, but there is not a single strand of barbed wire on the place. It is all log, much of it dating back to the original pre-emptions. There are good reasons for this. Log fences require trees, manpower and some wire to secure the top rails so moose won't knock them off. Barbed-wire fences require wire, posts, post holes, nails or staples, and a great deal of manpower.

The ranch winters some 1,500 head of cattle, a basic Hereford herd crossed with Shorthorn. Branding is still done the old way, using the 100-year-old Chilanko brand—15—on steers, Chezacut's V, Lazy V on everything else.

There is no farming. The Chilcotin River floods the natural grass meadows in spring, taking care of both irrigating and fertilizing the hay crop of wild sedge, timothy, red top and meadow foxtail. Around the end of July the grass is tall enough and the weather congenial enough for haying to

begin, and a crew of five can put up the 4,000 tons (3,600 t) required for overwintering—as long as the weather cooperates. While most ranches now use round bales, true to Ollie's credo that "if it isn't broke, don't fix it," Chezacut still uses equipment that puts up bales that look like loaves of bread. These bales use no string and are easy to feed out, but if a wind hits before they are stacked, the hay blows all over the place and retrieving it can be a lengthy chore. Feeding at Chezacut begins around the end of December and ends in May or early June, when the high grass country greens up. Fay can remember running out of feed only once.

When turned out in the spring, the old cows know where to go and the heifers follow. The bulls are escorted out later. When leaves and temperatures fall, most of the cows come home. They don't exactly wag their tails, but they know feed awaits them at the home place. It can take weeks of riding to find the stragglers and get the bulls in. Chezacut Ranch has only a few saddle horses because they use ATVs and snowmobiles for many chores.

The Rafter 25 Ranch

While Chezacut Ranch is a traditional BC cattle ranch, some 20 miles (32 km) down the road at Redstone, the Rafter 25 Ranch is anything but. In fact, it is probably the most revolutionary operation in the province, and its owners, Felix and Jasmin Schellenberg, surprise traditionalists because they do everything "wrong" and it works.

COMING HOME

Fred MacDonald was raised mostly at Chezacut with time away for school in Williams Lake, but he left the ranch for the big money to be made in logging. The big money was there all right, but the jobs took him farther and farther away from his family, and when he came home after one stint, his wee daughter didn't know him. "That did it," Fred says. "What's the point of making money if your kids don't even know you?"

When Fred and his wife Laurie sat down to figure things out, they discovered Fred was working as much for his stroke delimber as he was for himself. "I was putting in sixteen hours a day, seven days a week. The cheques looked good but between the bank and the insurance company, I was paying out $30,000 a year."

He was as glad to get back to Chezacut as his parents and grandparents were to have him: "There is no way to get bored on a ranch." While there was always plenty to do, most of the time he could choose when to do it— except in haying time. At Chezacut, there was hay to cut every day the sun shone. He spent at least two months out of the year riding. "And that means all day in the saddle—in the spring chasing the cattle out to make sure they go where they're supposed to be, and in the fall making sure they all get home." In between, he rode out to check that all was well with them because bears, wolves and cougars are a problem in the backcountry.

Fred and Laurie agree that ranch life is best for their kids, but not necessarily easy. Cameron, age sixteen, and Alissa, eight, had to be on the school bus every morning at 7:00 a.m. for the trip to Alexis Creek and didn't get home until 4:30. Then the school bus stopped coming to Chezacut, and buyers were showing interest in the ranch. It was the end of ranching for the MacDonalds and back to logging for Fred. At least for now.

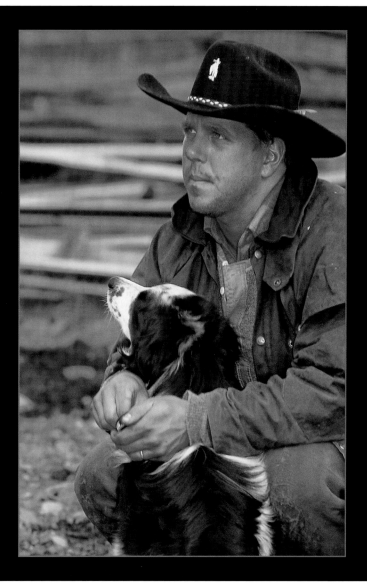

The Schellenbergs are a Swiss couple who discovered the Chilcotin in the 1970s; in 1979, with their partner David Altherr, they bought the Ross Ranch, established by Ralph Ross and his partner John Henderson in 1902.

It had been run by Ross's sons until 1970. The Schellenbergs began ranching traditionally, but along the way they realized they weren't in control of their lives, the ranch was. They enjoyed the ranch lifestyle but they knew there had to be a better way to achieve it and still keep the ranch profitable. At this point Felix, who had studied agriculture in Olds, Alberta, was attracted to Stan Parson's *Ranching for Profit*, which describes a system of ranch management that focusses on developing economically and ecologically sustainable ranching businesses.

"It didn't make sense to us to have expensive farm equipment sitting idle for most of the year," Felix explains, so instead of putting up their own hay, they looked for someone to share haying equipment. When that didn't work out, they hired Cariboo Custom Silage to put up winter feed for them. The company went out of business a few years later, so they began buying hay from a Vanderhoof supplier and using their own uncut hayfields as pasture. Originally they bought hay in square bales but they switched to round ones, which require less handling. Truckers deliver it close to where the cattle will be eating it. At their request, the supplier ties the bales with sisal string instead of the non-biodegradable plastic commonly used.

Although the Schellenberg ranch sees green grass a few weeks before Chezacut does, some of the coldest winter temperatures in the province have been recorded at Redstone. Historically the cattle had been fed for 150 days in winter; the Schellenbergs have it down to 70 to 80 days. They've done it by putting the cattle onto the hayfields to graze as soon as they return from summer pasture. Left on their own, a herd of cows will tramp the grass down and waste it, so grazing is controlled by fences, most of it electric. The cattle tend to pig out for the first few days, so they have to work harder for the grass that is left before they are moved to the next section of pasture. They can graze in fairly deep snow as long as there is no crust on it.

When it comes time to feed the cattle in January, cattle dogs are used to escort them to the feeding area where hay awaits them, then to water, and finally back to their living quarters, where they can still rustle if they want to. The pastureland is enriched by having the cattle on it all winter because cows are walking fertilizer machines, and the manure, combined with leftover fodder, makes commercial fertilizers unnecessary.

The Schellenberg cattle are British breeds, but "as long as a cow can live on grass and do well, she is welcome here," Jasmin says.

Jasmin discovered Rafter 25's major innovation at a 150 Mile House ranch, where she saw New Zealand Huntaway dogs performing. After investigating further, the Schellenbergs hired two New Zealand shepherds and imported their dogs, which included the Huntaways and New Zealand heading dogs, which are similar to border collies but capable of working over greater distances. They

AKBASH DOG AT WORK ON THE RAFTER 25 RANCH. THESE GUARDIAN DOGS WATCH OVER THE CATTLE, GOATS AND CHICKENS, AND KEEP THE WOLVES, BEARS AND COUGARS AWAY.

can also work on their own, sometimes a few miles away from the herder. Now the two men, each with six dogs and four horses, can herd 800 cow/calf pairs and 300 yearlings over a range of 150,000 mostly forested or clear-cut acres (60,000 ha). One of the benefits of this system is that fewer fences are required because the dogs keep the cattle grazing where the herder wants them to be—away from riparian areas—and moving so they don't overgraze one spot. In this way the available forage is used to its full potential but in a sustainable way without environmental damage.

The Schellenbergs also employ Akbash dogs as guardians on the ranch. Two of these large white beasts guard yearlings pastured some distance from the ranch house. One of them stays in the middle of the herd, the other circles the perimeter. Two more Akbash mind the ranch's goat herd, one looks after the chickens, and two are in charge of general ranch security.

Felix and Jasmin have a few more revolutionary ideas. They time calving for June when the mothers have been on green grass for some weeks and are therefore healthier before giving birth. They have had the grass on their ranges tested so they know what supplements to use. Felix, who has taken courses on cattle nutrition, points out that it is not economically sound to cheat cattle on minerals. The couple's long-term plan is to run the goats with the cattle on summer range to take care of brush encroachment on the grassland. There is also a growing market for goat meat in the lower mainland.

GRASS-FED BURGERS

Grain-fed beef came into demand because Alberta had a glut of grain, not because consumers—or cows—demanded it. Smart public relations types convinced consumers that grain-fed beef was good and grass-fed beef was bad. That was the end of ranch-to-packer production in BC, because it was cheaper to send animals to Alberta to be finished on grain and slaughtered there than to bring grain from Alberta to BC. Most BC packing plants went out of business.

Felix and Jasmin Schellenberg of the Rafter 25 Ranch think the time has come for grass-fed beef to get back in the picture, and they sell their grass-fed meat to the Laughing Loon. This popular Williams Lake pub advertises hamburgers made from "pasture-to-plate" beef raised on Chilcotin valley grass produced "on clean soil, clean water and sunshine."

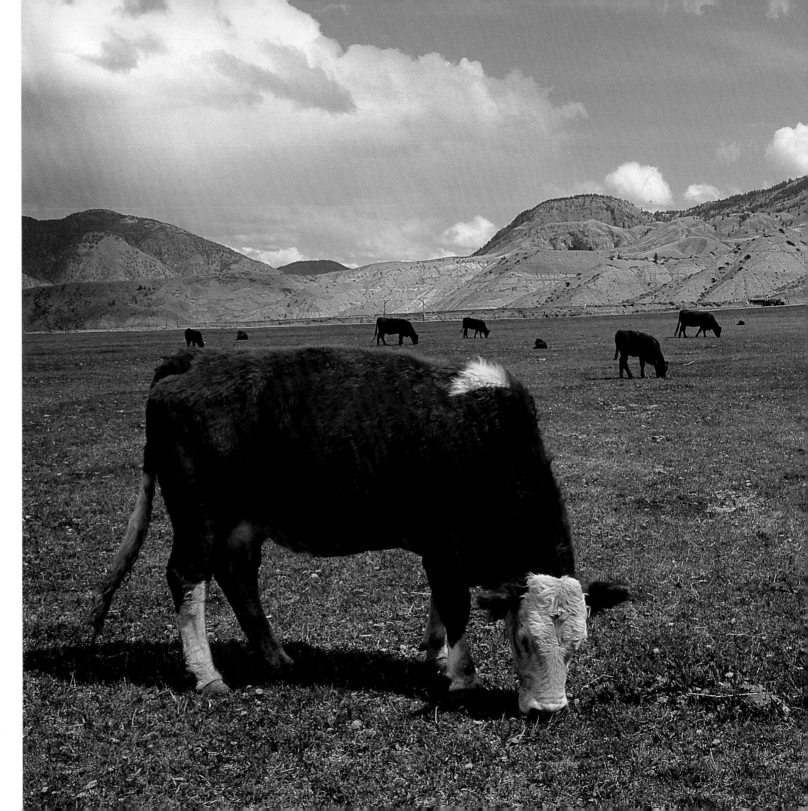

HEREFORD AT WATSON BAR RANCH.

Riding into the Future

*I*n cattle country there's a joke that goes: "What would a rancher do if he won a million dollars in a lottery?" The answer: "Keep ranching until it was gone." Ranching is a long-term investment. There are no quick returns. No one has found a way to guarantee that every cow will be a good mother, that a bull's performance will warrant his price or that the weather will co-operate. Cattlemen are making better use of land than ever before but the weather can louse up the best-laid plans. An early winter, an especially cold winter or a late spring can upset the feeding schedule. "We've been hailed out," says Cariboo rancher Helen Horn, "flooded out, frozen out, dried out and wiped out."

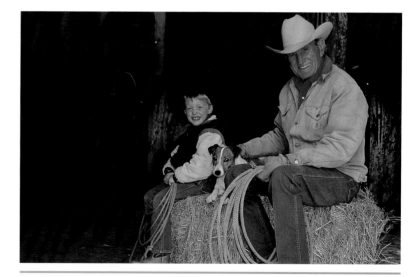

ROY WILLIAMS, RETIRED COWBOSS AT QUILCHENA WITH JAKE ROBINSON, WHOSE DAD ALEX TOOK ROY'S PLACE.

When it comes to return on investment, raising cattle is a pretty poor show. Money put into other industries can return 15 to 30 percent; ranching returns can be more like 3 percent, and most years the dollars tied up in land, machinery and basic herd would earn as much in a piggy bank. Cattle prices fluctuate, but overall they have not kept up with the cost of everything else. In the 1950s, Nicola Lake rancher Gerard Guichon bought a Buick sedan for family use. It sold for an average price, and it cost him 16 steers. In the 1990s his son Laurie bought a Suburban—also in the middle price range—and it cost him 60 steers. In 2001, when cattle prices were at the peak of the cycle and higher than ever, a mid-priced vehicle cost 30 steers. To quote Helen Horn, "Ranchers are expected to raise safe food and look after the environment, but people aren't prepared to pay for the product."

BC's Agricultural Land Reserve was designed to protect farmland, but it is not always up to the task, and nowadays ranchers wanting to expand their operations or start new ones are hindered by land prices jacked up by developers' insatiable demands and city folks' hunger for country retreats and hobby farms. The ranching community has no quarrel with wealthy businessmen who buy ranches because these "trophy ranches" are well managed and are an asset to the community. At the other end of the scale, it is difficult to distinguish between hobby or "pavement" ranches whose owners have no interest in the industry and owners of small-scale commercial enterprises that do. One might have cows for tax and lifestyle purposes, another

might be building up a herd. There are many more small ranches than there are self-supporting operations: it takes a herd of 250 cattle to support a family. Any less and someone in the household needs an outside wage or the ranch needs a very profitable sideline. At around 400 head, the ranch needs outside help, or, as one rancher said with a straight face, "a very hard-working family." (It is considered poor manners to ask the size of a ranch's herd, because if you multiply the number of cattle by $500 you are close to knowing the ranch's income.)

Ranchers struggle constantly with government bureaucrats wielding one-size-fits-all (or "pantyhose") regulations. Ranchers say they know their land better than anyone else does, they believe they are doing a good job caring for it and they would like to be left alone to do it. For instance, most cattlemen dislike arbitrary dates for range use. "No matter what month it is," Charlie Coldwell says, "if it's too dry, the cows will mow the grass down and the weeds will come. It should be left to the individual ranchers to decide when cows go out or come in. We don't put them out there to lose weight. In a wet summer they could go out earlier." Harold Steves agrees. A few years ago, two of his yearling steers went missing in the fall. They turned up in the spring as fat as butterballs, obviously having "found enough feed somewhere to do them."

Ranchers used to have major fights with forestry officials over the custom of burning old grass in the spring to hasten new growth. When forest policy prohibited the practice, some ranchers, including Ollie Knoll, kept doing

it anyway. Officials blamed him whenever they saw smoke rising over Chezacut, but they never actually caught him in the act. Now controlled burning is considered a useful tool in grass management. Protection of riparian areas is another sore point. One rancher was taken to task because his cattle were roiling a stream as they crossed it. As this particular crossing was used regularly by a nearby guest ranch for its trail rides, no one could know whose hooves were doing the roiling.

Overenthusiastic environmentalists are another irritant. Becher's Prairie near Riske Creek is a prime ornithological research area. Local ranchers gather their herds in one area prior to turning them out on summer range. One spring researchers arrived at the same time as the cattle; fearing for the safety of nesting birds, they chased the cows away. Cattle have been gathered at this spot for a few days every spring for over a century without any noticeable damage to the bird population. Chris Howarth, one of the cowboys who spent an extra day rounding them up again, was philosophical about it. "If you got mad every time something like this happens, you'd stay mad a long time. It's better just to shake your head and keep going."

Hunters, four-wheelers, snowmobilers and roaming tourists can wreak havoc. Seeds of the dreaded knapweed can hitchhike to new homes on wheels, boots and pant legs. Discarded plastic bags are a menace to calves, many of which eat anything that comes their way. Some backcountry travellers ignore the code of the west, which says leave a gate open if you find it open, close it after you if you found it

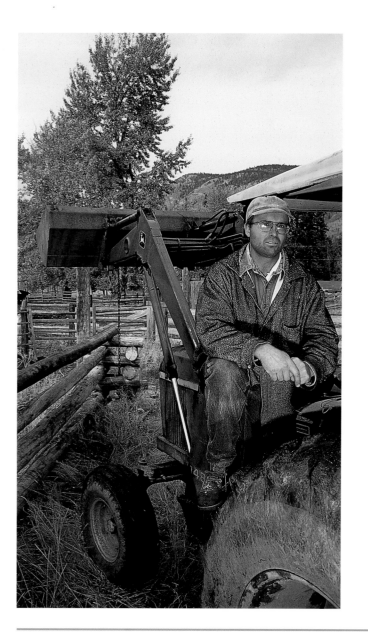

Jon Solecki, a Merritt rancher. Ranchland is at such a premium that when Solecki wanted to expand his operation, the closest parcel of land he could afford was at François Lake, 500 miles (840 km) away.

4-H CLUBS

Ranch kids miss out on after-school activities that most city kids enjoy because they are home-schooled or they ride a bus for hours to and from school. 4-H has no such restrictions. A community-based international organization, it is dedicated to the "personal growth and development of farm and non-farm rural youth" and to developing well-rounded, responsible, independent citizens. Its activities range from camping to public speaking and travel opportunities, as well as personal ranching or farming projects. Most ranch kids raise a steer as their project.

Minimum age for entry into 4-H varies from province to province. In BC it's eight, but when five-year-old Alissa MacDonald (Chezacut Ranch) wanted to join, she was allowed in as a "pre-4H-er." She could show but not sell her animal.

The down side of raising farm animals is that they have to be sold. Young people get very attached to their animals, so even a good price doesn't always prevent the tears on parting. One year the steer Cyrena Howarth raised formed an attachment to her dad's saddle horse. The horse was kept outside the steer's pen, but the two spent hours nuzzling each other through the fence. When sale day came, both Cyrena and the horse missed the steer. One youngster was more stoic about the fate of her 4-H animals. She raised two lambs—one to show and one to sell. She named the latter Souvlaki.

JIM (LEFT) AND DANNY ALBEITZ, WATSON BAR RANCH, WITH THEIR 4-H TROPHIES.

closed—even if there isn't a cow in sight. Once the Steves cows in Deadman Valley got through a gate left open by a tourist and they ambled out onto Highway 1 amid busy summer traffic. Harold and his daughters—on foot and horseback, respectively—tried to slow down the transport trucks whizzing by as they rounded up the escapees. There were no losses, but it wasn't an experience anyone cared to repeat. Charlie Coldwell has a different kind of gate problem. One of his gates is near a public campground, and he had to rebuild it three times within two years after campers got into their trucks and bunted it down. Backcountry travellers who can't be bothered to look for a gate sometimes take wire cutters to wire fences that are in their way. Good solid log fences are a more formidable barrier, although there aren't many of them around any more. And one Chilcotin rancher had to repair a log fence after someone took a chainsaw to it.

Fences need constant attention and repairs. Those beside highways and roads are particularly worrisome because, although they are built by the Ministry of Highways, the rancher is required to maintain them. If animals get out and are hit by passing motorists, there is a question of liability.

Rustling is alive and well in cow country. Harold Steves found the remains of one of his animals in a neat pile of bones and hide beside the road, left there by a rustler armed with a chainsaw. Carey Jules has lost animals every year. "There are too many back roads, and it's too easy to get an animal," he explains. Until they were caught, some enter-

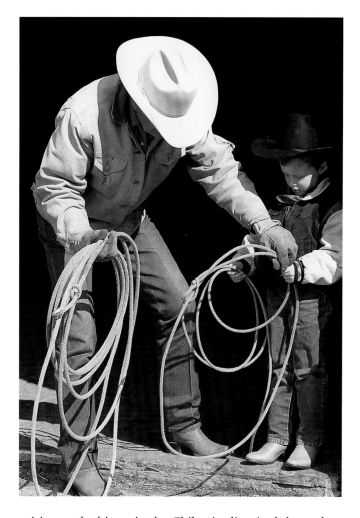

prising cattle thieves in the Chilcotin disguised themselves as campers with a very large tent. Nobody paid any attention to them until an alert rider discovered that they were butchering cattle inside the tent.

A ROPING LESSON.

GUEST RANCHES

Some large ranches, like Douglas Lake and Quilchena, are huge ranches with a tourism component. There are also tourist facilities that have a ranch component.

The Nicola Valley is a comfortable five-hour drive from Vancouver and it is a popular destination for city folk. The Douglas Lake ranch provides lakes for pay-for-fish anglers and its tourist accommodations range from campgrounds to luxurious lodge facilities. Guests at Quilchena can get a look at a working ranch, enjoy water sports in Nicola Lake, go on trail rides, or play tennis or golf in what was once a polo field. Both Douglas Lake and Quilchena have interesting general

stores. The Nicola Ranch and the historic Stump Lake Ranch also have tourist facilities.

Guest ranches come in a variety of shapes and sizes. Some cater to adults; others are family oriented. The bigger the operation the more activities there are, but most offer standard resort fare—fishing, swimming, hiking, photography and wildlife viewing, and most are open year-round, with snowmobiling and cross-country skiing in winter. Some are in remote areas; some are close to major highways, but they all have spectacular scenery, lots of land, western ambience and horseback riding.

The Nicola Valley has the big ranch/resorts, but the tiny village of Clinton on the Cariboo Road claims to be the guest ranch capital of the world. The area boasts the entire gamut from cattle ranch B&Bs to the oldest guest ranch in Canada—the Flying U on Green Lake, near 70 Mile House. It is not only Canada's oldest (founded in the 1800s) and biggest (40,000 acres/16,000 ha), it is the only guest ranch in North America that allows guests to ride horses unsupervised. The North West Company's post was taken over by the Hudson's Bay Company in 1849, and during the gold rush years a ranch and roadhouse located there served cowboys and miners. In 1886 William and Mary Boyd acquired it as a Crown grant. It was known as 70 Mile Ranch and Road House, but in 1923 the Boyds' son Jack turned it into the Flying U Guest Ranch and it has been flying ever since. Jack's friend, the American cowboy William S. Hart, came up with the name. Jack was one of the Cariboo's noted rodeo stars and for some years the ranch hosted one of the area's bigger stampedes.

The Flying U is a working ranch, running 260 head of cattle and 140 head of horses. It can accommodate 100 people in cabins with wood

THE MAIN LODGE AT ECHO VALLEY GUEST RANCH, ON THE JESMOND ROAD NEAR CLINTON.

stoves and log furniture served by a central washroom. The place oozes history: the lodge was built in 1886 and the dining room and saloon reflect the early days along the Cariboo Road. There are barbecues, barn dances and western entertainers for the guests' enjoyment. The ranch is child-friendly and has operated a children's outdoor education program since 1966. Among other things, kids learn to ride well enough to barrel race if they want to. The Fremlin family have owned the Flying U since 1979 and they operate it with Paul Crepeau.

Meadow Springs Guest Ranch, another working ranch in the 70 Mile area, can accommodate up to eleven guests, who are welcome to participate in whatever activity is underway at the time. The ranch is a quarter section (160 acres/64 ha) surrounded by Crown land, which provides plenty of places for guests to ride. The ranch has its own small lake and its own museum as well. The bunkhouse and the log cabin have modern facilities, but those who want to know what the real west was like can stay in the rustic cabin, which has a wood stove, washstand and an outhouse out back. Mark and Kathy McMillan are the host/owners.

At Echo Valley Ranch, on Jesmond Road, east meets west in the wilderness. This ranch has western ambience and Thai architecture.

Hosts Norm and Nan Dove offer two deluxe lodges, three cabins, two spas, satellite TV, gourmet meals made from their own organically grown veggies and ranch-raised meat—all the comforts of home and then some. One can loll in the heated pool, enjoy the spa, ride off on a four-day pack trip or sleep in a teepee on the Big Bar reserve. The property was a homestead taken up in 1908, and some of the old buildings remain.

Down the road is the Big Bar Guest Ranch. "Come as a city slicker, leave as a cowboy" is Big Bar's motto, and it is highly rated as a family resort. The emphasis here is on ranch activities: trail rides, cattle drives, roundups and day-to-day ranch work in conjunction with the neighbouring OK Ranch. The lodge was built from hand-hewn logs in 1936.

Another growing favourite is the Cattle Drive. Instituted in 1990 by a charitable group, this five-day cattle drive involves cattle, horses, wranglers, drovers, meals from a chuck wagon, cowboy songs and poetry around the campfire at night, and sleep under the stars in a traditional cowboy bedroll. The drive begins at a selected ranch and ends in a town or city. Cattle Drive 2001 ended in Kamloops.

LEFT: A YOUNG VISITOR AT A CHILCOTIN GUEST RANCH. RIGHT: A WRANGLER GREETS GUESTS AT THE BIG BAR GUEST RANCH.

Logging poses another problem. While trees encroaching on grasslands are a major concern and judicious logging can provide ranchers with added pasturelands, clearcuts can cause damage. Cows follow the line of least resistance, and if they get on a logging road they keep right on going and don't seem to know how to get back. Wild animals are not necessarily the rancher's friends. Deer are fond of alfalfa; wolves, bears and cougars have a preference for fat calves. Few people think of ravens as predators, but they sometimes peck the eyes and tongues out of newborn calves.

Unlike some other industries, the cattle business doesn't have an army of public relations people and lobbyists. The ranchers' political arm, the BC Cattlemen's Association, does not have a large staff, and its committees are composed of volunteers. Ranchers with smaller holdings and those with outside jobs—these two categories include many ranchers—can seldom afford the time to serve on committees.

Then there is the matter of cowboys. There aren't many of them any more, which is a major problem, especially for remote ranches like the Gang. It isn't easy to get farmhands either, and dads and granddads are often recruited to run machinery.

So why do ranchers stay with it? Is the reward at the end of the trail worth the ride? For most ranchers the answer is yes. The ride is what it's all about. They thrive on the relative peace and freedom of the daily life on a ranch, and most of the time they even make a living at it, although

one old-timer says the trick is not so much to make money as to keep from losing it.

At the production level of ranching, there are no unions, no conglomerates, no competitors trying to take the trade. (The only takeover threats come from the banks—which, as Doug Mervyn says, are partners in every ranch, one way or the other.) Ranchers are comfortable in their minds that they are where they want to be, doing what they want to do, when they want to do it.

"It is impossible to be stressed when you are riding a horse," comments Tim Bayliff, the third generation of his family to run Chilancoh Ranch, established in the Chilcotin in 1893. He is retired now, having turned the reins over to his son Hugh, who also has a son to follow him.

Of all the resource users, the rancher has the closest connection with the land. He is with his product from start to finish. "When you're feeding cows and calves," Fred Long says, "and a little guy sticks his head in the bin to see what Mom's got, and maybe he gets one blade of hay. And there she is, munching away with hay sticking out from each side of her mouth, and there he is, trying to figure out what to do with his one straw, and there you are, leaning on the pitchfork watching them for longer than you should be, but you've got the time to do it."

Or two calves will be bunting heads, then the whole little herd will take off, lined out, running hard, and just as suddenly they'll stop, find a patch of sun and have a nap. If something startles or frightens a calf, it will run to its mother for the comfort of a quick suck, little tail a-wagging. Or

one cow will "babysit" a batch of calves while their moms graze. "Money can't buy that show," Fred says.

When he is asked whether he would sell Back Valley, Harold Steves says yes, for $1 million. When told nobody in his right mind would pay that much, Harold smiles. That's his point. Back Valley is worth much more than dollars to the Steves family. As for Guy Rose of Quilchena, he admits he would be better off financially if he sold the ranch, but "then what would we do?" he asks. And Doug Mervyn explains, "You don't do it for the money. You do it because you love the land." He gestures to the grassland expanse of Alkali Lake Ranch and adds, "We still pinch ourselves to make sure this is real."

Will the ranching industry survive another century? Leonard Bawtree, the third generation to operate his family's Ashton Creek Ranch north of Enderby, is not optimistic. A staunch free-enterpriser, he insists there is just too much red tape and too much government interference. He agrees that some issues, such as wildlife and Crown range problems, are of long standing, but he takes exception to the "bureaucratic apparatus" that goes into overdrive with every environmental concern. Joe Lauder of the Nicola Valley looks back on his years in the industry and is optimistic. "In spite of hard times, adverse weather and government interference," he says, "with care of the land, adapting to changing circumstances, and perseverance, the ranching industry will be around for a long while yet." Ranchers are past masters at surviving, he says. It goes with the territory.

Broke But Happy
Frank Gleeson

Now people all laugh at him
And sometimes fun do poke
At that fellow called the rancher
'Cause the old guy's always broke.
See, he's always got his problems—
They pop up one by one—
And when he's got his problems,
Well, it isn't any fun.

See, his fence, it needs replacing
For his posts have rotted out.
His neighbour's supposed to help him,
But he came down with the gout.

See, the reason he's always broke
And he ain't a money king,
The fact is pretty simple—
He always needs something.

Like you take this morning
For why his wallet isn't full.
He had to buy a brand-new puller
To give a calf a pull.
And get himself new breeding stock
'Cause impotence got his bull.

His milk cow up and died last night.
He never had any luck.
The wind blew down the shade tree, see,
And smashed his pickup truck.

He was all smiles today
When he left the ranch for town,
But his calves, they sold at auction
For just forty cents a pound.

The bank wants more interest.
His steers don't seem to gain.
The pasture's all turned brown, you see,
'Cause we haven't had no rain.

His old stud horse got excited
'Bout the filly right next door.
He got cut on the barbed wire,
So that's another chore.

The wild geese got his oat crop,
And the barley's got the smut.
Some hunter ruined his old hog's ham,
When he shot him in the butt.
It seems things just keep piling up.
He's in the same old rut.

And yet he'll keep on smiling,
He'll grin from ear to ear.
It's nothing new to him, you see—
It was the same last year.

Although his pickup truck is rusty,
His wallet, it's still flat,
He just sold his calves and one old horse
And he bought a brand new hat.

Frank Gleeson is a Williams Lake area rancher who is spending more and more time on the cowboy poetry circuit.

CATTLE COUNTRY WORDS

artificial insemination—the process of mechanically introducing semen into the reproductive tract and uterus of a female for the purpose of fertilization

barren—sterile, not pregnant

brand—an animal's permanent identification markings, made by scar tissue usually produced by hot irons

breed—a group of animals that possess certain well-defined distinguishing characteristics and that reproduce these characteristics in their offspring with reasonable regularity

bunch grass—grass having the characteristic growth habit of forming a bunch

castrate—remove testicles from a male animal

chute—a narrow set of panels constructed for ease in handling cattle; often used for loading purposes

cattle guards—poles, 2x4s or iron pipes placed crossways over a pit, used instead of a gate: vehicles can cross but cattle won't

crossbreeding—mating of purebreds of the same species but different breeds

commercial cattle—in livestock breeding the offspring of a purebred with a non-purebred or from mating animals not purebred but having close purebred relatives

cull—(verb) take an animal out of a herd because it is below herd standards; (noun) an animal that is not up to herd standards

dewlap—the loose fold of skin found on brisket and on the necks of some cattle

drop—give birth

dry weight—weight of a cow after water is withheld for twelve hours

ear-notching—making slits or perforations in an animal's ears for the purpose of identification

ear-tagging—attaching a tag, usually metal or plastic, to an animal's ear for identification purposes

estrus—period when a cow is in heat

fill—the amount of food and water in an animal

finish—fatness (highly finished means very fat)

founder—a nutritional ailment caused by overfeeding: animals become lame with sore front feet and excessive foot growth

get—calves sired by same bull

grade—an animal not eligible for registration because both parents are not purebred

heifer—female cow, usually under three years of age, which has not yet produced a calf

line breeding—breeding grandfather to granddaughter

long fed—120 to 180 days of winter feeding

long yearling—cow between eighteen months and two years of age

marbling—distribution of fat in irregular streaks in lean meat, giving the appearance of marble

muley—naturally hornless

roughage—coarse feed high in fibre and low in total digestible nutrients

scrub—inferior animal

seed stock—foundation animals for establishing a herd

served—bred but not guaranteed pregnant

short fed—90 to 120 days of winter feeding

shrinkage—weight lost by cattle during transit or handling processes

spotter bull—bull that has been given a vasectomy so that it can be used to detect females in heat

squeeze—piece of equipment similar to a chute, used to control animals

stag—male castrated after breeding age

steer—male castrated when young

supplements—feeds, often high in protein, used to balance rations

wean—remove a calf from its mother so it can no longer nurse

weaner—calf that has just been weaned

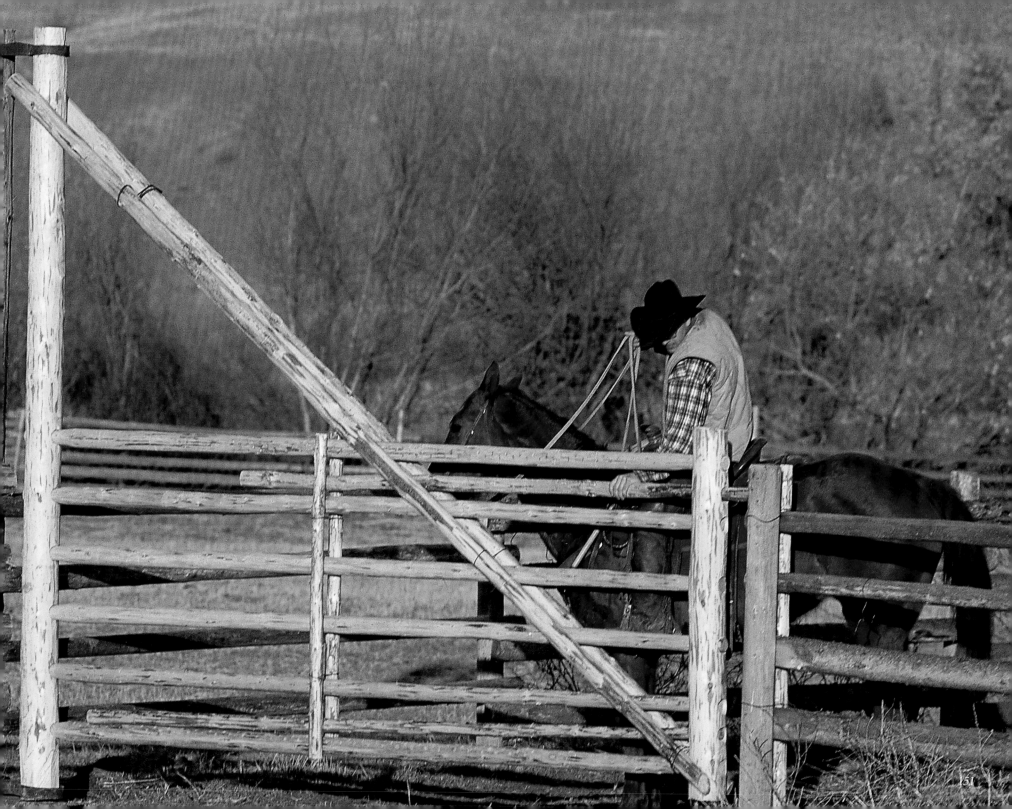

Acknowledgements

The authors would like to thank BC Heritage Trust and the Museum of the Cariboo Chilcotin for their support of this project.

Numerous ranches throughout BC were visited during the years it took to complete this project. One consistent theme was the hospitality provided by the ranch families. Every ranch welcomed us and opened their doors. This book could not have being completed without this "country hospitality."

Special thanks from Diana French to Pat Stewart and Pat Skoblanuik.

Index

Published by Harbour Publishing
P.O. Box 219, Madeira Park, BC Canada V0N 2H0
www.harbourpublishing.com

Cover, page design and composition by Martin Nichols
Edited by Betty Keller
All photographs by Rick Blacklaws, unless otherwise noted
Poem by Mike Puhallo on page 47 is reprinted from *Can't Stop Rhymin' on the Range*, published by Hancock House Publishing.

Printed in Canada

THE CANADA COUNCIL | LE CONSEIL DES ARTS
FOR THE ARTS | DU CANADA
SINCE 1957 | DEPUIS 1957

Harbour Publishing acknowledges the financial support of the Government of Canada through the Book Publishing Industry Development Program (BPIDP) and the Canada Council for the Arts, and the Province of British Columbia through the British Columbia Arts Council, for its publishing activities.

National Library of Canada Cataloguing in Publication Data

Blacklaws, Rick, 1953–

 Ranchland

 Includes index.
 ISBN 1-55017-232-8
 1. Ranching—British Columbia 2. Ranching—British Columbia Pictorial works. I. French, Diana. I. Title.
SF196.C2B52 2001 636.2'13'09711 C2001-910920-2

COVER AND PRELIMINARY PAGE PHOTOS:
FRONT COVER: Early on a winter morning, Empire Valley Ranch.
PAGE 1: BC Cattle Company hayfields along the Fraser River.
PAGE 2: Winter grazing at the Guichon Ranch.
PAGE 3: Spurs.
PAGE 4/5: Spring calf.
PAGES 6/7: Watching over the herd at spring roundup in the Chilcotin.
PAGE 9: The end of the day at Quilchena Cattle Company.
PAGE 10/11: The BC Cattle Company.
BACK COVER: Mike Jasper relaxing during the spring gathering at Separation Lake.
AUTHOR PHOTO OF DIANA FRENCH BY WENDY MCPHEE; AUTHOR PHOTO OF RICK BLACKLAWS BY CAROL TRAUMAN.